DRAWINGS FROM STOCKHOLM

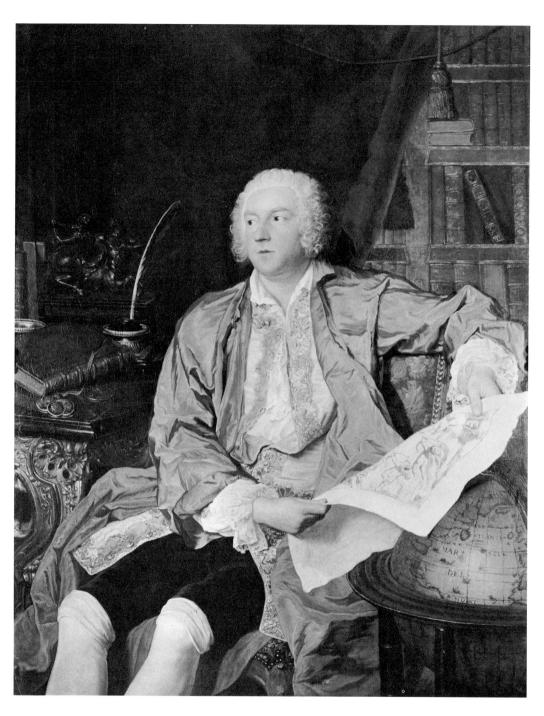

Portrait of Carl Gustaf Tessin by Jacques-André-Joseph-Camelot Aved

DRAWINGS FROM STOCKHOLM

A Loan Exhibition
from the Nationalmuseum

Compiled by Per Bjurström

1969



The Pierpont Morgan Library, New York
Museum of Fine Arts, Boston
The Art Institute of Chicago, Chicago

On the cover: REMBRANDT VAN RIJN *Girl Asleep in a Window* (No. 65)

FOREWORD

PRACTICALLY *every major museum has in its collections some section of which it is particularly proud. In the Nationalmuseum of Sweden this is the case with eighteenth-century art, both painting and sculpture as well as graphic and decorative art. And among the foreign countries represented, France naturally plays a leading part.*

We owe our predilection for the age of grace and reason to a great Swedish art lover, Count Carl Gustaf Tessin, the son of Nicodemus Tessin, Jr., architect of the Royal Palace in Stockholm and grandson of Nicodemus Tessin, Sr., architect of Drottningholm Palace. Although Carl Gustaf was thus predestined by family tradition to become an architect, he in fact became creative in another way— as the finest connoisseur and collector Sweden ever had.

The history of his collection of old master drawings is told in detail by Dr. Bjurström in the introduction to this catalogue. Still, however important this part of his collecting activities was, it constituted only one of his grand achievements towards securing for Sweden a proper part of Europe's cultural heritage. The spirit in which he acted is well expressed in the diary he kept in his retirement after he had lost his fortune and fallen into political disgrace. "My inclination, my fortune and perhaps some pardonable pride in being called a promoter of the fine arts in my country made me buy a lot of things, to which was joined the belief I still cherish that this and other collections judiciously made by connoisseurs, never lose but rather gain in value. Can a hungry man who has teeth and liberty be expected to sit at a table ready spread without eating?"

As pointed out by Dr. Bjurström, other donors, following in the footsteps of Tessin, added in the course of the nineteenth and twentieth centuries entire collections as well as single pieces of outstanding quality. But to this day the renown of the Stockholm Print Room is still based mainly upon its "Tessiniana."

This is the first time that an essential part of the very best drawings belonging to the Nationalmuseum has been sent abroad on an exhibition intended to be shown in three leading American museums. Sweden was in the eighteenth century the first European country to recognize the United States, and in a more

5

modest way this exhibition may perhaps be seen as a friendly gesture of understanding between our two countries.

The first to suggest such an appearance by the Nationalmuseum on the American scene was the Director of the Pierpont Morgan Library in New York, Mr. Frederick B. Adams, Jr. He and his staff, particularly Miss Felice Stampfle, Curator of Drawings and Prints, and Mrs. Elizabeth Jennison, Curatorial Assistant, have taken an active part in the realization of this project. I wish to extend to them, as well as to their colleagues in the museums in Boston and Chicago, my warmest thanks for their keen interest and hospitality.

Part of the financial responsibility for the exhibition is being carried by the Swedish Institute for Cultural Relations with Foreign Countries. Our gratitude is due to its Director, Dr. Per Axel Hildeman, and his colleague, Mr. Lars Björkbom, and also to the Swedish Consul General in New York, Mr. Tore Tallroth, for their always strong support.

CARL NORDENFALK
Director of the Nationalmuseum

Stockholm, September, 1968

INTRODUCTION

The first collection of drawings of any consequence in Sweden belonged to Queen Christina, who acquired five or six volumes containing drawings in 1651 through Pieter Spiering Silfvercrona, her minister at The Hague. Some, if not all of these drawings came from the collection compiled by Joachim von Sandrart in Italy. There was one volume of drawings by Raphael, one by Michelangelo, one of "antiques" by Goltzius, one that included drawings by Parmigianino and two volumes with sheets by various Italian masters. We do not know what happened to the collection during Christina's residence in Rome from 1655 onwards, but Nicodemus Tessin the Younger (1654–1728) described a visit to the Queen in 1688 during which he studied "all seven of the volumes" containing her drawings, so that the extent of the collection may in fact have remained largely unaltered. A substantial part of Christina's collection is still preserved intact at the Teyler Foundation, Haarlem.[1]

There is no way of knowing whether or not it was Nicodemus Tessin's visit to the Queen that led him to start collecting master drawings in addition to architectural drawings. He collected chiefly for practical reasons, that is, to obtain material for his activities as an architect and director of dramatic performances and *festivitas*. His acquisitions of drawings of a non-architectural character reveal a preference for the art of the preceding generation.[2]

In contrast to the predominantly practical approach of Nicodemus Tessin, his son Carl Gustaf (1695–1770), incomparably Sweden's most important collector of art, applied purely esthetic criteria to his collecting. While visiting Paris as a young man in 1715, he acquired several counterproofs, probably directly from Watteau, with whom he became closely acquainted,[3] and this at a time when his financial resources were very limited.

Carl Gustaf's next opportunity came in 1728 when he was on an official commission to Paris to study the latest developments in the decorative arts and possibly also to engage artists for the embellishment of the Royal Palace in Stockholm.[4] The death of his father in that same year and his

1. A more extensive assessment of Queen Christina as a collector of drawings is given by J. Q. van Regteren Altena, *Les Dessins italiens de la reine Christine de Suède*, Analecta Reginensia II, Stockholm, 1966, pp. 13–39.

2. The primary source of information concerning Nicodemus Tessin's collection is a catalogue (now in the Nationalmuseum's archives) drawn up by Carl Gustaf Tessin (1695–1770) some time between 1728, when Nicodemus died, and 1739, when Carl Gustaf left for Paris. It lists architectural drawings from Nicodemus's collection but none of the Crozat items acquired in Paris.

3. C. D. Moselius, *Carl Gustaf Tessins ungdom*, Stockholm, 1967, p. 45.

4. For a more detailed consideration of Tessin as a collector of drawings, see P. Bjurström, "Carl Gustaf Tessin as a Collector of Drawings," *Contributions to the History and Theory of Art, Figura*, N.S. VI (Acta Universitatis Upsaliensis), Stockholm, 1967, pp. 99–120 and the references given there.

marriage with a rich heiress the year before had made him a man of means. It was now that he laid the foundation of his collection of French paintings; which drawings he acquired on this occasion is not clear.

A few years later, in 1735–36, Tessin undertook a diplomatic mission to Vienna and paid a brief visit to Venice, mainly in order to find out whether some important Venetian painter would undertake the decoration of several ceilings in the Royal Palace in Stockholm. While in Vienna Tessin added chiefly to his library and his collection of engravings; in Venice he acquired several paintings. A letter home from Venice[5] mentions six portrait heads in chalk by Piazzetta, but at this point, however, the list in the letter breaks off and it is not known whether he acquired any other drawings in Venice.

Tessin returned to Paris on a diplomatic mission in the summer of 1739 and stayed there until 1742. During these years he collected avidly, bringing himself to the verge of ruin. After some minor purchases in the first two years, the opportunity to establish a really outstanding collection of drawings came in 1741 at the auction of the fabulous collection of Pierre Crozat. Tessin did not hesitate. Of the more than 19,000 drawings, catalogued for the sale by Pierre-Jean Mariette, he obtained no less than 2,057 for the sum of 5,072 livres 10 sous, making him one of the principal buyers. All the great dealers and connoisseurs of the age were represented at the auction. The former included Mariette himself, Huguet, Huquier, Hagard, Joulain and Gersaint; the latter, Comte de Caylus, Marquis de Gouverney, d'Argenville, Nourri, Jullienne, Lempereur and Marquis de Cailleres.

It now becomes easier for us to follow his purchases thanks to the preservation of such important documents as his catalogues and cashbooks. The vital acquisitions were concentrated in the period from April 10, when he made the first payment for the Crozat items, and July 29, 1741. Apart from the Crozat purchase, he bought drawings from Hagard on six occasions for a total of 949 livres and from Huquier on five occasions for 813 livres. Most of these items probably came from large lots in the Crozat sale which the dealers had later broken up to dispose of piece by piece. Tessin had already in March bought twenty-two drawings from Huquier for the relatively high price of 200 livres, and in 1742 he paid 500 livres for a collection of theatrical designs at an auction after the death of the Prince de Carignan and 220 livres to Huquier for a series of drawings by Oppenord. On the other hand, the cashbooks give no indication of any direct purchases of drawings from artists such as Boucher, Chantereau or Chardin, which means that Tessin's numerous sheets by these artists were either gifts connected with the purchase of paintings or acquisitions from dealers.

The collection assembled by Tessin, still the nucleus of the important group of old master drawings at the Nationalmuseum, is highly diversified. At the Crozat auction, Tessin obviously tried to obtain items from all the fields represented in the collection. Fifteenth-century drawings, for instance, were at the time generally regarded as artistic curiosities and yet Tessin bought the most important lots available. In the case of Rembrandt he purchased more than a hundred drawings, which were almost a third of those put up for auction. More than eighty of them are still in the Nationalmuseum and over thirty of these are today generally accepted as originals by Rembrandt. Much the most numerous group is comprised of drawings from the Italian Renaissance and the period of the Baroque, including sheets by Raphael and his pupils, Titian, Barocci and the Carracci. There was also a substantial number of seventeenth-century French drawings, with extensive selections of works by Poussin, Callot and Mellan. The Netherlandish section included important sheets by

5. To Carl Hårleman, President of the Board of Royal Works and Buildings.

Rubens and Van Dyck in addition to Rembrandt, and the relatively small group of German drawings contained masterpieces by Dürer and Grünewald.

Tessin's interest in his drawings led him to compile a manuscript catalogue of the collection on two occasions. The second catalogue, compiled after his return from Paris, is the more nearly complete; it was probably drawn up in 1749. It indicates that the collection was arranged in twenty-five "livrés,"[6] primarily by schools but with special groups for certain subjects, i.e., portraits of artists, Italian landscapes, portrait studies, nudes and animals. In addition there was a special port-folio containing one hundred and eight *dessins d'élite*, which seem to be the only drawings that Tessin himself had specially mounted. Most of the other drawings he probably left untouched, since the mountings are extremely varied and bear inscriptions in his own handwriting.

In 1748, Tessin had made a Christmas gift to Princess Lovisa Ulrica, the wife of the Swedish crown prince, of twenty-one of his most prized sheets. These included works by or attributed to Raphael, Giulio Romano, Federigo Zuccaro, Barocci, Maratta, Annibale Carracci, Veronese, Rubens, Van Dyck and Jordaens.[7]

Soon thereafter financial straits unfortunately obliged Tessin to dispose of his drawings and engravings, the collection passing to the royal family about 1750. In 1777, it was redeemed by King Gustavus III from his father's debt-encumbered estate and deposited in the Royal Library.

Thereupon the collection was entrusted to a nephew of Carl Gustaf Tessin, Fredrik Sparre, who rearranged it exclusively by schools and artists and had the sheets mounted in a single size (51.7 × 36.4 cm.), gilt-edged all around. Older mountings (for example, those by Vasari) were retained and the other sheets were given borders of different kinds: a golden strip distinguished the more esteemed sheets, a colored border (often bright yellow, pink or green) marked an intermediate rank and a simple ink border sufficed for the rest. The collection was also numbered in sequence from 1 to 3,025, the number usually being written on both the drawing itself (in the bottom righthand corner) and its mount. Thirteen new portfolios were produced for the collection, with the three crowns of Sweden repeated six times on their calfskin spines.[8]

It was in this state that the collection was taken over in 1794 by the newly founded Royal Museum, and practically no additions were made during the first half of the nineteenth century. In 1866, however, the museum was given its present name—Nationalmuseum—and its collections were transferred from the Royal Palace to the building in which they are still housed. Acquisitions of new drawings became more frequent and the collection was recatalogued and renumbered according to a system that is still in use. This work started in 1863, which is why all the Tessin sheets have this date included in their number. The new museum had the important task of building up a collection of Swedish graphic art. By acquiring the various collections left by the Swedish sculptor Johan Tobias Sergel (1740–1814), the museum became the owner of a small collection of master drawings as well as sheets by Sergel's contemporaries and friends in Rome. The chief drawings in this collection are the *Homer* by Rembrandt (No. 68) and the *Triumph of Titus* by Poussin (No. 87).

A substantial addition was made in 1896 in the form of drawings by foreign masters that had

6. "Livré" is the term Tessin uses to indicate a group of drawings that he stored together, meaning probably "livret," which would have been pronounced more or less in the same way and which he as a foreigner could have misspelled.

7. These sheets were subsequently owned by Nils Barck (Lugt 1959), who sold them in instalments in the mid-nineteenth century. Barck's entire collection, however, was much larger and we know that Lovisa Ulrica's collection, too, contained sheets with another provenance. At her death in 1782 she had on her walls ninety-seven framed drawings.

8. G. Upmark, "Handteckningssamlingen," *Statens Konstsamlingar 1794–1894, en festskrift*, Stockholm, 1894, pp. 38 ff.

been collected earlier by Michael Gustaf Anckarsvärd (1792–1878), a former head of the museum. Although of uneven quality, the some seven hundred sheets included several important works, namely, three peasant studies by Pieter Bruegel the Elder (No. 48) and a number of early Netherlandish sheets (Nos. 46, 47). A *Klebeband* acquired in 1918 mainly contained German Renaissance drawings (including sheets by Grünewald and Hans Burgkmair the Elder), which was all the more gratifying because German graphic art was poorly represented in Tessin's collection.

Several substantial purchases of French nineteenth-century art (Delacroix, Rodin) were made in the 1920's and 1930's, but subsequent acquisitions have had to be restricted to single items, important master drawings that serve to make the existing collection more representative. In 1958, for instance, the museum acquired its first four sheets by Claude Lorrain (No. 91) and in 1963 its first study by Tintoretto (No. 18). In 1968, the first drawing by Goya was purchased together with two important sheets by Parmigianino, who had previously been sparsely represented in the museum's collections.

PER BJURSTRÖM
Curator of Prints and Drawings
Nationalmuseum

Works Cited in Abbreviated Form

Bartsch | Adam Bartsch, *Le Peintre graveur*, 21 vols., Vienna, 1803–21.

Berenson, 1938 | Bernard Berenson, *The Drawings of the Florentine Painters*, amplified ed., 3 vols., Chicago, 1938.

Berenson, 1961 | Bernard Berenson, *I Disegni dei pittori fiorentini*, 3 vols., Milan, 1961.

Briquet | Charles Moise Briquet, *Les Filigranes. Dictionnaire historique des marques du papier*, 4 vols., Geneva, 1907.

Heawood | Edward Heawood, *Watermarks, Mainly of the 17th and 18th centuries*, Hilversum, Holland, 1950.

Lugt | Frits Lugt, *Les Marques de collections de dessins et d'estampes . . .*, Amsterdam, 1921.

Lugt S. | Frits Lugt, *Les Marques de collections de dessins et d'estampes . . . Supplément*, The Hague, 1956.

Mariette | (See under "Catalogues . . .")

Schönbrunner and Meder | Joseph Schönbrunner and Joseph Meder, *Handzeichnungen alter Meister aus der Albertina und anderen Sammlungen*, 12 vols., Vienna, 1896–1908.

Sirén, 1902 | Osvald Sirén, *Dessins et tableaux de la Renaissance italienne dans les collections de Suède*, Stockholm, 1902.

Sirén, 1917 | Osvald Sirén, *Italienska handteckningar från 1400- och 1500-talen i Nationalmuseum. Catalogue raisonné*, Stockholm, 1917.

Sirén, 1933 | Osvald Sirén, *Italienska tavlor och teckningar i Nationalmuseum och andra svenska och finska samlingar*, Stockholm, 1933.

Tietze, 1944 | Hans Tietze and Erica Tietze-Conrat, *The Drawings of the Venetian Painters in the 15th and 16th Centuries*, New York, 1944.

Catalogues Cited in Abbreviated Form

Cat. 1730 | Manuscript catalogue drawn up by Carl Gustaf Tessin some time between 1728 and 1739 (Nationalmuseum).

Cat. 1749 | Manuscript catalogue drawn up by Carl Gustaf Tessin in 1749 (Nationalmuseum).

Cat. 1785 | *Catalogue d'une collection* (Tessin's) *. . . dont la Vente au plus offrant se fera le* (8.) *du mois de* (May) 1786 *. . .*, Stockholm, 1785.

Cat. 1790	Manuscript catalogue drawn up by Fredrik Sparre while the collection belonged to Kongliga Biblioteket (Royal Library). The original manuscript is in the National Archives, a copy in the Nationalmuseum.
List 1739–41	Manuscript list of the items Tessin brought back from his stay in Paris, 1739–42 (Kongliga Biblioteket Ms. S. 12).
Mariette	Pierre-Jean Mariette, *Description sommaire des desseins des grands maistres . . . du cabinet de feu M. Crozat*, Paris, 1741.

Exhibitions Cited in Abbreviated Form

Leningrad, 1963	*Risunki XV—nacala XIX vv. iz national'nogo museja Stokgolma*, State Hermitage Museum, Leningrad, 1963.
Stockholm, 1922	*Carl Gustaf Tessins Franska handteckningar från 18:e århundradet*, Nationalmuseum, 1922, Cat. no. 15.
Stockholm, 1933	*Exposition d'un choix de dessins du quinzième au dix-huitième siècle*, Nationalmuseum, 1933, Cat. no. 43.
Stockholm, 1953	*Dutch and Flemish Drawings in the Nationalmuseum and other Swedish Collections*, Nationalmuseum, 1953, Cat. no. 200.
Stockholm, 1956	*Rembrandt*, Nationalmuseum, 1956, Cat. no. 231.
Stockholm, 1958	*Fem sekler fransk konst 1400–1900*, Nationalmuseum, 1958, Cat. no. 247.
Stockholm, 1962–63	*Konstens Venedig*, Nationalmuseum, 1962–63, Cat. no. 269.
Stockholm, 1965	*Italienska barockteckningar*, Nationalmuseum, 1965, Cat. no. 296.
Stockholm, 1966	*Christina, Queen of Sweden*, Nationalmuseum, 1966, Cat. no. 305.
Stockholm, 1967	*Holländska mästare i svensk ägo*, Nationalmuseum, 1967, Cat. no. 309.

CATALOGUE

ITALIAN

Benozzo Gozzoli
Florence 1420–Pisa 1497

1. *Nude Young Man Holding a Staff, a Lion at his Feet*

Silverpoint, pen and brown ink, heightened with white on greenish prepared paper. 22.3 × 15.7 cm. No watermark.

Inscribed at bottom left in pen and brown ink *Beato fra da fiesole*. Numbered at upper right *34*, in the left margin *36*, and at lower right *36* (overpainted) and *3*, all in pen and brown ink.

Verso: Cherub's head seen against halo with eight wings decoratively arranged. Pen and brown ink, wash, heightened with white on reddish ground. Inscribed in pen and brown ink at lower right *Del Beato Giou: da Fiesole Domenicano, del quale ne scrive la vita il Vasari* and along the upper margin *Del Beato Giovanni da Fiesole Domenicano morii d'anni 62 1455* (both inscriptions upside down).

Berenson identified the figure as identical with that of the young man who appears clothed in the *Rape of Helen* in the National Gallery, London (no. 591), a work from Benozzo's youth; in the National Gallery catalogue (Martin Davies, *Earlier Italian Schools*, London, 1951–53) the painting is ascribed to "Follower of Fra Angelico," however. Berenson also compares it with Benozzo's *St. Sebastian* in the church of S. Francesco at Montefalco and another *St. Sebastian* in the church of S. Agostino at S. Gimignano.

Popham has convincingly shown that the drawing was once part of a little album of drawings now in the Museum Boymans-Van Beuningen in Rotterdam, the sheets of which may be partly by Benozzo, partly by his pupils (cf. Berenson, 1938, no. 558 B, Berenson, 1961, no. 559 G-I).

A workshop copy of the drawing is in the Albertina, Vienna (Alfred Stix and Anna Spitzmüller, *Beschreibender Katalog der Handzeichnungen in der Staatlichen Graphischen Sammlung Albertina*, Vienna, 1941, no. 770; Berenson, 1938, no. 559 O, Berenson, 1961, no. 559 O⁺).

PROVENANCE: Crozat (Mariette, no. 1 or 2); C. G. Tessin (List 1739–41, p. 53 v; Cat. 1749, livré 3, no. 42); Kongl. Biblioteket (Cat. 1790, no. 36); Kongl. Museum (Lugt 1638).

BIBLIOGRAPHY: Schönbrunner and Meder, no. 1086; Sirén, 1902, p. 16, no. 1 (as Fra Angelico); Sirén, 1917, nos. 2 and 3; A. E. Popham, "A Book of Drawings of the School of Benozzo Gozzoli," *Old Master Drawings*, IV, March, 1930, p. 56, no. 3; Berenson, 1938, no. 545 B; Berenson, 1961, no. 545 B.

EXHIBITIONS: Stockholm, 1933, no. 3.

Inv. no. 57–58/1863

Francesco di Simone (Ferrucci)
Fiesole 1437–Florence 1493

2. *The Tomb of Alessandro Tartagni, S. Domenico, Bologna*

Pen and brown ink. 32.8 × 22.8 cm. Many tears and holes. Damaged by water around the edges.

Inscribed in pen and brown ink *Vieux Maitres de Florence, Cabinet de Crozat* (Tessin). Numbered in pen and brown ink on the old mount *20*, struck out.

This study for the Tartagni tomb is one of the very rare drawings from the fifteenth century for a sculptural monument. Francesco di Simone was a pupil of Desiderio da Settignano from whose Marsuppini tomb in S. Croce in Florence this monument is derived. It was simplified in the execution, the outermost garland and its supporting putti being omitted. The monument, which was executed during Francesco's stay in Bologna, 1480–82, was described by Vasari as his masterpiece.

PROVENANCE: Crozat (Mariette, no. 1 or 2); C. G. Tessin; Kongl. Biblioteket (The Tessin-Hårleman collection of architectural drawings); Kongl. Museum.

BIBLIOGRAPHY: O. Sirén, "En nyupptäckt teckning av en italiensk renässansskulptör i Nationalmuseum," *Nationalmusei Årsbok*, N.S. XIV–XV, 1944–45, pp. 155–60.

Inv. no. THC 2090

LUCA SIGNORELLI
Cortona 1441–Cortona 1523

3. *Head of Youth with Long Curls*

Black chalk, heightened with white, traces of red chalk. Pricked for transfer. 25.2 × 24.4 cm. Long tear running through the area of the right eye down to the lower edge. Pieces of paper added at the right.

Numbered in pen and brown ink at upper left *648*, at lower right *18* and *6*.

Study for the head of John the Baptist in the Perugia altarpiece of 1484.

PROVENANCE: Crozat (Mariette, no. 1 or 2); C. G. Tessin (List 1739–41, p. 53 v., as "Maitre non connu"; Cat. 1749, livré 3, no. 57, as "Maitre inconnu"); Kongl. Biblioteket (Cat. 1790, no. 6); Kongl. Museum (Lugt 1638).

BIBLIOGRAPHY: Schönbrunner and Meder, no. 1051; Sirén, 1917, no. 153; L. Dussler, *Signorelli*, (Klassiker der Kunst), Berlin and Leipzig, 1927, p. xix (Dussler 40); B. Berenson, "Les Dessins de Signorelli," *Gazette des Beaux-Arts*, 6:VII, 1932, pp. 173, 209; Berenson, 1938, no. 2509 I; Berenson, 1961, no. 2509 I.

EXHIBITIONS: Stockholm, 1933, no. 4.

Inv. no. 9/1863

DOMENICO GHIRLANDAIO
Florence 1449–Florence 1494

4. *Head of an Old Man*

Silverpoint and point of the brush, heightened with white on pink prepared paper. 28.2 × 21.4 cm. without frame. Cut down to oval and framed with decorative Michelangelesque nudes by Vasari. Small stains on the model's temple, a large one on his throat.

Inscribed in pen and black ink in the oval framing to the left *Vieux Maitres de l'ecole de Florence du Recueil de Vasari* (Tessin's handwriting), and to the right in the frame in black chalk, barely visible, *Di Paolo Ucello*. Numbered in pen and brown ink at lower right *1* and *2* struck out.

Mounted by Vasari.

Verso: Filippino Lippi, *Hercules and Nessus*, and inset below, a centaur downing a male nude, in the presence of a herm with hand extended. Pen and brown ink, brown wash, heightened with white. (Berenson, 1938, no. 1366 C; Berenson, 1961, no. 1366 D +.)

Study for the Louvre picture of an old man and his little grandson (no. 1322; Van Marle, 13, p. 101). Berenson is of the opinion that the drawing must have been made when the subject was asleep or, more likely, had just expired. In either case it must have been done in a single sitting, and that not a long one.

PROVENANCE: Vasari; Crozat (Mariette, no. 1 or 2); C. G. Tessin (List 1739–41, p. 32; Cat. 1749, livré 17, no. 3); Kongl. Biblioteket (Cat. 1790, no. 1); Kongl. Museum (Lugt 1638).

BIBLIOGRAPHY: Sirén, 1902, p. 29, no. 26; Schönbrunner and Meder, no. 886; Sirén, 1917, no. 28; H. S. Ede, *Florentine Drawings*, London, 1926, pl. 33; R. van Marle, *The Development of the Italian Schools of Painting*, XIII, The Hague, 1931, p. 101; B. Berenson, "Nova Ghirlandajana," *L'Arte*, 1933, pp. 171, 175; O. Kurz, "Giorgio Vasari's 'Libro de' disegni,'" *Old Master Drawings*, XII, June, 1937, p. 13; Berenson, 1938, no. 890 B; J. Lauts, *D. Ghirlandajo*, Vienna, 1943, no. 112, p. 56; L. Grassi, *Il Disegno italiano*, Rome, 1956, p. 66; Id., *I Disegni italiani del' 300 e 400*, Venice, 1962, no. 72; Berenson, 1961, no. 890; B. R. Häusler and J. E. Schuler, *Meisterzeichnungen von der Welt bewundert*, Stuttgart, 1962, no. 54; W. Ames in *Great Drawings of All Time*, (Ira Moscowitz, ed.), New York, 1962, Vol. I, Italian, no. 138.

EXHIBITIONS: Stockholm, 1933, no. 6.

Inv. no. 1/1863

5. *Two Young Women in Fluttering Draperies*

Pen and brown ink, light brown wash. 17.5 × 17.3 cm. Tears and small holes along the right and lower margin. Lined.

Inscribed at lower center in pen and brown ink *girlandai*. Numbered at lower right *74* (Sparre) and *11* struck out.

Verso: Perspective study for a pavement. Inscribed *Ghirlandai*. Pen and brown ink.

The studies were presumably executed under the inspiration of some work of ancient art.

PROVENANCE: Crozat (Mariette, no. 1 or 2); C. G. Tessin (List 1739–41, p. 53 v.; Cat. 1749, livré 3, no. 21); Kongl. Biblioteket (Cat. 1790, no. 74); Kongl. Museum (Lugt 1638).

BIBLIOGRAPHY: Sirén, 1902, p. 28, no. 23; Schönbrunner and Meder, no. 951; Sirén, 1917, no. 29; Berenson, 1938, no. 890 A; Berenson, 1961, no. 890 A; W. Ames in *Great Drawings of All Time*, (Ira Moscowitz, ed.), New York, 1962, Vol. I, Italian, no. 135.

Inv. no. 109/1863

PIETRO PERUGINO
Città della Pieve ca. 1445–Fontignano near Perugia 1523

6. *Studio Model Posed as an Angel Holding a Body in his Arms*

Silverpoint heightened with white, on pale brown prepared paper. 18 × 14.5 cm. The white has darkened in some places. Stain in upper margin.

Numbered in pen and brown ink *236* (Sparre), and *82* struck out.

The arms are repeated in the lower part of the drawing, where Perugino has suggested that they hold

the body of the Child Jesus instead of the loosely sketched adult figure. He used the drawing for the angel in the center panel of the *Adoration of the Child* triptych, 1499, at Certosa di Pavia. Although there he depicted the angel in the same position, he changed his age, making the young man of the drawing a boy in the painting. Perugino repeated the group in a replica in the Pitti Gallery.

PROVENANCE: Crozat (Mariette, no. 100?); C. G. Tessin (List 1739–41, p. 50 r; Cat. 1749, livré 8, no. 1); Kongl. Biblioteket (Cat. 1790, no. 236); Kongl. Museum (Lugt 1638).

BIBLIOGRAPHY: J. D. Passavant, *Raphael d'Urbin et son père Giovanni Santi*, Edition française . . . revue et annotée par M. Paul Lacroix, Paris, 1860, no. 625; O. Fischel, "Die Zeichnungen der Umbrer," *Jahrbuch der Königlich Preussischen Kunstsammlungen*, XXXVIII sup., 1917, p. 47, no. 53; Sirén, 1917, no. 154; Sirén, 1933, p. 84; Schönbrunner and Meder, no. 892.

EXHIBITIONS: Stockholm, 1933, no. 5.

Inv. no. 286/1863

FILIPPINO LIPPI
Prato 1457–Florence 1504

7. *The Youthful Baptist Seated*

Silverpoint, heightened with white on gray prepared paper. 25.8 × 18.2 cm. Top right, bottom left and right margin of the drawing lacking and replaced.
 Verso: Two powerful nudes, one of whom holds a cow by the tail. Inscribed in pen and brown ink *Antonio Pollajolo*. Numbered *4* and *47* (Sparre).

The drawing has been dated by Reuterswärd to the years after the completion of the Brancacci chapel in S. Maria del Carmine in Florence, 1484–85. Referring to an article by M. Aronberg Lavin ("Giovanni Battista: a Study in Renaissance Religious Symbolism," *Art Bulletin*, XXXVII, 1955, pp. 85–101; and supplementary "Notes" in *Art Bulletin*, XLIII, 1961, pp. 319–26), he points to Domenico Cavalca's *Vita di San Giovanni Battista* from the first half of the fourteenth century as Filippino's source of inspiration. He interprets the axe as a symbol of the future activity of St. John (Matthew 3:10, Luke 3:9), and the sleeping dog as a sign of his prophetic gifts.

PROVENANCE: Crozat (Mariette, no. 1 or 2); C. G. Tessin (List 1739–41, p. 53 r, as "Pollajolo"; Cat. 1749, livré 17,

no. 6); Kongl. Biblioteket (Cat. 1790, no. 47, as "Pollajolo"); Kongl. Museum (Lugt 1638).

BIBLIOGRAPHY: Schönbrunner and Meder, no. 868, no. 1188 (as Filippino Lippi); Sirén, 1917, nos. 41–42; Berenson, 1938, no. 1366 B; Berenson, 1961, no. 1366 C; P. Reuterswärd, "Den unge Johannes Döparen i öknen," *Konsthistoriska studier tillägnade Sten Karling*, Stockholm, 1966, pp. 79 ff., repr. p. 81.

Inv. no. 74, 76/1863

UNKNOWN LOMBARD ARTIST
ca. 1500

8. *Portrait of a Young Girl*

Silverpoint, shaded with black chalk, heightened with white with traces of red on the lips, on pink prepared paper. 14 × 10.6 cm. Lined.

The drawing is a typical example of a drawing that has at different times and by different scholars been attributed to different artists in the circle of Leonardo. The deliberate adaptation of the artists' style to common ideals makes differentiation of the individual hands an almost insolvable—and perhaps not too interesting—problem.

PROVENANCE: Crozat (Mariette, no. 175 or 177, as "Timothée Viti d'Urbin"); C. G. Tessin (List 1739–41, p. 32 v, as "Thimothée Viti"; Cat. 1749, livré 17, no. 16); Kongl. Biblioteket (Cat. 1790, no. 275); Kongl. Museum (Lugt 1638).

BIBLIOGRAPHY: Schönbrunner and Meder, no. 960 (as "Altniederländische Schule"); E. Voigtländer, "Ein Beitrag zu dem Bildnis der Sammlung Czartoryski," *Kunstchronik*, June 25, 1915 (as Boltraffio); Sirén, 1917, no. 447 (as Bernardino Luini).

EXHIBITIONS: Stockholm, 1933, no. 10; Leningrad, 1963.

Inv. no. 337/1863

FRA BARTOLOMMEO
Florence 1472–Pian' di Mugnone 1517

9. *View of a Town with Renaissance Buildings by a River*

Pen and brown ink. 16 × 22 cm. All four corners cut diagonally. No watermark.
 Numbered in pen and brown ink *232* (Sparre).
 Verso: Two studies for Christ on the cross. Lead, pen and brown ink.

PROVENANCE: Crozat (Mariette, no. 100, as Raphael); C. G. Tessin (List 1739–41, p. 50 r; Cat. 1749, livré 17, nos. 1–8,

as Raphael); Kongl. Biblioteket (Cat. 1790, no. 232, as Raphael); Kongl. Museum (Lugt 1638).

BIBLIOGRAPHY: Sirén, 1902, p. 42, no. 69 (as Perugino); Schönbrunner and Meder, no. 1194; Sirén, 1917, no. 75 (as School of Fra Bartolommeo); Berenson, 1938, and Berenson, 1961, no. 506 B (as Fra Bartolommeo).

Inv. no. 280, 282/1863

Strassburg, 1898, no. 28; Sirén, 1902, p. 52, no. 83; Schönbrunner and Meder, no. 901; O. Fischel, *Rafaels Zeichnungen*, Berlin, 1913, I, no. 29; Sirén, 1917, no. 301; Sirén, 1933, p. 118, no. 74; O. Fischel, *Raphael*, London, 1948, I, p. 28; II, pl. 13.

EXHIBITIONS: Stockholm, 1933, no. 12.

Inv. no. 296/1863

RAFFAELLO SANTI, CALLED RAPHAEL
Urbino 1483–Rome 1520

10. *The Adoration of the Magi*

Pen and brown ink over silverpoint. 27.2 × 42 cm.
 Horizontal fold 3.5 cm. from the upper border, vertical fold in the center. Dark stain at upper right. Repaired tears along the lower border. Traced with stylus. Lined.
 Numbered at upper left in light brown ink *1693*, at lower right in dark brown ink *13* struck out.

The drawing is a sketch for one of the paintings in the predella of the *Coronation of the Virgin* commissioned by Alessandra di Simone degli Oddi and executed in 1503 for the church of S. Francesco in Perugia and since 1817 in the Pinacoteca of the Vatican.

There are some differences between the drawing and the painting: the old king contemplates the Child in the drawing, and in the painting he has been turned more to the left to establish contact with the youngest king. The left portion of the drawing has not been finished and lacks a couple of figures and horses.

PROVENANCE: Jacques Stella–Claudine Bouzonnet Stella (cf. *Archives de l'art Français*, V, 1877, "Testament de Claudine Bouzonnet Stella," p. 45: Au 5ᵉ feuillet un dessein de Raphael: l'Adoration des trois Roys 140); Crozat (Mariette, no. 100; cf. p. vi: "Bientôt il (Crozat) réunit à son cabinet les Dessins que l'illustre Mlle Stella avoit trouvés dans la succession de M. Stella, son oncle, et qu'elle avoit conservés précieusement toute sa vie"); C. G. Tessin (List 1739–41, p. 50 r; Cat. 1749, livré 8, no.5); Kongl. Biblioteket (Cat. 1790, no. 243); Kongl. Museum (Lugt 1638).

BIBLIOGRAPHY: J. D. Passavant, *Raphael von Urbino und sein Vater*, Leipzig, 1839–58, II, p. 615, no. 542; III, p. 215, no. 622; A. H. Springer, *Raffael und Michelangelo*, Leipzig, 1883, 2nd ed., p. 71; J. A. Crowe and G. B. Cavalcaselle, *Raphael, sein Leben und seine Werke*, Leipzig, 1883, I, p. 125; E. Müntz, in *Gazette des Beaux-Arts*, II:31, 1885, pp. 196–97; Id., *Raphael, sa vie, son oeuvre et son temps*, 1886 ed., p. 79, note p. 98; 1900 ed., p. 18; G. Morelli (Lermolieff), *Die Werke italienischer Meister in den Gallerien von München, Dresden und Berlin*, Leipzig, 1880, p. 364; K. von Lützow, *Graphische Künste*, 1888, p. 61; W. Koopmann, *Raphaels Handzeichnungen*, Marburg, 1897, p. 246; O. Fischel, *Raphaels Zeichnungen*,

DOMENICO BECCAFUMI
Siena 1486–Siena 1551

11. *The Deposition*

Pen and brown ink. 20.5 × 26.4 cm. Lined. The two upper corners cut obliquely.
 Inscribed in pen and brown ink at lower left BECCAFUME. Numbered at lower right *67* and *B*.

The drawing, dated ca. 1540 by Sanminiatelli, seems to be a preparatory study for a lost painting. The composition is related to a painting of the same subject by Sodoma now in the Pinacoteca at Siena.

PROVENANCE: N. Lanier (Lugt 2908); P. Lely (Lugt 2092); Crozat (Mariette, no. 79); C. G. Tessin (List 1739–41, p. 39 v; Cat. 1749, livré 16, no. 2); Kongl. Biblioteket (Cat. 1790, no. 186); Kongl. Museum (Lugt 1638).

BIBLIOGRAPHY: Sirén, 1917, no. 119; D. Sanminiatelli, *D. Beccafumi*, Milan, 1967, no. 120; C. Brandi, "Disegni inediti di D. Beccafumi," *Bolletino d'Arte*, 1934, p. 350 f.; L. Becherucci, *Manieristi Toscani*, Bergamo, 1944, p. 35.

Inv. no. 228/1863

GIROLAMO ROMANINO
Brescia 1484/7–Brescia 1562

12. *Battle in Front of a Castle*

Pen and brown ink. 18.8 × 25.7 cm. Lined. Hole 17 × 4 mm. at upper center.
 Inscribed in pen and brown ink at lower left TICIAN. Numbered in pen and brown ink at lower center *1205* (Sparre) and at lower right *34* struck out.

Traditionally attributed to Titian, the drawing was connected by Sirén in 1917 with a drawing in Budapest (Tietze, 1944, no. 387) and then assigned to Romanino, an attribution accepted by G. Nicodemi, W. Suida, F. Lechi-G. Panazza, A. Morassi and F. Kossoff. L. Fröhlich-Bum suggests Paris Bordone as the artist. The Tietzes accepted the Budapest drawing as Romanino's but were more

hesitant about the Stockholm drawing which they connected with the work of Titian. The quality of the drawing certainly justifies its being associated with the name of Titian.

PROVENANCE: Crozat (Mariette, no. 655 or possibly 664, "Dessein pour celui/le tableau/de la Bataille de Giaradadda"); C. G. Tessin (List 1739–41, p. 48 r; Cat. 1749, livré 10, no. 2); Kongl. Biblioteket (Cat. 1790, no. 1205); Kongl. Museum (Lugt 1638).

BIBLIOGRAPHY: Sirén, 1902, pp. 64 and 134 (as Titian); Schönbrunner and Meder, no. 1075 (as Titian); Sirén, 1917, no. 455 (as Romanino); G. Nicodemi, *Girolamo Romanino*, n.d., p. 202; L. Fröhlich-Bum, "Studien zu Handzeichnungen der italienischen Renaissance," *Jahrbuch der Kunsthistorischen Sammlungen in Wien*, N.F. II, 1928, p. 187 (as Paris Bordone); Sirén, 1933, pl. 95; W. Suida, "Romanino," *Allgemeines Lexikon der Bildenden Künstler* . . . (U. Thieme and F. Becker, eds.), Leipzig, 1934, XXVIII, pp. 549–50; F. Lechi-G. Panazza, *La Pittura bresciana del Rinascimento*, (exh. cat.), 1939, p. 342; Tietze, 1944, no. A 1968 (as Titian); A. Morassi, "Alcuni disegni inediti del Romanino," *Festschrift Karl M. Swoboda zum 28. Januar 1959*, Vienna, 1959, p. 192.

EXHIBITIONS: Stockholm, 1962–63, no. 216; Brescia, *Mostra di Girolamo Romanino*, 1965, no. 129.

Inv. no. 1384/1863

GIOVANNI DA UDINE
Udine 1487–Rome 1564

13. *Finch*

Watercolors. 16.5 × 13.6 cm. No watermark. Black spots on the bird's chest.
Numbered in pen and brown ink at lower right *4*.

The drawing belongs to a group of eight drawings which Tessin acquired from the Crozat collection. Two of them have inscriptions on the mount in a seventeenth-century hand: *Gio da Vdine Fece un libro d'ogni sorte di volatili ritratti dal vero che era lo spasso, e'l trastullo di Rafaello dal quale si sono tratti questi pezzi. Vasari nella vita di Gio.* (on a drawing depicting twelve beetles and grasshoppers, no. 386/1863); and *Dell'istesso Libro, e si uede dipinto nelle Loggie* (on a drawing depicting a bird, no. 387, 390/1863). The drawing dates from the first half of the sixteenth century and in general appearance is very like the birds in Giovanni's frescoes in Raphael's *Logge* but cannot be demonstrably connected with them. A drawing in Dresden (C. 197) is the only one which depicts a recognizable detail from the *Logge*.

PROVENANCE: Crozat (Mariette, no. 178?); C. G. Tessin (List 1739–41, p. 62 v, "Jean da Udine"; Cat. 1749, livré 20,

nos. 7–10); Kongl. Biblioteket (Cat. 1790, no. 326); Kongl. Museum (Lugt 1638).

BIBLIOGRAPHY: Sirén, 1902, p. 61 f., p. 130, no. 120; Sirén, 1917, no. 348; Cf. T. Borenius, "Giovanni da Udine—a Wild Duck," *Old Master Drawings*, I, December, 1926, p. 37, pl. 41; P. Pouncey and J. A. Gere, *Italian Drawings in . . . the British Museum, Raphael and his Circle*, London, 1962, no. 153, pl. 220.

Inv. no. 389/1863

GIULIO ROMANO
Rome 1493–Mantua 1546

14. *Apollo and Cyparissus*

Pen and brown ink, wash. 28.7 × 23 cm. Lined.
Inscribed in pen and brown ink *Julio Romano*; on the mount, *Cabinet de Crozat* (by Tessin).

Hartt has identified the subject as "Apollo Embracing Cyparissus (Ovid, *Metamorphoses*, X, 106 ff.) in a woodland where the boy had been hunting and the god making music on the viol. Behind the rock on which they sit, the Carthean nymph, finger in mouth in jealous surprise, hides in the shadow of a tree, in possible reference to the cypress into which the boy was later transformed." Hartt further suggests that the character of the subject might indicate that the sheet was done for Pietro Aretino.

PROVENANCE: Crozat (Mariette, no. 134); C. G. Tessin (List 1739–41, p. 50 v; Cat. 1749, livré 8, no. 18); Kongl. Biblioteket (Cat. 1790, no. 287); Kongl. Museum (Lugt 1638).

BIBLIOGRAPHY: Sirén, 1902, no. 115; Sirén, 1917, no. 326 (as copy); F. Hartt, "Drawings by Giulio Romano in the National Museum in Stockholm," *Nationalmusei Årsbok*, N.S. IX, 1939, pp. 61 ff., fig. 30; Id., *Giulio Romano*, New Haven, 1958, I, p. 252, no. 298; II, fig. 517.

Inv. no. 347/1863

JACOPO PONTORMO
Pontormo 1494–Florence 1557

15. *Dog*

Red chalk, squared for transfer. 17.2 × 14.6 cm. Lined.
Inscribed on the old mount in pen and red ink AGOSTINO; in brown ink, *Questo e quel suo cane per cui mosse tante risa.* Numbered *10* struck out, *2* struck out, and *783* (Sparre).

The drawing has been identified by Walter Vitzthum as a study for the dog seen *di sotto in su* in the

left half of the lunette at Poggio a Caiano. Earlier it had been attributed to Agostino Carracci.

PROVENANCE: Crozat (Mariette, no. 454); C. G. Tessin (List 1739–41, p. 62; Cat. 1749, livré 20, no. 17); Kongl. Biblioteket (cat. 1790, no. 783); Kongl. Museum (Lugt 1638).

BIBLIOGRAPHY: W. Vitzthum, review of L. Berti, *Pontormo Disegni*, in *Master Drawings*, IV, 1966, p. 311.

Inv. no. 931/1863

FRANCESCO PRIMATICCIO
Bologna 1504–Paris 1570

16. *The Knight of the Swan*

Pen and brown ink. Red, brown and yellow watercolor. 28 × 22 cm. Watermark: small shield.
 Numbered in pen and brown ink at lower right *708* (Sparre) and *19*.

The drawing is one in a set of costume designs preserved in Stockholm, which were discovered and published by L. Dimier in 1899; very similar material in the Biblioteca Nazionale in Florence was discovered by B. Dahlbäck and published in part by him in 1957.

This enigmatic design perhaps has some connection with the family of Clèves, which originated in Kleef in the Rhineland and whose early history was linked with the legend of the Knight of the Swan. The box tied to the swan's neck and to which the bird's beak is turned perhaps contains the challenge to a tournament thus delivered to the chief of the *fête*. It is evident that the swan's legs are in fact those of the wearer of the costume, while the legs attached to the bird's wings are false.

PROVENANCE: Crozat (Mariette, no. 412, as Nicolo dell'Abbate); C. G. Tessin (List 1739–41, p. 41 v: "Desseins de Mascarades pour Ballets, et fig.s pour un Tournois legerement colorés par Nicolò dell'Abbate. Ils sont faits pour des Fetes données a Charles V par François l.r"; Cat. 1749, livré 26, no. 46–81); Kongl. Biblioteket (Cat. 1790, no. 708); Kongl. Museum (Lugt 1638).

BIBLIOGRAPHY: L. Dimier, "Några minnen från den gamla Fontainebleauskolan," *Ord och Bild*, Stockholm, 1899, p. 594 ff; Id., *Le Primatice*, Paris, 1900, no. 192; Id., *Le Primatice*, Paris, 1928, pl. 42; Sirén, 1917, no. 257; H. Comstock, "Designs for Stage Scenery," *The Connoisseur*, London, 1934, p. 306; A. Beijer, "16th–18th century Theatrical Designs at the National Museum," *Gazette des Beaux-Arts*, 1945, 6: XXVIII, p. 213; P. Bjurström-B. Dahlbäck, "Témoignages de l'ephémère, "*L'Oeil*, XXIV, 1956, p. 40; Cf. also B. Dahlbäck, "La Tradition médiévale dans les fêtes françaises de la renaissance," *Les Fêtes de la renaissance*, I, Paris, 1957, p. 399 f.

EXHIBITIONS: New York, Museum of Modern Art, *International Exhibition of Theatre Art*, 1934, no. 10; Paris, Musée Carnavalet, *Théâtre et fêtes à Paris*, 1956, no. 40; London, The Arts Council, *Sixteenth and Seventeenth Century Theatre Design in Paris*, 1956, no. 2; Stockholm, 1958, no. 185.

Inv. no. 851/1863

17. *Ulysses Has the Servants of Penelope Executed*

Red chalk, heightened with white (partly oxidized) on paper tinted light red. 24.6 × 32.5 cm. Lined.
 Numbered in pen and brown ink *690* (Sparre) and *15* struck out.

This compositional drawing for one of the paintings in La Galerie d'Ulysse at Fontainebleau is part of a set of nineteen similar drawings in Stockholm. The composition has been engraved by Van Thulden.

La Galerie d'Ulysse, which depicted Ulysses' changing fortunes after leaving Troy, was executed between 1541 and 1570. The wall paintings to which this subject belongs were executed at the beginning of this period, 1540–47. There are also five drawings in the Albertina and one at Chantilly which are related to the work.

PROVENANCE: Crozat (Mariette, nos. 399 and 400); C. G. Tessin (List 1739–41, p. 55 r; Cat. 1749, livré 5, no. 31); Kongl. Biblioteket (Cat. 1790, no. 690); Kongl. Museum (Lugt 1638).

BIBLIOGRAPHY: Louis Dimier, *Le Primatice*, Paris, 1900, no. 179; Sirén, 1917, no. 245.

EXHIBITIONS: Leningrad, 1963.

Inv. no. 832/1863

JACOPO ROBUSTI, CALLED TINTORETTO
Venice 1518–Venice 1594

18. *Three Studies of a Sculpture of Atlas*

Black chalk. 26.5 × 41 cm. A tear ca. 19 cm. long runs from the upper border through the middle figure. Watermark: Anchor, close to Briquet 570, Verona 1579.
 Verso: Three further studies of the Atlas. Black chalk with traces of white. Inscribed on the verso at the upper left in black chalk *Tintoretto*; repeated at the right upside down.

There are at least twelve drawings by Tintoretto depicting this Atlas figure, which were obviously drawn from a small sculpture once at Tintoretto's

disposal. M. Lieberman has identified it with a small bronze of an old man walking, in the Museum of Art in Moscow, attributing it to a pupil of Sansovino. Hans R. Weihrauch has later attributed it to Jacopo Sansovino himself, as a work executed in the 1540's.

When Tintoretto had the sculpture, it was supposedly still in wax, not having been cast until later when it was already somewhat damaged. The figure was first used by Tintoretto in a painting executed before 1549. Most Tintoretto drawings after sculptures are dated by R. Pallucchini and A. Forlani to the late 1540's and the 1550's. It is important to note, however, that a contemporary of Tintoretto, Rafaello Borghini, describes in 1584 how Tintoretto even in his later years drew from sculptures.

An examination of the Stockholm drawing, in particular the trunk and the legs of the figures, reveals a technique of nervous accentuation, interrupted lines and sudden reinforcement of the contours, all of which work to create an effect of plasticity, roundness and dramatic lighting. This is an expression of a coloristic vision which can to some extent be traced in Tintoretto's later painting. This method is not to be found in Tintoretto's earlier drawings and seems to have first emerged around 1580.

PROVENANCE: Matthiesen Gallery, 1963.

BIBLIOGRAPHY: W. Hugelshofer, "Zeichnungen mit der Feder von Jacopo Tintoretto," *Pantheon*, XX, 1962, p. 340 f.; P. Bjurström, "On a Newly-Acquired Drawing by Tintoretto," *Meddelanden från Nationalmuseum, Stockholm*, 88, 1963, pp. 87–91; *Gazette des Beaux-Arts*, 6:63 suppl., February, 1964, p. 99, verso repr.; H. R. Weihrauch, "Italienische Bronzen als Vorbilder deutscher Goldschmiedekunst," *Studien zur Geschichte der Europäischen Plastik, Festschrift Theodor Müller*, Munich, 1965, pp. 266 f., nos. 13 and 15.

Inv. no. 150/1963

FEDERIGO BAROCCI
Urbino 1526–Urbino 1612

19. *Study of a Tree*

Black, green and brown chalk. 40.4 × 26.4 cm. Stained. Old horizontal fold. No watermark.
 Inscribed in black chalk at upper right, *Il Tuto . . . uno.* Numbered in pen and brown ink *348* (Sparre) and *23* struck out.
 Verso: Black chalk study of a landscape, fragmentary.

This free study after nature might be connected with other drawings of the same kind, for example, the study of a slope with a bush in the British Museum (P. 3-202) which Olsen associates with the etching, *Stigmatization of St. Francis* (Bartsch 3). Other drawings in this very limited group of studies of trees are in the Louvre, Paris (2), the Albertina, Vienna, the Uffizi, Florence, Biblioteca Communale, Urbino, and the collection of Frits Lugt, Institut Néerlandais, Paris.

PROVENANCE: Crozat (Mariette, no. 224); C. G. Tessin (List 1739–41, p. 32 r; Cat. 1749, livré 12, no. 34); Kongl. Biblioteket (Cat. 1790, no. 348); Kongl. Museum (Lugt 1638).

BIBLIOGRAPHY: A. Schmarsow, "Federigo Baroccis Zeichnungen, 3, Die Zeichnungen in den Sammlungen ausserhalb Italien, B: Östliche Hälfte Europas," *Abhandlungen der Philologisch-Historischen Klasse der Königlichen Sächsischen Gesellschaft der Wissenschaften*, Leipzig, 1914, p. 27; Sirén, 1917, no. 173; Harald Olsen, *Federico Barocci*, Uppsala, 1955, p. 182; Id., *Federico Barocci*, Copenhagen, 1962, p. 234.

Inv. no. 410/1863

20. *The Visitation*

Pen and brown ink, wash. 28.4 × 20.4 cm.
 Fragment of unidentified watermark. Small repaired tears along the bottom and right edge.
 Inscribed in pen and brown ink on the left *Federigo Barroccio*; on the right *Le B.* Numbered in pen and brown ink *349* (Sparre).
 Verso: Further studies for the Virgin and St. Elizabeth. Pen and brown ink, wash.

Both recto and verso of this sheet are studies for the painting executed during the years 1583–86 for the Cappella della Visitazione in the Chiesa Nuova, Rome.

The group of the Virgin and St. Elizabeth is also repeated three times on the verso of the sheet. The most accomplished version shows the Virgin coming up the stairs from the left and a vaulted porch in the background. In the final painting the artist turns this main group in the opposite direction, repeating the figure of Mary as a woman with birds in a basket at the lower right of the painting. This grouping is found in one of the sketches on the verso of the sheet.

PROVENANCE: Chechelsberg, Venice?; Crozat (Mariette, no. 231 lists a "Visitation de sainte Elisabeth, grande et belle Composition qui a appartenu à Pietre Lely," which does not seem to be identical with this sheet however); C. G. Tessin (List 1739—41, p. 61 r; Cat. 1749, livré 9, no. 3); Kongl. Biblioteket (Cat. 1790, no. 349); Kongl. Museum (Lugt 1638).

BIBLIOGRAPHY: Sirén, 1902, no. 187; A. Schmarsow, "Federigo Baroccis Zeichnungen, III, Die Zeichnungen in den Sammlungen ausserhalb Italiens, B: Östliche Hälfte Europas," *Abhandlungen der Philologisch-Historischen Klasse der Königlichen Sächsischen Gesellschaft der Wissenschaften*, Leipzig, 1914, p. 24; Sirén, 1917, nos. 174–75; Sirén, 1933, pl. 126; Schönbrunner and Meder, no. 1159; Charles de Tolnay, *History and Technique of Old Master Drawings*, New York, 1948, no. 180; Harald Olsen, *Federico Barocci*, Uppsala, 1955, p. 140; Id., *Federico Barocci*, Copenhagen, 1962, p. 180.

EXHIBITIONS: Leningrad, 1963.

Inv. no. 412–413/1863

TADDEO ZUCCARO

S. Agnolo in Vado 1529–Rome 1566

21. *Portrait of a Young Man*

Black and red chalk. 25.4 × 17.1 cm. Watermark: Angel within a circle.

Inscribed with pen and brown ink at upper right *B 10 Zucaro*; at lower left *Schizzo de mano de Tadeo* (according to J. Gere in the hand of Federigo Zuccaro) and *Zuccaro*. Numbered *386* (Sparre).

Verso: Two sea dragons. Black and red chalk. 24.5 × 16 cm.

In front of the young man, in the lower right part of the sheet, is a small study of the Farnese *Hercules* seen from behind. The studies on the verso of the sheet are attributed to Federigo Zuccaro by Gere.

PROVENANCE: Jabach; Crozat (Mariette, nos. 204, 210 or 215); C. G. Tessin (List 1739–41, p. 34 v, no. 8; Cat. 1749, livré 17, no. 107); Kongl. Biblioteket (Cat. 1790, no. 386); Kongl. Museum (Lugt 1638).

BIBLIOGRAPHY: Sirén, 1902, no. 193; Schönbrunner and Meder, no. 312; Sirén, 1917, nos. 391–392.

EXHIBITIONS: Leningrad, 1963.

Inv. no. 458–59/1863

FEDERIGO ZUCCARO

S. Agnolo in Vado 1529–Rome 1609

22. *The Assumption*

Pen and brown ink, wash. 33 × 19.6 cm. Watermark: Ladder (close to Briquet 5930, Lucca 1560).

Numbered in pen and brown ink *371* (Sparre), *86* struck out.

Verso: Flying angels.

PROVENANCE: Crozat (Mariette, no. 204 or 210); C. G. Tessin (List 1739–41, p. 51 v; Cat. 1749, livré 8, no. 55); Kongl. Biblioteket (Cat. 1790, no. 371); Kongl. Museum (Lugt 1638).

BIBLIOGRAPHY: Sirén, 1917, no. 376–77.

Inv. no. 442, 444/1863

FRANCESCO CURIA

1538–1610, worked in Naples

23. *Baptism in a Church*

Pen and gray ink, violet wash. 28.8 × 22.2 cm. No watermark. Horizontal fold across center.

Numbered at lower right in pen and brown ink *605* (Sparre) and *137* struck out.

Verso: Figures on stairs, Cupid, Venus. Pen and gray ink, violet wash.

The Nationalmuseum owns the largest existing collection of Curia drawings; it numbers eighty-two sheets.

PROVENANCE: N. Tessin the Younger (Cat. 1730, p. 4); C. G. Tessin (Cat. 1749, livré 19, nos. 91–143); Kongl. Biblioteket (Cat. 1790, no. 605); Kongl. Museum (Lugt 1638).

EXHIBITIONS: Stockholm, 1965, no. 80.

Inv. no. 729–30/1863

JACOPO PALMA, CALLED PALMA GIOVANE

Venice 1544–Venice 1628

24. *St. John the Evangelist, St. Mark and St. Paul in the Clouds*

Pen and brown ink, brown wash over black chalk indications. 25.9 × 18.8 cm. Small hole in the left margin. The margins brownish. Lined.

Numbered in pen and brown ink *1287* (Sparre).

The three saints, with the lion of St. Mark in their midst, dominate the composition; Christ floats in the upper arched zone. Under the heavenly vision is a distant view of Venice. The detail studies of a figure on the right are without obvious relationship to the main composition.

The drawing is a preparatory study for the altarpiece in the Scuola di S. Marco, signed and dated 1614, a work originally ordered from Domenico Tintoretto. There is another somewhat different study in the Victoria and Albert Museum, London (Dyce 252).

PROVENANCE: Crozat (Mariette, no. 735); C. G. Tessin (List 1739–41, p. 49 v; Cat. 1749, livré 10, no. 82); Kongl. Biblioteket (Cat. 1790, no. 1287); Kongl. Museum (Lugt 1638).

BIBLIOGRAPHY: Tietze, 1944, p. 208, no. 992.

EXHIBITIONS: Stockholm, 1962–63, no. 247.

Inv. no. 1473/1863

LUDOVICO CARRACCI
Bologna 1555–Bologna 1619

25. *The Martyrdom of St. Catherine*

Pen and gray ink with gray and reddish wash, heightened with white, on paper prepared with light red wash. Cut to a semicircle at the top (the topmost part lacking). 39.6 × 26.3 cm. The arch is on a separate piece of paper. Repaired holes in the upper part of the drawing and at the right border. Lined.

Numbered in pen and brown ink at lower right *748* (Sparre).

PROVENANCE: Crozat (Mariette, no. 435); C. G. Tessin (List 1739–41, p. 60 v; Cat. 1749, livré 21, no. 41); Kongl. Biblioteket (Cat. 1790, no. 748); Kongl. Museum.

Inv. no. 891/1863

AGOSTINO CARRACCI
Bologna 1557–Parma 1602

26. *Christ and the Adulteress*

Pen and gray-brown ink. 18.5 × 19.2 cm. Upper right corner replaced. Repaired hole in the upper left portion of the drawing.

Numbered in brown ink at lower right *773* (Sparre) and *127* struck out.

Verso: Small study of woman seen from the back.

PROVENANCE: Crozat (Mariette, no. 454); C. G. Tessin (List 1739–41, p. 56 r; Cat. 1749, livré 5, no. 84); Kongl. Biblioteket (Cat. 1790, no. 919); Kongl. Museum.

Inv. no. 919, 922/1863

ANNIBALE CARRACCI
Bologna 1560–Rome 1609

27. *Madonna and Child with St. John, Surrounded by Angels, the Child Crushing the Serpent*

Pen and brown ink over sketch in red chalk. 35.2 × 24.7 cm. No watermark.

Numbered in brown ink at lower right *883* (Sparre) and *96* struck out.

Verso: Cupid and studies of the Madonna. Red chalk.

Dated by W. Vitzthum to the period soon after Annibale's arrival in Rome.

PROVENANCE: Crozat (Mariette, no. 450, "la sainte Vierge accompagnée de l'enfant Jesus qui écrase le serpent"); C. G.

Tessin (List 1739–41, p. 55 v; Cat. 1749, livré 5, no. 43); Kongl. Biblioteket (Cat. 1790, no. 833); Kongl. Museum (Lugt 1683).

EXHIBITIONS: Stockholm, 1965, no. 55; reviewed by W. Vitzthum, *Master Drawings*, III, 1965, p. 413.

Inv. no. 990–991/1863

GUIDO RENI
Bologna 1575–Bologna 1643

28. *The Penitent Magdalene*

Black chalk on gray-green paper, heightened with white. 41.3 × 29 cm. Brownish stains.

Inscribed in pen and brown ink at lower right *Guido Rheni*. Numbered *889* (Sparre), *14* and *2* struck out.

Study for the painting of the same subject from ca. 1630, now in the Galleria Nazionale d'Arte Antica, Rome.

PROVENANCE: Crozat (Mariette, no. 526); C. G. Tessin (List 1739–41, p. 56 v; Cat. 1749, livré 6, no. 14); Kongl. Biblioteket (Cat. 1790, no. 889); Kongl. Museum (Lugt 1638).

EXHIBITIONS: Stockholm, 1965, no. 122.

Inv. no. 1055/1863

GIOVANNI LANFRANCO
Parma 1582–Rome 1647

29. *Seated Woman Seen "di sotto in sù"*

Black chalk, heightened with white on gray paper. 24.8 × 34 cm. No watermark. Brown stains in upper left part.

Inscribed in pen and brown ink at lower left *Vanegas*. Numbered at lower right *1429* (Sparre) and *30* struck out.

Verso: Figure studies. Black chalk heightened with white.

Attributed to Lanfranco by W. Vitzthum, the figure has been identified by E. Schleier as a study for the right angel on the cloud at the upper right of Lanfranco's altarpiece the *Blessed Andrea Avellino* in S. Andrea della Valle, Rome.

PROVENANCE: Crozat (Mariette, no. 779); C. G. Tessin (List 1739–41, p. 59 r; Cat. 1749, livré 11, no. 58); Kongl. Biblioteket (Cat. 1790, no. 1429 as Vanegas); Kongl. Museum (Lugt 1638).

Inv. no. 1620–21/1863

PIETRO TESTA
Lucca 1607/1611–Rome 1650

30. *The River Tiber Surrounded by Nymphs and Virtues*

Pen and brown ink over preliminary indications in graphite. 37.3 × 30.4 cm. Large stain in upper right corner; several smaller stains; fold line across center. Small hole in lower left quadrant. Lined.

Inscribed in pen and brown ink at upper center in an old hand *original di pietro Testa*. Numbered in brown ink at lower right *453* (Sparre).

The sheet is a preparatory study, in reverse, for Testa's etching of the subject (Bartsch, XX, p. 224, no. 30), from which it differs somewhat particularly at the right. There, in the print, three theological virtues on a cloud and an accompanying griffin replace the two female personifications with a putto, and a chariot drawn by four horses and carrying a globe with a putto. According to Bartsch the print is supposed to celebrate the arrival of a cardinal in Rome.

PROVENANCE: Crozat (Mariette, no. 272); C. G. Tessin (List 1739–41, p. 52 v; Cat. 1749, livré 23, no. 22); Kongl. Biblioteket (Cat. 1790, no. 453); Kongl. Museum (Lugt 1638).

EXHIBITIONS: Stockholm, 1965, no. 134 repr.

Inv. no. 535/1863

STEFANO DELLA BELLA
Florence 1610–Florence 1664

31. *Piazza della Rotonda*

Pen and brown ink. 16.5 × 24.7 cm. Two small holes along the upper edge. Two repaired tears at left margin. Lined.

Inscribed in pen and black ink at lower right *SDBella, 1656*. Numbered in brown ink at lower right corner *150* (Sparre) and *20*.

The artist has focused his interest on the picturesque accumulation of market stalls, hawkers, pilgrims, peasants, and horses. The Pantheon is shown with the two turrets of Bernini, the so-called "orecchie asinine del Bernini," which were demolished in 1883. In the center of the piazza is the fountain erected in 1575 by Onorio Lunghi which was replaced by the obelisk of S. Macuto in 1667.

PROVENANCE: Crozat (Mariette, no. 69); C. G. Tessin (List 1739–41, p. 32 r?; Cat. 1749, livré 4, no. 34); Kongl. Biblioteket (Cat. 1790, no. 150); Kongl. Museum (Lugt 1638).

BIBLIOGRAPHY: Gunnar Wengström, "Handteckningar i Nationalmuseum av Stefano della Bella," *Nationalmusei Årsbok*, III, 1921, p. 147, no. 4, fig. 46; M. Egger, *Römische Veduten, Handzeichnungen aus dem XV. bis XVIII. Jahrhundert zur Topographie der Stadt Rom*, II, Vienna, 1931, p. 39, pl. 94.

EXHIBITIONS: Stockholm, 1965, no. 14, repr.

Inv. no. 191/1863

32. *Standard Bearer*

Pen and brown ink. 15.4 × 19.6 cm. Lined.

Numbered in pen and black ink at lower right corner *8* (Crozat?), under the framing line in pencil *2473* (inv. no.) and in brown ink *2369* (Sparre).

Tessin believed this drawing to be by Callot, but Gregor Paulsson identified it as a work by Della Bella, whose hand is especially recognizable in the landscape. The drawing has not been engraved; the closest parallel is a standard bearer, turned in the opposite direction, in the Albertina sketchbook (no. 35).

PROVENANCE: Crozat (Mariette, no. 69, as Della Bella?); C. G. Tessin (List 1739–41, p. 54 r, as Della Bella; Cat. 1749, livré 13, no. 145, as Callot); Kongl. Biblioteket (Cat. 1790, no. 2369); Kongl. Museum (Lugt 1638).

BIBLIOGRAPHY: Gregor Paulsson, "Handteckningar av Jacques Callot i Nationalmuseum," *Nationalmusei Årsbok*, II, 1920, p. 92; Gunnar Wengström, "Handteckningar i Nationalmuseum av Stefano della Bella," *Nationalmusei Årsbok*, III, 1921, p. 148, no. 5, fig. 51.

EXHIBITIONS: Leningrad, 1963; Stockholm, 1965, no. 17.

Inv. no. 2473/1863

33. *"Trionfo della virtù," a Cavalcade and Tournament Held in Modena to Celebrate the Birth of a Prince, 1660*

Pen and brown ink. 34 × 72.6 cm. Lined. The sheet, made up of two pieces of paper joined horizontally, was cut into three vertical parts and re-joined. There are also two vertical folds. Some dark brown stains.

Inscribed in pen and black ink at lower right corner *15* (Crozat), and on the mount *Cabinet de Crozat* (Tessin), and STEFANINO DELLA BELLA/*Fiorentino Intagliatore.*/*d'anni 54 morì nel 1664*.

Wengström identified the drawing as depicting a festival held in Modena, by comparing it with the set of engravings executed by Della Bella representing *La Gara delle Stagioni*, a cavalcade arranged there in 1652. On this latter occasion Bartolomeo Avanzini built a theatre with galleries in three tiers surrounding the court of the Palazzo Ducale. The

performance was executed with machines invented by Gaspare Vigarani and the decorations were by Giovanni Giacomo Monti and Baldassare Bianchi.

Although the structure represented in the present drawing shows essential differences from the theatre used for *La Gara delle Stagioni*, it seems quite plausible to suggest that it was erected on the same spot. Wengström also supposed this to be the case and suggested that the performance represented could have taken place in connection with the festivities of the marriage of the Prince d'Este to Laura Martinozzi.

It has, however, been possible to identify the occasion through a set of fifteen engravings by Francesco Stringa (not listed by Bartsch, Nagler or Thieme-Becker), of which there are impressions in the Nationalmuseum. One reproduces Stefano della Bella's drawing partly in the same direction, partly in reverse, with the title "Teatro nel qvale si e representato il Trionfo della Virtv Festa fatta per la nascita del Ser^mo Prencipe de Modana l'anno MDCCLX." The other prints of the set depict the chariots of the different virtues and some of the figures in the tournament.

PROVENANCE: Crozat (Mariette, no. 69: "Quarante Desseins, . . . & parmi un grand Dessein d'un Carousel fait à Modene"); C. G. Tessin (List 1739–41, p. 41 v; Cat. 1749, livré 27, no. 90); Kongl. Biblioteket (Cat. 1790, no. 149); Kongl. Museum (Lugt 1638).

BIBLIOGRAPHY: Gunnar Wengström, "Handteckningar i Nationalmuseum av Stefano della Bella," *Nationalmusei Årsbok*, III, 1921, p. 146, no. 3, fig. 44.

EXHIBITIONS: Stockholm, 1965, no. 16.

Inv. no. 190/1863

PIER FRANCESCO MOLA
Coldrerio/Como 1612–Rome 1666

34. *Hagar and Ishmael in the Desert*

Red chalk. 22.1 × 33.8 cm. Hole in lower right quadrant. Lined.
Inscribed in pen and black ink at lower left margin *F. Mola*. Numbered at lower right in pen and black ink *484* (Sparre) and *66* struck out.

The sheet is a preparatory study for the painting of the same subject in the Galleria Colonna, Rome, which differs only slightly from it in that the figures of the painting are brought closer together than in the drawing, thus tending to concentrate the

composition. Arslan dates the painting to the years around 1641.

PROVENANCE: Crozat (Mariette, no. 276); C. G. Tessin (List 1739–41, p. 52 v; Cat. 1749, livré 16, no. 36); Kongl. Biblioteket (Cat. 1790, no. 569); Kongl. Museum (Lugt 1638).

BIBLIOGRAPHY: Edoardo Arslan, "Disegni del Mola a Stoccolma," *Essays in the History of Art Presented to Rudolf Wittkower*, (Douglas Fraser, Howard Hibbard and Milton J. Lewine, eds.), London, 1967, pp. 197 ff., pl. XXVIII:1.

EXHIBITIONS: Stockholm, 1965, no. 106, repr.

Inv. no. 569/1863

SALVATOR ROSA
Aranella (Naples) 1615–Rome 1673

35. *Jason Bewitching the Dragon*

Pen and brown ink, wash. 31 × 19.8 cm. Repaired tears along the upper border, repaired hole at lower left.

Preparatory study for the etching (Bartsch 18). The subject, which is derived from Ovid, *Metamorphoses* VII, 149–55, was treated by Rosa in several paintings as well, the best known being that in the Museum of Fine Arts at Montreal (for this and related versions see L. Salerno, *Salvator Rosa*, Milan 1963, no. 89). There is a further version in the City Art Museum, St. Louis. This subject, one of the last treated by Rosa, is datable to the last years of the 1660's.

PROVENANCE: N. Tessin the Younger (Cat. 1730, p. 5); C. G. Tessin (Cat. 1749, livré 23, no. 62); M. G. Anckarsvärd; A. Michelson; K. Michelson; acquired by the Nationalmuseum in 1896.

EXHIBITIONS: Stockholm, 1965, no. 126.

Inv. no. Anck 400

CIRO FERRI
Rome 1628–Rome 1689

36. *Academy with Pupils Drawing*

Black chalk. 19.8 × 33.6 cm. No watermark.
Verso: Red chalk study of a nude. Numbered in pen and brown ink *513* (Sparre).

Ferri was one of the closest followers of Pietro da Cortona, and his drawings, particularly those in black chalk, are often difficult to distinguish from

those of his master and fellow pupils. This drawing may serve as a memento of these difficulties, as it depicts the group of artists among whom we may have to try to find its author.

PROVENANCE: N. Tessin the Younger (Cat. 1730, p. 6); C. G. Tessin (Cat. 1749, livré 10, no. 53); Kongl. Biblioteket (Cat. 1790, no. 513); Kongl. Museum (Lugt 1638).

EXHIBITIONS: Stockholm, 1965, no. 82.

Inv. no. 599–600/1863

FRANCESCO SOLIMENA
Canale di Serino 1657–Barra 1747

37. *The Remains of St. John the Baptist Brought Ashore in Genoa*

Pencil and black chalk, pen and brown ink, gray wash. 31.9 × 53.5 cm. The drawing fills the whole breadth of the paper but its upper and lower limits are irregular.
Inscribed at lower center in pen and brown ink *Solimene Napolitano dipinse nella Sala del gran Consiglio in Genova*. Numbered in pen and brown ink at lower right *1419* (Sparre) and *64* struck out.

This is a preparatory drawing for the painting executed for the Sala del Consiglio del Senato, Palazzo Reale, Genoa, 1715–17, which is now destroyed. A *bozzetto* in the De Ferrari collection and a drawing at Holkham Hall survive.

PROVENANCE: C. G. Tessin (Cat. 1749, livré 23, no. 64); Kongl. Biblioteket (Cat. 1790, no. 1419); Kongl. Museum (Lugt 1638).

BIBLIOGRAPHY: F. Bologna, *Francesco Solimena*, Naples, 1958, pp. 111, 253–54, 285; P. Bjurström, "Carl Gustaf Tessin as a Collector of Drawings," *Contributions to the History and Theory of Art, Acta Universitatis Upsaliensis, Figura*, N.S. VI, 1967, pp. 115 ff.

Inv. no. 1611/1863

GIUSEPPE GHEZZI
Commanza 1634–Rome 1721

38. *Self-Portrait*

Red chalk. 41.6 × 28.7 cm. Watermark: Lamb in a circle.
Inscribed IOSEPH.GHEZZIVS.PICTOR.NEC.IN.CARMINE. VATES. ASCOLANVS. NATVS. ANNO. SALVTIS. MDCXXXIIII. HONESTE. PROVIVIT. Numbered in pen and brown ink at lower right *2270* (Sparre).

This is one example from the collection of portraits of artists drawn for Nicola Pio, a Roman collector who died after 1724. The main part of his collection is preserved in Stockholm.

Giuseppe Ghezzi was a devoted member of the Academy of St. Luke and has in this portrait emphasized his position as the learned painter by putting an image of "Filosofia secondo Boetio" from Ripa's *Iconologia* on his easel.

The drawing was used by Giuseppe's son Pier Leone when he made a commemorative (?) portrait of his father, now at Windsor, the year of his death. Pier Leone's inscription on the verso of the drawing gives the age of his father as eighty-four, which would mean that this portrait was executed in 1718.

PROVENANCE: Nicola Pio; Crozat (Mariette, no. 329–33); C. G. Tessin (List 1739–41, p. 64 r; Cat. 1749, livré 2, no. 14); Kongl. Biblioteket (Cat. 1790, no. 2270); Kongl. Museum (Lugt 1638).

BIBLIOGRAPHY: A. M. Clark, "The Portraits of Artists Drawn for Nicola Pio," *Master Drawings*, V, 1965, pp. 3 ff., no. 19; Cf. A. Blunt and H. Lester Cooke, *The Roman Drawings of the XVII & XVIII Centuries at Windsor Castle*, London, 1960, p. 43, no. 176.

Inv. no. 3026/1863

AGOSTINO MASUCCI
AND ALESSIO DE' MARCHIS
Rome 1691–Rome 1758
Naples 1684–Perugia 1752

39. *Portrait of Alessio de' Marchis*

Brush, bistre and red ink, black chalk. 46 × 31 cm. No watermark.
Inscribed ALEXVS DE MARCHIS PICTOR NEAPOLITANVS NATVS ANNO MDCLXXXIV SALVTIS NOSTRAE ET IN PRAESENTIA VIVIT ET FLORESCIT ROMAE. Numbered in pen and brown ink at lower right *2305* (Sparre) and *18* struck out.

Like the previous sheet, this is a drawing from the collection of portraits of artists drawn for Nicola Pio. As Pio states in his own manuscript "Le Vie Di Pittori Scultori et Architetti..." (Bibl. Vaticana, Cod. Capponiana 257) this portrait "e stato fatto, e delineato, da Agostino Masucci entro un masso antico, il quale con tutto il resto di quel foglio à disegnato da lui medesimo." The technical difference between the two hands—Masucci's portrait and de' Marchis' landscape is almost not discernible.

PROVENANCE: Nicola Pio; Crozat (Mariette, nos. 329–33); C. G. Tessin (List 1739–41, p. 64 v; Cat. 1749, livré 2, no. 67); Kongl. Biblioteket (Cat. 1790, no. 2305); Kongl. Museum (Lugt 1638).

BIBLIOGRAPHY: A. M. Clark, "The Portraits of Artists Drawn for Nicola Pio," *Master Drawings*, V, 1965, pp. 3 ff., no. 59.

Inv. no. 3061/1863

GIOVANNI ANTONIO PELLEGRINI
Venice 1675–Venice 1741

40. *Triumph of a Conqueror*

Pen and brown ink, brown wash over sketch in black chalk. 23.1 × 40 cm. Watermark: Lion.
 Inscribed in pen and brown ink at lower center *Tintorette*. Numbered *1219* (Sparre).

Bettagno stressed the influence of Rembrandt in this drawing, which Pignatti dates to Pellegrini's Roman-Venetian period 1700–08.

PROVENANCE: C. G. Tessin; Kongl. Biblioteket (Cat. 1790, no. 1219, as Tintoretto); Kongl. Museum (Lugt 1638).

BIBLIOGRAPHY: Sirén, 1902, p. 134, no. 155 (Tintoretto); Schönbrunner and Meder, no. 1133 (as Palma Giovane); T. Pignatti, "Pellegrini Drawings in Venice," *Burlington Magazine*, CI, 1959, p. 451.

EXHIBITIONS: Venice, *Pellegrini*, 1959, no. 74; Stockholm, 1962–63, no. 278.

Inv. no. 1400/1863

GASPARE DIZIANI
Belluno 1689–Venice 1767

41. *The Martyrdom of St. Felix and St. Fortunatus*

Pen and brown ink, brown wash over red chalk. 37 × 30.7 cm. The upper part of the composition is arched.
 Inscribed in pen and brown ink *Sebastien Ricci* (Tessin). Numbered *1338* (Sparre).

This preliminary study for the painting in the cathedral of Chioggio can be dated 1734–45, the period of the construction of the cathedral.

 Felix and Fortunatus were two brothers from Aquileia who were tortured and decapitated in 296 A.D., during the reign of Diocletian.

PROVENANCE: C. G. Tessin (Cat. 1749, livré 22, no. 20); Kongl. Biblioteket (Cat. 1790, no. 1338, as Sebastien Ricci); Kongl. Museum (Lugt 1638).

BIBLIOGRAPHY: O. Sirén, "Venetiansk 1700-talskonst," *Konsthistoriska sällskapets publikation*, 1915, repr. p. 72, p. 106, no. 22; R. Pallucchini, "Nota per Gaspare Diziani," *Arte Veneta*, 1948, pp. 135 ff.

EXHIBITIONS: Stockholm, *Tavlor och teckningar av venetianska målare, huvudsakligen från 1700-talet*, 1915, no. 22; Stockholm, *Äldre italiensk konst ur svenska och italienska samlingar*, 1944, no. 90; Stockholm, 1962–63, no. 290.

Inv. no. 1528/1863

GIOVANNI BATTISTA TIEPOLO
Venice 1696–Madrid 1770

42. *Apotheosis of the Poet Geresio Soderini*

Pen and yellowish brown ink and wash over slight traces of black chalk. 31 × 24.2 cm. No watermark.

Preliminary study for the ceiling decoration of the room next to the main hall of the Villa Soderini at Nervesa, which was destroyed in 1917. This decoration was dated to the 1730–40's by earlier scholars (Boucher, Molmenti, Sack) while Morassi and Pallucchini prefer a date of about 1754. This opinion is shared by Knox when discussing another drawing for the same set of frescoes.

 The Nationalmuseum drawing itself confirms the later date on purely stylistic grounds. It does not show the distinctive plasticity of Tiepolo's early mature period, the figures are almost on one plane, and the decorative surface is stressed. The closest parallel to this drawing is a sheet from the same period in the collection of Count Seilern. There, however, the hero has a lion and not a book as his primary attribute and so differs from the final version.

PROVENANCE: Gift from the present King of Sweden, 1914.

BIBLIOGRAPHY: O. Sirén, "Venetiansk 1700-talskonst i Sverige," *Konsthistoriska sällskapets publikation*, 1915, p. 81, p. 107, no. 43; A. Seilern, *Italian Paintings and Drawings at 56 Princes Gate, London SW 7*, London, 1959, pp. 131 f., fig. 46; Cf. A. Morassi, *G. B. Tiepolo, His Life and Work*, London, 1955, fig. 44; R. Pallucchini, *La Pittura veneziana del Settecento*, 1960, p. 92; G. Knox, *Catalogue of the Tiepolo Drawings in the Victoria and Albert Museum*, London, 1960, under no. 229.

EXHIBITIONS: Stockholm, *Tavlor och teckningar av venetianska målare*, 1915, no. 43; Stockholm, 1962–63, no. 298.

Inv. no. 24/1914

DUTCH AND FLEMISH

LUCAS VAN LEYDEN
Leiden 1494–Leiden 1533

43. *Portrait of a Young Man*

Black chalk. 26.2 × 32.3 cm. The four corners trimmed diagonally and replaced. Light brown stains. No watermark.
Dated and signed at the left in black chalk *1521* and letter *L*. Inscribed in brown ink at lower right *Lucas de Leide*. Numbered in black ink *9*.

A number of Lucas van Leyden's drawings of 1521, executed with broad strokes in black chalk (Friedländer, 1963, nos. 16–22), were made in imitation of Dürer whom he had met in Antwerp that year. The Nationalmuseum's Dürer drawing of a *Young Girl*, dated 1515, is obviously the kind of drawing which inspired Lucas, even in the matter of scale. In his technique, however, Lucas is more dependent on the cross-hatching method of his own graphic art.

Cf. copy in the Bibliothèque Nationale, Paris (F. Lugt and J. Vallery-Radot, *Inventaire général des dessins des écoles du nord*, Paris, 1936, no. 144).

PROVENANCE: Crozat; C. G. Tessin (List 1739–41, p. 35 v; Cat. 1749, livré 17, no. 137); Kongl. Biblioteket (Cat. 1790, no. 1668); Kongl. Museum (Lugt 1638).

BIBLIOGRAPHY: Schönbrunner and Meder, no. 869; F. Dülberg, "Lucas van Leyden," *Onze Kunst*, 1909, p. 10; Id., *Elsevier's Maandschrift*, Amsterdam, II, 1933, p. 10; M. Friedländer, *Die altniederländische Malerei*, Berlin, 1932, X, p. 102; L. Baldass, "Die Bildnisse des Lucas van Leyden," Pantheon, XX, 1937, pp. 205 ff.; C. G. Hoogewerff, *De Noord-Nederlandsche Schilderkunst*, The Hague, 1939, III, p. 273; N. Beets, *Lucas van Leyden*, Paris, 1913, p. 77; M. Friedländer, *Lucas van Leyden*, Berlin, 1963, no. 17.

EXHIBITIONS: Stockholm, 1933, no. 43; Rotterdam, *Jeroen Bosch. Noord-Nederlandsche Primitieven*, 1936, no. 52; Stockholm, 1953, no. 9; Amsterdam, *Middeleeuwse Kunst der noordelijke Nederlanden*, 1958, no. 203.

Inv. no. 1858/1863

THE MASTER OF THE MIRACLES OF THE APOSTLES
Active in Leiden ca. 1520–30

44. *Illustration to Erasmus' "Encomium Moriae" ("The Praise of Folly")*

Black chalk. 28.2 × 20.1 cm. Brown and black stains. The surface damaged in the lower right corner. No watermark.
Inscribed in pen and brown ink *Lucas de Leide*.

The subject of this drawing was identified by E. Panofsky. The scene depicts Folly on her throne, speaking to representatives of different classes and assuring them that thanks are due to her alone for their happiness and contentment (cf. Holbein's version of the same subject, reproduced in the facsimile edition by H. A. Schmidt, Basel, 1931, p. 9). On the left Erasmus himself, with lifted hand, can be discerned. Contrary to usual practice, Folly is here not furnished with a foolscap, but with glasses, which, according to Panofsky, can convey the same symbolic meaning. The scrolls of lettering favor the view that the drawing is a design for a title page, of which so far no evidence has been found.

The drawing was first noticed by Benesch, who connected it with an Albertina drawing of a market scene in a Dutch town (no. 7849). J. G. van Gelder attributes the drawing to the Master of the Miracles of the Apostles, the anonymous master first established by Paul Wescher. J. Q. van Regteren Altena includes the drawing in the work of Aertgen van Leyden.

PROVENANCE: Crozat?; C. G. Tessin (Cat. 1749, livré 24, no. 44); Kongl. Biblioteket (Cat. 1790, no. 1669); Kongl. Museum (Lugt 1638).

BIBLIOGRAPHY: Schönbrunner and Meder, no. 883 (Lucas van Leyden?); O. Benesch, *Beschreibender Katalog der Handzeichnungen in der Graphischen Sammlung Albertina: Die Zeichnungen der Niederländischen Schulen*, II, Vienna, 1928, p. 15, no. 97; P. Wescher, "Holländische Zeichner zur Zeit des Lucas van Leyden," *Oud-Holland*, XXXXV, 1928, pp. 245 ff.; J. Q. van Regteren Altena, "Aertgen van Leyden," *Oud-Holland*, XLVI, 1939, pp. 222 ff., no. 118.

EXHIBITIONS: Stockholm, 1933, no. 44; Stockholm, 1953, no. 10.

Inv. no. 1859/1863

PIETER CORNELISZ (KUNST)
Leiden ca. 1490–Leiden after 1542

45. *The Temptation of Christ in the Wilderness*

Pen and black ink. 19.5 × 21.8 cm. The original roundel is cut on four sides. No watermark.
Dated at lower left in pen and black ink *1542*. Numbered at lower right in brown ink *1602* (Sparre).

Son of the painter Cornelis Engebrechtsz, Pieter Cornelisz became his pupil in company with Lucas van Leyden who was of almost the same age. His dated drawings range from 1517 to 1542 with very little change in style during these twenty-five years.

PROVENANCE: C. G. Tessin (Cat. 1749, livré 25, no. 19 as "Maitre inconnu"); Kongl. Biblioteket (Cat. 1790, no. 1602, as "Maitre non connu"); Kongl. Museum (Lugt 1632).

BIBLIOGRAPHY: L. von Baldass, "Notizen über Holländische Zeichner des XVI. Jahrhunderts, Pieter Cornelisz," *Mitteilungen der Vereinigung für vervielfältigende Kunst*, XXVIII, 1915, p. 25; A. E. Popham, *Catalogue of Drawings by Dutch and Flemish Artists . . . in the British Museum*, London, 1932, V, p. 10; N. Beets, "Nog eens 'Jan Wellens de Cock' en de sonen van Cornelis Engebrechtsz: Pieter Cornelisz Kunst, Cornelis Cornelisz Kunst, Lucas Cornelisz de Kock," *Oud-Holland*, LXVII, 1952, p. 13, and fig. 7 (as attributed to Lucas Cornelisz).

EXHIBITIONS: Stockholm, 1953, no. 13.

Inv. no. 1794/1863

MAERTEN VAN HEEMSKERK (?)
Heemskerck 1498–Haarlem 1574

46. *The Transept of St. Peter's in Rome under Construction*

Pen and brown wash. 20 × 27.5 cm. Watermark: Coat of arms with star.
Signed in brown ink *MHK* (monogram).
Verso: Study of two figures in pen and brown ink.

The drawing is the first known representation of the new transept in St. Peter's and shows remains of the old basilica still standing in the interior.

According to R. Krautheimer the drawing was executed either by Heemskerk, or by a copyist or one of his followers using a similar signature. The same hand can be recognized in C. Hülsen and H. Egger, *Die römischen Skizzenbücher von Maerten van Heemskerk*, Berlin, 1916, II, fol. 52 r. The studies on the back support an attribution to Heemskerk.

PROVENANCE: M. G. Anckarsvärd; A. Michelson; K. Michelson. Acquired by the Nationalmuseum in 1896.

BIBLIOGRAPHY: R. Krautheimer, "Some Drawings of Early Christian Basilicas in Rome: St. Peter's and S. Maria Maggiore," *Art Bulletin*, XXXI, 1949, pp. 211–13.

EXHIBITIONS: Stockholm, 1953, no. 14.

Inv. no. Anck 637

AFTER JAN VAN STINEMOLEN (?)
1518–1582

47. *Mountain Scenery: Bagnoregio, Close to Lago di Bolsena*

Pen and brown ink, with touches of gray wash. 26.6 × 39.2 cm. Watermark: Coat-of-arms, fleur-de-lis (almost identical with Briquet 1620).
Inscribed in a seventeenth-century hand *de Gheyn*.

This drawing corresponds almost exactly with a drawing acquired by the Pierpont Morgan Library in 1967. This was compared by C. Dodgson with a drawing in the National Gallery of Scotland, Edinburgh, signed *Jan Staynemer*, which, however, he did not consider to be by the same hand. Guided by a drawing in the Albertina, Vienna, signed *Jan van Stinemolen*, J. Q. van Regteren Altena has shown that Stinemolen is also the right name for the master of the Edinburgh drawing.

As to the two corresponding drawings in New York and Stockholm, they show a clear connection with Stinemolen's work in their topographic precision and Chinese pantheistic conception of nature, although Stinemolen's finical minuteness of penwork is lacking in the two other drawings with their more temperamentally flowing lines. The Stockholm drawing differs from the New York one in omitting some details but there is greater fusion of details into a painterly whole, and atmospheric perspective is aided by the use of a slight wash over

the receding landscape and sky (possibly by a later hand).

As regards the relationship between the two drawings, Van Regteren Altena works on no less than three possibilities, of which the most plausible seems to be that both are copies after Stinemolen, the Stockholm drawing being executed by Goltzius, the New York one by De Gheyn. An argument against this hypothesis is the fact that the watermark of the Stockholm drawing belongs to a rather closed group, in which all marks are French and scarcely any are later than about 1570. The identification of the locale represented by the drawing is due to Janos Scholz.

PROVENANCE: M. G. Anckarsvärd; A. Michelson; K. Michelson. Acquired by the Nationalmuseum in 1896.

BIBLIOGRAPHY: C. Dodgson, "Staynemer: An Unknown Landscape Artist," *Burlington Magazine*, XXI, 1912, p. 34; J. Q. van Regteren Altena, "Verzeten Namen-Staynemer of Stinemolen?," *Oud-Holland*, XXXXIX, 1932, pp. 91 ff.

EXHIBITIONS: Stockholm, 1953, no. 24; Leningrad, 1963.

Inv. no. Anck 200

PIETER BRUEGEL THE ELDER
Bruegel at Breda 1525–Brussels 1569

48. *Three Peasants*

Pen and yellowish brown ink over black chalk. 17 × 19.7 cm. Watermark: Tower (close to Briquet 15940).
Inscribed by the artist: on the lefthand figure *Swartte mus/ Swartte kanten/ grijse rock/ ville swartte brouck*; on the figure in the middle *Swartte mus/ groene brouck/ Swartte housen*; on the righthand figure *Swartte rock/ bruin okker rock/ Nart het leven*.

This is one of three drawings in the Nationalmuseum which belong to a group of "Naer het leven" drawings unanimously dated about 1559–63. The seated peasant is identical with the peasant in a drawing in the collection of Curtis O. Baer, New Rochelle, New York (Munz 77).

PROVENANCE: M. G. Anckarsvärd; A. Michelson; K. Michelson. Acquired by the Nationalmuseum in 1896.

BIBLIOGRAPHY: Schönbrunner and Meder, no. 938; R. van Bastelaer and G. Hulin de Loo, *Pieter Bruegel l'ancien*, Brussels, 1907, cat. no. 77; K. Tolnai, *Die Zeichnungen Pieter Bruegels*, Munich, 1925, no. 53; O. Kurz, "Drei Zeichnungen P. Brueghels des Aelteren," *Die graphischen Künste*, N.S. I, 1936, p. 5; C. de Tolnay, *The Drawings of Pieter Bruegel the Elder*, London, 1952, no. 83; L. Münz, *Bruegel, The Drawings, Complete Edition*, London, 1961, no. 79; R. Genaille, *Breugel l'ancien*, Paris, 1953, pl. 110.

EXHIBITIONS: Brussels, *Cinq siècles d'art*, 1935, no. 468; Rotterdam, *Van Eyck tot Rubens, Tekeningen*, 1948–49, no. 17; Paris, Bibliothèque Nationale, *De Van Eyck à Rubens*, 1949, no. 58; Stockholm, 1953, no. 37; Leningrad, 1963.

Inv. no. Anck 7

HENDRICK GOLTZIUS
Venlo 1558–Haarlem 1617

49. *Landscape with a Waterfall*

Pen and brown ink, heightened with white on brown paper. 25.7 × 22 cm. No watermark.
Inscribed at lower center in black ink *Ticiano fe.*, at lower right in brown ink *Goltzius*.

Goltzius in this landscape shows the influence of drawings and woodcuts of the Titian school. The drawing must have been made sometime after 1595 when Goltzius began to combine the penwork and heightening with white on a rather dark paper to achieve an effect approaching the manner of De Gheyn.

PROVENANCE: Crozat (Mariette, no. 808); C. G. Tessin (List 1739–41, 31 r); Kongl. Biblioteket (Cat. 1790, no. 1677); Kongl. Museum (Lugt 1638).

BIBLIOGRAPHY: Schönbrunner and Meder, no. 1165; O. Hirschmann, *Meister der Graphik*, 1919, p. 137; J. G. van Gelder, *Jan van de Velde*, The Hague, 1933, pp. 17 f., 20; J. Q. van Regteren Altena, *Jacques de Gheyn*, Amsterdam, 1935, p. 88; E. K. J. Reznicek, *Hendrick Goltzius Zeichnungen*, Utrecht, 1961, no. 406.

EXHIBITIONS: Stockholm, 1953, no. 57; Rotterdam-Haarlem, *Hendrick Goltzius als tekenaar*, 1958, no. 85; Leningrad, 1963; Stockholm, 1967, no. 202.

Inv. no. 1866/1863

50. *Young Man Wearing a Large Plumed Hat*

Black chalk, heightened with white on prepared blue paper. 41 × 28.8 cm. Watermark: Eagle in crowned shield. Old horizontal and vertical folds.
Signed with monogram *HG 99*.

The sheet is part of a whole series of variations after Lucas van Leyden and his contemporaries, its closest parallel being an even larger drawing in the Biblioteca Marucelliana, Florence (Reznicek 307).

PROVENANCE: Crozat (Mariette, no. 808); C. G. Tessin (List 1739–41, p. 36 r; Cat. 1749, livré 17, no. 172); Kongl. Biblioteket (Cat. 1790, no. 1699); Kongl. Museum (Lugt 1638).

BIBLIOGRAPHY: E. K. J. Reznicek, *Hendrick Goltzius Zeichnungen*, Utrecht, 1961, no. 341.

EXHIBITIONS: Stockholm, 1953, no. 62; Stockholm, 1967, no. 204.

Inv. no. 1870/1863

JAN BRUEGEL THE ELDER
Brussels 1568–Antwerp 1625

51. *Landscape with Wagons and Wayfarers*

Pen and brown ink, blue wash. 19.7 × 25.8 cm. No watermark.

At one time the painting after this sketch was in the collection of Prof. E. Perman, Stockholm.

PROVENANCE: Crozat (Mariette, no. 910 or 914); C. G. Tessin (List 1739–41, p. 31 r; Cat. 1749, p. 171); Kongl. Biblioteket (Cat. 1790, no. 1749); Kongl. Museum (Lugt 1638).

BIBLIOGRAPHY: Schönbrunner and Meder, no. 930; F. Klauner, "Zur Landschaft Jan Brueghels d.Ä.," *Nationalmusei Årsbok*, N.S. XIX–XX, 1949–50, pp. 20 ff.

EXHIBITIONS: Stockholm, 1953, no. 87.

Inv. no. 1942/1863

GILLIS (AEGIDIUS) VAN VALCKENBORCH
Antwerp before 1572–Frankfort on Main 1622

52. *River Landscape*

Pen and brown ink, brown and blue wash. 17.7 × 22.6 cm. No watermark.
 Signed in pen and black ink *Gilis. van. Valckenborch.| Roma 1595.*

PROVENANCE: C. G. Tessin; Kongl. Biblioteket (The Tessin-Hårleman Collection of Architectural Drawings); Kongl. Museum (Lugt 1638).

BIBLIOGRAPHY: W. Bernt, *Die Niederländischen Zeichner des 17. Jahrhunderts*, Munich, 1958, II, no. 586; C. G. Faggin, "De gebroeders Frederick en Gillis van Valckenborch," *Bulletin Museum Boymans van Beuningen*, XIV, 1963:1, p. 13.

EXHIBITIONS: Stockholm, 1953, no. 91.

Inv. no. THC 3249

PETER PAUL RUBENS
Siegen 1577–Antwerp 1640

53. *Portrait of the Mantuan Prince Silvio*

Black chalk with touches of red and white chalk. 22.4 × 16 cm. No watermark. Small brown stains to the left.
 Inscribed in pen and brown ink *Ferdinando Gonzaga*

Cardinale di Mantova or Duca, fatto in presenza sua da P.P. Rubens. Ce portrait a été donné a M. Crozat par M. le Comte de Cailus (Tessin). Numbered at lower right *1726* (Sparre).

This is one of two very similar drawings which have the same provenance and evidently have never been separated. The other (Nationalmuseum, Inv. no. 1918/1863) is similarly inscribed and according to the inscription represents Francesco IV Gonzaga (1586–1612), the brother of Ferdinando. Both these princes of the Gonzaga family were depicted in the large painting of the *Adoration of the Trinity* which Rubens painted between August, 1604, and May, 1605, in Mantua. The painting is preserved only in fragments.

It has been assumed that the two drawings were studies made by Rubens for the large painting of 1604–05. There is, however, considerable difficulty involved in this theory because of the age of the children. In 1604, Francesco was eighteen years old and Ferdinando, seventeen. The boys in the drawings look very much younger. One solution is to assume that the drawings were made during one of Rubens' first visits to Mantua, 1600 or 1601.

The young man appears to wear the white Maltese cross on his chest and J. Held in 1959 pointed out that Ferdinando was not the only one of the brothers to become a Knight of Jerusalem. A natural brother, Silvio (1592–1612), was also knight of the order from 1598 and might well be represented in the drawing.

In 1961, M. Jaffé revived Wilde's earlier idea (1936) that the second drawing, inscribed *Francesco* is a portrait of the youngest of the legitimate sons of Vincenzo I, the second Vincenzo who was one year younger than his half brother. The correctness of this idea is emphasized by the radiograph of the fragment of the Mantuan altarpiece preserved in Kunsthistorisches Museum, Vienna, where a head which lies beneath the neck and shoulder of the actual Francesco is visible. It is the portrait of another prince and obviously a painted transcription of the Stockholm portrait called Francesco. The two drawings must have been made in 1604–05 specifically for the altarpiece and represent Silvio at the age of twelve (the exhibited sheet) and Vincenzo Gonzaga the Younger at eleven.

PROVENANCE: Comte A.P.C. de Caylus; Crozat (Mariette, no. 841 or 842); C. G. Tessin (List 1739–41, p. 35 v, no. 11 or 12; Cat. 1749, livré 17, no. 144); Kongl. Biblioteket (Cat. 1790, no. 1726); Kongl. Museum (Lugt 1638).

BIBLIOGRAPHY: M. Rooses, *L'Oeuvre de P. P. Rubens*, Antwerp, 1892, V, no. 1508; G. Glück and J. M. Haberditzl, *Die Handzeichnungen von P. P. Rubens*, Berlin, 1928, no. 49; G. Glück, *Rubens, van Dyck und ihr Kreis*, Vienna, 1933, pp. 6 and 373, no. 9; J. Wilde, "Zum Werke des Domenico Fetti," *Jahrbuch der kunsthistorischen Sammlungen in Wien*, X, 1936, p. 212, note 11; J. S. Held, *Rubens, Selected Drawings*, London, 1959, pp. 69, 125 f., no. 80; M. Jaffé, "The Deceased Young Duke of Mantua's Brother," *Burlington Magazine*, CIII, 1961, pp. 374 ff.

EXHIBITIONS: Stockholm, 1933, no. 34; Mantua, Palazzo Ducale, 1937; Brussels, *Dessins de Rubens*, 1938–39, no. 22; Rotterdam, *P. P. Rubens tekeningen*, 1939, no. 15; Rotterdam, *Van Eyck tot Rubens, tekeningen*, 1948–49, no. 109; Paris, *De Van Eyck à Rubens*, 1949, no. 96; Helsinki, *P. P. Rubens*, 1952–53, no. 29; Stockholm, 1953, no. 95.

Inv. no. 1917/1863

54. *Robin, the Dwarf of the Earl of Arundel*

Black, red and white chalk, and pen and ink, on light gray-brown paper. 40.8 × 25.8 cm. Watermark: VAR and numeral 4. Repaired tear at upper left.

Color notes in Rubens' own hand (starting at upper left): *Het Wambuys vermach wesen root sattyn ende de broeck root flouwell; Tannoyt flowel* (twice); *root; Geel; root, swart, Geel vudringhe;* (The mantle may be red satin and the breeches red velvet; brown velvet; red; yellow; red; black, yellow lining).

Inscribed in pen and brown ink *P. P. Rubens*. Numbered in pen and brown ink *1722* (Sparre).

This drawing is a costume study for a painting of the Countess of Arundel in Munich (*Klassiker der Kunst* 200), where a hunting falcon sits on Robin's raised and gloved right hand. The portrait was executed in the summer of 1620 when the Countess passed through Antwerp. On July 17, 1620, the Count's secretary wrote to the Count telling how Rubens in one day "finished the likeness of the countess, of Robin the dwarf, of a jester and a dog [which all traveled with her] . . . and drew on paper the postures and the costumes."

PROVENANCE: Crozat (Mariette, no. 841 or 842); C. G. Tessin (List 1739–41, p. 35 v, no. 9; Cat. 1749, livré 17, no. 148); Kongl. Biblioteket (Cat. 1790, no. 1722); Kongl. Museum (Lugt 1638).

BIBLIOGRAPHY: M. Rooses, *L'Oeuvre de P. P. Rubens*, Antwerp, 1892, V, no. 1498; G. Glück and J. M. Haberditzl, *Die Handzeichnungen von P. P. Rubens*, Berlin, 1928, no. 133; L. van Puyvelde, "Die Handzeichnungen des P. P. Rubens zu der Ausstellung in Brüssel," *Pantheon*, XXIII, 1939, p. 75 ff.; H. G. Evers, *P. P. Rubens*, Munich, 1942, p. 88; W. Burke, *Rubens' Handzeichnungen*, Zürich, 1948, pl. 13; J. S. Held, *Rubens, Selected Drawings*, London, 1959, pp. 10, 32, 44, 55, 136, no. 101.

EXHIBITIONS: Stockholm, 1933, no. 36; Brussels, *Dessins de Rubens*, 1938–39, no. 26; Rotterdam, *P. P. Rubens tekeningen*, 1939, no. 42; Rotterdam, *Van Eyck tot Rubens, tekeningen*, 1948–49, no. 120; Paris, Bibliothèque Nationale, *De Van Eyck à Rubens*, 1949, no. 94; Helsinki, *P. P. Rubens*, 1952–53, no. 40; Stockholm, 1953, no. 100; Antwerp, *Tekeningen van P. P. Rubens*, 1956, no. 89; Leningrad, 1963.

Inv. no. 1913/1863

55. *The Virgin Adored by Saints*

Black chalk, pen and ink, washed in gray and brown. 56.1 × 41.2 cm. No watermark.

Inscribed in pen and brown ink at lower left on an added piece of paper *A. Vandick*; at lower right *Rubb.ˢ* Numbered in pen and brown ink at lower right *1773* (Sparre).

Verso: Detail studies of the Virgin and Child for the composition on the recto and sketches in pen and pencil for *St. George in a Landscape*, Buckingham Palace, London (*Klassiker der Kunst* 311).

The drawing is one of the studies for the great altarpiece which in 1628 was placed on the high altar of the Augustines in Antwerp (*Klassiker der Kunst* 305). In his list of things acquired in Paris, 1741, Count Tessin lists the drawing as a work of Rubens but he changed the attribution to Van Dyck in his catalogue of 1749. The drawing was, however, restored to Rubens by Lugt in 1925, and the attribution was supported by the discovery of the reverse with its further sketches for the Virgin and for the *St. George in a Landscape*. The studies for St. George are specially interesting as they demonstrate the preparations for a stage in the painting which was abandoned by Rubens but left traces visible under X-ray.

It is difficult to read all the different layers of the drawing as they show the gradual crystallization of a complex compositional idea. Rubens completed his preparations in oil sketches, four of which are known.

PROVENANCE: Crozat?; C. G. Tessin (List 1739–41, p. 44 v as Rubens; Cat. 1749, livré 16, no. 83, as Van Dyck); Kongl. Biblioteket (Cat. 1790, no. 1773); Kongl. Museum (Lugt 1638).

BIBLIOGRAPHY: F. Lugt, "Notes sur Rubens," *Gazette des Beaux-Arts*, 5:XII, 1925, pp. 199 f.; G. Glück and J. H. Haberditzl, *Die Handzeichnungen von P. P. Rubens*, Berlin, 1928, no. 172; L. v. Puyvelde, *Les Esquisses de Rubens*, Basle, 1940, p. 83; E. Haverkamp Begemann, "Rubens' Schetsen," *Bulletin Museum Boymans*, Rotterdam, V, 1954, p. 4, note; P. Bjurström, "Rubens' St. George and the Dragon," *The Art Quarterly*, XVIII, 1955, pp. 27 ff.; F. Grossmann, "Notes on Some Dutch and Flemish Paintings at Rotterdam," *Burlington Magazine*, XCVII, 1955, pp. 335 ff.; J. S. Held, *Rubens, Selected Drawings*, London, 1959, no. 53.

EXHIBITIONS: Brussels, *Dessins de Rubens*, 1938–39, no. 14; Rotterdam, *P. P. Rubens tekeningen*, 1939, no. 38; Helsinki, *P. P. Rubens*, 1952–53, no. 26; Stockholm, 1953, no. 102; Antwerp, *Tekeningen van P. P. Rubens*, 1956, no. 108.

Inv. no. 1966/1863

CLAES JANSZ VISSCHER THE YOUNGER (?)

Amsterdam 1586–Amsterdam 1652

56. Scene of Traders in a Dutch Colony

Black chalk, pen and brown ink, brown wash. 12.1 × 16.1 cm. No watermark.
Numbered in brown ink at lower left *1492* (Sparre).

This drawing comes very close to one of the drawings in the Rijksprentenkabinet, Amsterdam (*Handzeichnungen der holländischen und vlämischen Schule im . . . Amsterdam*, E. W. Moes, ed., The Hague, s.d., II, pl. 87) which, however, is very different from other drawings attributed to Visscher in the same collection.

PROVENANCE: Crozat?; C. G. Tessin; Kongl. Biblioteket (Cat. 1790, no. 1492, as P. Stevens).

EXHIBITIONS: Stockholm 1953, no. 114; Leningrad 1963.

Inv. no. 1685/1863

JAN PORCELLIS (?)

Before 1584 Ghent–Zoeterwoude 1632

57. Seascape with Fishing Boats

Lead; small traces of pen and black ink. 20.5 × 32.1 cm. Lined.
Inscribed in pen and black ink *Jan Van Goien*.

The attribution is tentative; it is accepted by John Walsh, Jr.

PROVENANCE: C. G. Tessin (List 1739–41, p. 67 r); Kongl. Biblioteket (Cat. 1790, no. 1769); Kongl. Museum (Lugt 1638).

EXHIBITIONS: Stockholm, 1967, no. 215.

Inv. no. 1962/1863

ESAIAS VAN DE VELDE

Amsterdam ca. 1591–The Hague 1630

58. River Landscape

Black chalk. 20 × 30.8 cm. Watermark: Fleur-de-lis (near Heawood 1762).
Signed in the foreground in black chalk *E. V. Velde* 1624.

PROVENANCE: C. G. Tessin (Cat. 1749, p. 171); Kongl. Biblioteket (Cat. 1790, no. 1963); Kongl. Museum (Lugt 1638).

BIBLIOGRAPHY: Schönbrunner and Meder, no. 1030; R. Grosse, *Die holländische Landschaftskunst 1600–1650*, Berlin and Leipzig, 1925, p. 47, pl. 14.

EXHIBITIONS: Stockholm, 1953, no. 118; Stockholm, 1967, no. 217.

Inv. no. 2164/1863

LUCAS VAN UDEN

Antwerp 1595–Antwerp 1672

59. Landscape with a Country Estate

Pen and brown ink, gray wash and touches of watercolor and gouache. 20 × 33.8 cm. Watermark: IHS and cross over the H.
Signed on a tree trunk to the right *Lucas van Vden*.

PROVENANCE: Crozat (Mariette, no. 932 or 933); C. G. Tessin (List 1739–41, p. 31 v); Kongl. Biblioteket (Cat. 1790, no. 1766); Kongl. Museum (Lugt 1638).

BIBLIOGRAPHY: Schönbrunner and Meder, no. 1060.

EXHIBITIONS: Stockholm, 1953, no. 140; Brussels, Musées Royaux, *Le Siècle de Rubens*, 1965, no. 358.

Inv. no. 1959/1863

ANTHONY VAN DYCK

Antwerp 1599–London 1641

60. Profile and Left Arm of a Young Woman Looking Left

Black and white chalk on brownish gray paper. 45.8 × 28.5 cm. No watermark. Brown stains.
Inscribed in pen and brown ink at upper right *A VD*, and close to the right margin, under the woman's arm in light brown ink *A VDyck*. Numbered in pen and brown ink *1788* (Sparre) and *48* struck out.

This study from the model is preparatory for the figure of the woman at the right edge of the picture *The Brazen Serpent* in the Prado (*Klassiker der Kunst* 73) painted during Van Dyck's first Antwerp period (before 1621) and under the influence of Rubens whose treatment of the same subject of about 1610 (the painting in the collection of Count Seilern, London) engaged Van Dyck's attention before he found his own solution for the subject. The figure was added to the composition after Van Dyck had established its main character in the drawing now at Chatsworth (Vey, 1962, no. 47).

PROVENANCE: Crozat?; C. G. Tessin (Cat. 1749, livré 18, no. 48, as Rubens); Kongl. Biblioteket (Cat. 1790, no. 1788, as Rubens); Kongl. Museum (Lugt 1638).

BIBLIOGRAPHY: M. Rooses, *L'Oeuvre de P. P. Rubens*, Antwerp, 1892, V, p. 147 (as Rubens); H. Vey, *Van Dyck-Studien*, Cologne, 1958, p. 152 ff.; Id., *Die Zeichnungen Anton van Dycks*, Brussels, 1962, no. 49.

EXHIBITIONS: Stockholm, 1933 (as Rubens); Stockholm, 1953, no. 99 (as Rubens); Antwerp-Rotterdam, *Antoon van Dyck. Tekeningen en Olieverfschetzen*, 1960, no. 27; Leningrad, 1963.

Inv. no. 1981/1863

61. *Portrait of Cornelius van der Geest*

Black chalk. 25.5 × 18.4 cm. Small brown stains all over the paper. Watermark: Coat-of-arms with the numeral 4.

Inscribed at lower right in pen and brown ink CORNELIVS VANDER GEEST. Numbered *1780* (Sparre).

Cornelius van der Geest (1577–1638) was a merchant in colonial wares and one of the greatest *amateurs* and collectors of his time in Antwerp. The drawing was executed during one of Van Dyck's sojourns in Antwerp between the fall of 1627 and the spring of 1635. The final study for the engraving by Paulus Pontius in the *Iconographie*, it is one of the most interesting in the set because of its penetrating realism and the unpretentious attitude of the subject. (M. Mauquoy-Hendrickx, *L'Iconographie d'Antoine van Dyck, Catalogue raisonné, Mémoire* IX, Académie royale de Belgique, Brussels, 1956, no. 48.) There is a contemporary copy of the drawing in the collection of Janos Scholz, New York.

PROVENANCE: Crozat (Mariette, no. 848); C. G. Tessin (List 1739–41, p. 36 r, no. 7; Cat. 1749, livré 17, no. 158); Kongl. Biblioteket (Cat. 1790, no. 1780); Kongl. Museum (Lugt 1638).

BIBLIOGRAPHY: P. J. Mariette, *Abécédario, Archives de l'Art Français*, IV (P. de Chennevières-A. de Montaiglon eds.), Paris, 1853–62, II, p. 202; Schönbrunner and Meder, no. 1028; M. Rooses, "De Teekeningen der Vlaamsche Meesters," *Onze Kunst*, II, 1903, p. 138; T. W. Muchall-Viebrook, *Flemish Drawings of the Seventeenth Century*, London, 1926, no. 42; M. Delacre, "Recherches sur le role du dessin dans l'iconographie de van Dyck," *Mémoires*, 2nd series, Académie royale de Belgique, Brussels, 1932, II and IV, p. 95; A. J. J. Delen, "Cornelius van der Geest," *Antwerpen*, V, 1959, pp. 51–71; H. Vey, *Die Zeichnungen Anton van Dycks*, Brussels, 1962, no. 262.

EXHIBITIONS: Stockholm, 1933, no. 42; Stockholm, 1953, no. 152; Antwerp-Rotterdam, *Antoon van Dyck. Tekeningen en Olieverfschetzen*, 1960, no. 84.

Inv. no. 1973/1863

ADRIAEN BROUWER (?)
Oudenarde 1605–Antwerp 1638

62. *Self-Portrait (?)*

Pen and brown ink. 11.6 × 8.9 cm.

Inscribed in pen and black ink *Adrien Braur* (Tessin). Numbered *1902* (Sparre).

The drawing is from a sketchbook or set of sketches of which there are other sheets in the Nationalmuseum and at Groningen.

There is also a sketchbook with drawings dispersed between museums in Berlin, London, Vienna and Hamburg which has been generally accepted as original.

The group to which the Stockholm sheets belong was dated to Brouwer's last Antwerp period, 1631–38, by Bode. G. Knuttel does not accept the Stockholm drawings as original; he speaks of "their lines being crude, intensively scratched in and slap-dash"—a characterization that may be a little too depreciating. J. Bolten suggests Philips Koninck for a Groningen sheet by the same hand since the head in the drawing appears in a sketch attributed to that artist by Gerson. The likeness may, however, be coincidental.

PROVENANCE: Crozat (Mariette, no. 891); C. G. Tessin (Cat. 1749, livré 17, nos. 185–95); Kongl. Biblioteket (Cat. 1790, no. 1902); Kongl. Museum (Lugt 1638).

BIBLIOGRAPHY: W. Bode "Adriaen Brouwer," *Die graphischen Künste*, VI, 1884, pp. 58 ff.; Schönbrunner and Meder, no. 1049; M. Rooses, "De Teekeningen der Vlaamsche Meesters," *Onze Kunst*, III, 1904, pp. 65 ff.; W. von Bode, *Adriaen Brouwer*, Berlin, 1923, p. 180 ff.; A. J. J. Delen, *Vlämische Meisterzeichnungen des 17. Jahrhunderts*, 1949, pl. 86; G. Knuttel, *Adriaen Brower*, The Hague, 1962, p. 172; J. Bolten, *Dutch Drawings from the Collection of Dr. C. Hofstede de Groot*, Groninger Museum voor Stad en Lande, Utrecht, 1967, p. 77, no. 42.

EXHIBITIONS: Stockholm, 1953, no. 162; Stockholm, 1967, no. 227.

Inv. no. 2103/1863

REMBRANDT VAN RIJN
Leiden 1606–Amsterdam 1669

63. *Nude Woman in a Landscape, Seen from the Back*

Black chalk. 19.7 × 23.5 cm. Watermark: close to Briquet 7857 (Basel 1586). The paper damaged in the area of the figure's back.

Inscribed in black ink, verso *Rhimbrandt difficilement* (Tessin).

The drawing was attributed to Rembrandt in 1953 by Nils Lindhagen, who further suggested that it might be a life study preparatory for the painting of 1635, *Diana, Actaeon and Callisto* (Bredius 472). The attribution was accepted by Valentiner and Benesch but not by F. Lugt, who attributes the drawing to Govaert Flinck. J. W. von Moltke lists the drawing as a work by Flinck in his recent monograph on this artist.

PROVENANCE: Roger de Piles? (cf. Mariette, p. 101); Crozat (Mariette, nos. 869, 873, 877 or 878); C. G. Tessin (List 1739–41, p. 46 v; Cat. 1785, no. 236); Otto Wrede (1766–1804); Martin Carlsson.

BIBLIOGRAPHY: O. Benesch, *The Drawings of Rembrandt*, London 1954–57, VI, Addenda 6; C. Müller-Hofstede, "Die Rembrandt-Ausstellung in Stockholm," *Kunstchronik*, IX, 1956, p. 94; J. W. von Moltke, *G. Flinck*, Amsterdam, 1965, p. 218, no. D 215.

EXHIBITIONS: Stockholm, 1953, no. 166; Stockholm, 1956, no. 68; Rotterdam-Amsterdam, *Rembrandt*, 1956, no. 69 a; Vienna, *Rembrandt*, 1956, no. 16; Stockholm, 1967, no. 268.

Inv. no. 35/1956

64. *Farmstead beneath Trees by a Little Canal*

Reed pen and brown ink, wash, brownish paper. 12.9 × 28.4 cm. No watermark.
 Inscribed in brown ink *Rimbrant* (Tessin). Numbered in brown ink *310* (?), cut by the border.
 Verso: Landscape.

The same motif occurs in three other drawings by Rembrandt: one formerly in the De Robiano collection, Brussels, one in the Louvre, and one in the Kobberstiksamling in Copenhagen (Benesch nos. 1286, 1287, 1288). The Stockholm sheet is the most advanced and monumental of the four. In the earlier drawings, the trees are much larger and higher in relation to the building. Rembrandt gave prominence to the latter in the present drawing, his last version, creating a unity of trees and roof. Benesch dated this drawing 1654, two years later than the other versions of the subject. The drawing on the verso is one of Rembrandt's most concentrated and simplified landscape drawings.

PROVENANCE: Roger de Piles? (cf. Mariette, p. 101); Crozat (Mariette, no. 877 or 878); C. G. Tessin (List 1739–41, p. 31 r; Cat. 1785, no. 237–243?); C. H. Tersmeden. Acquired by the Nationalmuseum in 1919 as a gift from Nationalmusei Vänner.

BIBLIOGRAPHY: G. Wengström, "Rembrandts landskapsskisser i Nationalmuseum," *Festskrift vid Föreningen Nationalmusei Vänners tioårsjubileum*, 1921, p. 121 ff.; O. Benesch, *Rembrandt, Werk und Forschung*, 1935, p. 57; Id., *The Drawings of Rembrandt*, London, 1954–57, VI, no. 1289.

EXHIBITIONS: Stockholm, 1956, no. 178; Rotterdam-Amsterdam, *Rembrandt*, 1956, no. 194; Vienna, *Rembrandt*, 1956, no. 160; Stockholm, 1967, no. 287.

Inv. no. 54/1919

65. *Girl Asleep in a Window*

Reed pen and brush in brown, wash, heightened with white. 16.2 × 17.4 cm. Lined.
 Numbered in brown ink at lower right *1883* (Sparre).

Most authorities agree that the sitter is probably Hendrickje Stoffels. The Nationalmuseum owns another sheet, executed on the same occasion, where the model is drawn in a similar position, seated in the same place. The drawing is dated in the second half of the 1650's.

PROVENANCE: Roger de Piles? (cf. Mariette, p. 101); Crozat (Mariette, no. 869 or 873); C. G. Tessin (List 1739–41, p. 36 v; Cat. 1749, livré 17, no. 177); Kongl. Biblioteket (Cat. 1790, no. 1883); Kongl. Museum (Lugt 1638).

BIBLIOGRAPHY: C. Hofstede de Groot, *Die Handzeichnungen Rembrandts*, Haarlem, 1906, no. 1590; J. Kruse and C. Neumann, *Die Zeichnungen Rembrandts und seiner Schule im National-Museum zu Stockholm*, The Hague, 1920, no. IV, 3; C. Neumann, *Rembrandt Handzeichnungen*, Munich, 1919, no. 63; W. R. Valentiner, *Rembrandt, Des Meisters Handzeichnungen*, Berlin and Leipzig, 1925–34, no. 711; O. Benesch, *Rembrandt, Werk und Forschung*, Vienna, 1935, p. 61; Id., *Rembrandt, Selected Drawings*, London and New York, 1947, no. 248; Id., *The Drawings of Rembrandt*, London, 1954–57, V, no. 1101.

EXHIBITIONS: Amsterdam, *Rembrandt*, 1935, no. 80; Stockholm, 1956, no. 171; Rotterdam-Amsterdam, *Rembrandt*, 1956, no. 230; Munich, *Rembrandt*, 1956; Stockholm, 1967, no. 295.

Inv. no. 2084/1863

66. *Christ and the Woman Taken in Adultery*

Reed pen and brown ink. 18.9 × 24.8 cm. Watermark: Foolscap.
 Numbered in pen and brown ink *1803* (Sparre) and *182* struck out.

The drawing was dated by Kruse and Saxl to the mid-1650's while Benesch suggests a somewhat later date, 1658–59. Rembrandt had already treated this subject in a painting of 1644 now in London,

in which the adulteress kneels before Christ, but chose for the drawing another moment of the action, the incident of Christ's writing his reply in the sand.

The striking simplicity of line and the bold compositional idea of grouping the figures around a blank central space show the capacity of the aging master.

PROVENANCE: Roger de Piles? (cf. Mariette, p. 101); Crozat (Mariette, no. 869 or 873); C. G. Tessin (List 1739–41, p. 46 v; Cat. 1749, livré 15, no. 81); Kongl. Biblioteket (Cat. 1790, no. 1803); Kongl. Museum (Lugt 1638).

BIBLIOGRAPHY: F. Lippmann, *Zeichnungen von Rembrandt*, Berlin, 1900–01, II, no. 12; C. Hofstede de Groot, *Die Handzeichnungen Rembrandts*, Haarlem, 1906, no. 1038; J. Kruse and C. Neumann, *Die Zeichnungen Rembrandts und seiner Schule im National-Museum zu Stockholm*, The Hague, 1920, no. II, 5; E. W. Bredt, *Rembrandt-Bibel*, Munich, 1921, II, p. 64; W. R. Valentiner, *Rembrandt, Des Meisters Handzeichnungen*, Berlin and Leipzig, I, 1925, no. 406; L. J. van Rijckevorsel, *Rembrandt en de Traditie*, Rotterdam, 1932, p. 185, fig. 233; O. Benesch, *Rembrandt, Werk und Forschung*, Vienna, 1935, p. 62; Id., *Rembrandt, Selected Drawings*, London and New York, 1947, no. 211; Id., *The Drawings of Rembrandt*, London, 1954–57, V, no. 1038.

EXHIBITIONS: Amsterdam, *Rembrandt*, 1935, no. 87; Stockholm, 1956, no. 156; Rotterdam-Amsterdam, *Rembrandt*, 1956, no. 212; Vienna, *Rembrandt*, 1956, no. 137; Stockholm, 1967, no. 296.

Inv. no. 1998/1863

67. *Manoah's Offering*

Reed pen and wash in brown. 23.3 × 20.3 cm. Lined.
Inscribed in black ink along the bottom *L'ange quitte Manué et sa femme, et s'eleve au milieu de la flamme quil avoit excitée* (Crozat). Numbered in pen and brown ink *1807* (Sparre) and *79* struck out.

The subject is drawn from Judges XIII, 19–20.

Project for a new version of the painting, now in Dresden, dated 1641 and executed by one of Rembrandt's pupils (according to Sumowski by Jan Victors). Supposedly the painting originally had the same proportions as our drawing.

According to Saxl the composition was planned without the angel, which might have been added in the fifties, that is, contemporaneously with the Stockholm drawing.

PROVENANCE: Roger de Piles? (cf. Mariette, p. 101); Crozat (Mariette, no. 869 or 873); C. G. Tessin (List 1739–41, p. 46 v; Cat. 1749, livré 15, no. 70); Kongl. Biblioteket (Cat. 1790, no. 1807); Kongl. Museum (Lugt 1638).

BIBLIOGRAPHY: F. Lippmann, *Zeichnungen von Rembrandt*, Berlin, 1888–92, I, no. 128; C. Hofstede de Groot, *Die Hand-*

zeichnungen Rembrandts, Haarlem, 1906, no. 1546; J. Kruse and C. Neumann, *Die Zeichnungen Rembrandts und seiner Schule im Nationalmuseum zu Stockholm*, The Hague, 1920, no. I, 5; C. Neumann, *Rembrandt Handzeichnungen*, Munich, 1919, no. 63; F. Wickhoff, *Seminarstudien, Einige Zeichnungen Rembrandts mit biblischen Vorwürfen*, Innsbruck, 1906, no. 5; W. R. Valentiner, *Rembrandt, Des Meisters Handzeichnungen*, Berlin and Leipzig, 1925, I, no. 135; L. J. van Rijckevorsel, *Rembrandt en de Traditie*, Rotterdam, 1932, p. 9, fig. 5, p. 142, fig. 170; O. Benesch, *Rembrandt, Werk und Forschung*, Vienna, 1935, pp. 30, 56; F. Saxl, "Rembrandt's Sacrifice of Manoah," *Studies of the Warburg Institute*, IX, 1939, pp. 11 f.; O. Benesch, *Rembrandt, Selected Drawings*, London and New York, 1947, no. 211; Id., *The Drawings of Rembrandt*, London, 1954–57, V, no. 975.

EXHIBITIONS: Stockholm, 1956, no. 111; Rotterdam-Amsterdam, *Rembrandt*, 1956, no. 215; Vienna, *Rembrandt*, 1956, no. 119; Leningrad, 1963; Jerusalem, *Rembrandt*, 1965, no. 29; Stockholm, 1967, no. 285.

Inv. no. 2003/1863

68. *Homer Dictating to a Scribe*

Pen and brown ink, brush, heightened with white. 14.5 × 16.7 cm. Arched at top.

Study for the painting of 1663 in the Bredius collection, The Hague (Hofstede de Groot 217, Bredius 483). The painting was ordered by Don Antonio Ruffo in Messina, as a companion piece to the *Aristotle*, now in the Metropolitan Museum of Art, New York. The drawing was supposedly sent to Ruffo beforehand to give him an idea of the composition and renders the original composition of the painting before it was damaged by fire and cut down to its present shape. The drawing belongs to Rembrandt's last period and can be compared with a small number of drawings, i.e., the preliminary studies for *De Staalmeesters* of 1662.

PROVENANCE: J. T. Sergel (supposedly acquired by Sergel in Rome in the 1770's).

BIBLIOGRAPHY: J. Kruse, "Eine neuentdeckte Homeros-Zeichnung von Rembrandt im Nationalmuseum zu Stockholm," *Oud Holland*, XXVII, 1909, p. 221; F. Schmidt-Degener, "Rembrandt en Homerus," *A. Bredius Feest-Bundel*, Amsterdam, 1915, pp. 15 ff., pl. 11; G. J. Hoogewerff, "Rembrandt en een Italiaansche Maecenas," *Oud Holland*, XXXV, 1917, pp. 129–148; C. Ricci, *Rembrandt in Italia*, Milano, 1918, p. 41; J. Kruse and C. Neumann, *Die Zeichnungen Rembrandts und seiner Schule im National-Museum zu Stockholm*, The Hague, 1920, no. V:4; W. R. Valentiner, *Rembrandt, Des Meisters Handzeichnungen*, Berlin and Leipzig, 1925, I, no. 567; O. Benesch, *Rembrandt, Werk und Forschung*, Vienna, 1935, p. 68; J. Rosenberg, *Rembrandt*, Cambridge, Mass., 1948, p. 168, pl. 244; R. Hamann, *Rembrandt*, Berlin, 1948, pp. 189, 191; O. Benesch, *The Drawings of Rembrandt*, London, 1954–57, V, no. 1066; C. Müller-Hofstede, "Die Rembrandt Ausstellung in Stockholm," *Kunstchronik*, IX,

1956, p. 94; O. Benesch, "Rembrandt and Ancient History," *Art Quarterly*, XXI, 1959, p. 328.

EXHIBITIONS: Stockholm, 1956, no. 186; Rotterdam-Amsterdam, *Rembrandt*, 1956, no. 254; Vienna, *Rembrandt*, 1956, no. 146.

Inv. no. 1677/1875

PHILIPS DE KONINCK
Amsterdam 1619–Amsterdam 1688

69. *Lowland Scenery with Canal and Arnhem in the Background*

Pen and ink, gray wash and watercolors. 13 × 24 cm. No watermark.

Dated by Horst Gerson to the 1650's.

PROVENANCE: Rosersberg collection.

BIBLIOGRAPHY: H. Gerson, *Philips Koninck*, Berlin, 1926, p. 60, no. z 77.

EXHIBITIONS: Stockholm, 1953, no. 210; Stockholm, 1967, no. 292.

Inv. no. Z 378/1957

GERBRAND VAN DEN EECKHOUT
Amsterdam 1621–Amsterdam 1674

70. *David and Uriah*

Pen and brown ink. 14 × 19 cm. No watermark.
Inscribed with measurements *1 2 3 4* (×) *1 2 3 4 5 & 1/4 Vodt*; and in pen and dark brown ink (later hand) *urias an david*. Numbered in black ink *1849* (Sparre) and *193* struck out.

Valentiner, Van Regteren Altena and Byam Shaw have identified this drawing as a work of Eeckhout. Sumowski dates the sheet to the 1660's. A less elaborate study for the same composition has been published by Sumowski as *Hamann and Ahasuerus*.

PROVENANCE: Roger de Piles? (cf. Mariette, p. 101); Crozat (Mariette, nos. 869, 873, 877 or 878); C. G. Tessin (List 1739–41, p. 46 v; Cat. 1749, livré 15, no. 25); Kongl. Biblioteket (Cat. 1790, no. 1849); Kongl. Museum (Lugt 1638).

BIBLIOGRAPHY: C. Hofstede de Groot, *Die Handzeichnungen Rembrandts*, Haarlem, 1906, no. 1547; J. Kruse and C. Neumann, *Die Zeichnungen Rembrandts und seiner Schule im Nationalmuseum zu Stockholm*, The Hague, 1920, no. I:13; W. Sumowski, "Gerbrand van den Eeckhout as Draughtsman," *Oud Holland*, LXXVII, 1962, p. 19, fig. 25; cf. also W. Wegner, *Rembrandt und sein Kreis*, exhibition catalogue,

Staatliche Graphische Sammlungen, Munich, 1966, p. 40, no. 81.

EXHIBITIONS: Stockholm, 1967, no. 279.

Inv. no. 2049/1863

CONSTANTIJN VAN RENESSE
and REMBRANDT
Maarssen 1626–Eindhoven 1680

71. *Job with his Wife and Friends*

Pen and wash in two shades of brown, white bodycolor, over traces of black chalk; the upper corners rounded. 18 × 23.8 cm. No watermark.
Numbered in pen and brown ink on the old mount *1799* (Sparre) and *181* struck out.

Renesse's drawing showed one of Job's friends standing in front of him and between them the half-length figure of Job's wife. Rembrandt, in correcting his pupil's drawing, discarded both figures and replaced them with the single figure raising his arms above Job's head. He further changed Job's head, left the second standing friend almost untouched and completely redrew the seated friend at the left, adding a column and foliage in the background.

Rembrandt's reworking is dated by Benesch about 1655; there is a copy of the drawing in the Albertina, Vienna.

PROVENANCE: Roger de Piles? (cf. Mariette, p. 101); Crozat (Mariette, no. 869, 873, 877 or 878); C. G. Tessin (List 1739–41, p. 46 v; Cat. 1749, livré 15, no. 78); Kongl. Biblioteket (Cat. 1790, no. 1799); Kongl. Museum (Lugt 1638).

BIBLIOGRAPHY: E. Michel, *Rembrandt*, Paris, 1893, p. 517; F. Lippmann, *Zeichnungen von Rembrandt*, Berlin, 1900–01, II, no. 11; C. Hofstede de Groot, *Die Handzeichnungen Rembrandts*, Haarlem, 1906, no. 1548; F. Saxl, "Zu einigen Handzeichnungen Rembrandts," *Repertorium für Kunstwissenschaft*, XXXI, 1908, p. 336; C. Neumann, *Aus der Werkstatt Rembrandts*, Heidelberg, 1918, p. 112, fig. 39; J. Kruse and C. Neumann, *Die Zeichnungen Rembrandts und seiner Schule im Nationalmuseum zu Stockholm*, The Hague, 1920, no. I:6; G. Falck, "Ueber einige von Rembrandt übergangene Schülerzeichnungen," *Jahrbuch der preussischen Kunstsammlungen*, XXXXV, 1924, p. 195; W. R. Valentiner, *Rembrandt, Des Meisters Handzeichnungen*, Berlin and Leipzig, 1925, no. 207; L. Münz, "Rembrandts Alterstil und die Barockklassik, 3," *Jahrbuch der kunsthistorischen Sammlungen, Wien*, N.F. IX, 1935, p. 312, Fig. 164; O. Benesch, *Rembrandt, Werk und Forschung*, Vienna, 1935, p. 51; J. Rosenberg, *Rembrandt*, Cambridge, 1948, p. 180; O. Benesch, *The Drawings of Rembrandt*, London, 1954–57, VI, no. 1379; W. Sumowski, *Bemerkungen zu O. Beneschs Corpus II*, Bad Pyrmont, 1961, p. 22.

EXHIBITIONS: Stockholm, 1967, no. 305.

Inv. no. 1993/1863

ANTHONIE VAN BORSSOM
Amsterdam 1629/30–Amsterdam 1677

72. *Jetty with Buildings*

Pen and brown ink, wash. 16.3 × 29.3 cm. Watermark: P B.

The attribution is founded on the drawing's stylistic affinities with drawings in London, Amsterdam and Florence (cf. bibliography below). The drawings in London and Amsterdam are also similar in size.

PROVENANCE: Unknown.

BIBLIOGRAPHY: Cf. A. M. Hind, *Catalogue of Drawings by Dutch and Flemish Artists . . . in the British Museum*, London, 1915, I, p. 63, no. 3, pl. 21; H. D. Henkel, *Catalog van de neder-lansche teekeningen in het Rijksmuseum te Amsterdam, I: Teekeningen van Rembrandt en zijn School*, Amsterdam, 1942, p. 67, no. 4, pl. 98; E. K. J. Reznicek, *Mostra di disegni fiamminghi e olandesi*, Florence, 1964, no. 82.

Inv. no. Z 26/1954

AERT DE GELDER
Dordrecht 1645–Dordrecht 1727

73. *Vertumnus and Pomona in a Landscape*

Pen and brown ink. 20.7 × 32 cm. Watermark: Foolscap. Numbered at lower right *1816* (Sparre), and *68* struck out. Verso: Vertumnus and Pomona.

PROVENANCE: Roger de Piles? (cf. Mariette, p. 101); Crozat (Mariette, nos. 869, 873, 877 or 878); C. G. Tessin (List 1739–41, p. 46 v; Cat. 1749, livré 15, no. 62); Kongl. Biblioteket (Cat. 1790, no. 1816); Kongl. Museum (Lugt 1638).

BIBLIOGRAPHY: C. Hofstede de Groot, *Die Handzeichnungen Rembrandts*, Haarlem, 1906, no. 1545; J. Kruse and C. Neumann, *Die Zeichnungen Rembrandts und seiner Schule im Nationalmuseum zu Stockholm*, The Hague, 1920, no. V:3 (verso V:1); W. R. Valentiner, *Rembrandt, Des Meisters Handzeichnungen*, Berlin, 1934, II, p. xxxvii.

EXHIBITIONS: Stockholm, 1967, no. 300.

Inv. no. 2012/1863

ADRIAEN VAN OSTADE
Haarlem 1610–Haarlem 1685

74a. *Seated Peasant Holding a Glass*

Pen and brown ink, watercolor (white oxidized). 12 × 8.7 cm.
Numbered *1933* (Sparre).

74b. *Peasant Seated on a Bench and Holding a Pipe*

Pen and brown ink, watercolor (white oxidized). 11.4 × 9.4 cm.
Inscribed in pen and gray ink *AV* (monogram). Numbered *1934* (Sparre).

74c. *Seated Peasant with a Pipe in his Right Hand and a Glass in His Left*

Pen and brown ink, watercolor (white oxidized). 11.4 × 7.4 cm.
Numbered *1935* (Sparre), and *46* struck out.

PROVENANCE: Crozat (Mariette, no. 892); C. G. Tessin (List 1739–41, p. 46 v; Cat. 1749, livré 15, no. 104–114); Kongl. Biblioteket (Cat. 1790, nos. 1933–35).

BIBLIOGRAPHY: Schönbrunner and Meder, no. 1083

EXHIBITIONS: Stockholm, 1953, no. 185; Stockholm, 1967, nos. 232–234.

Inv. no. 2134–36/1863

ISAAC VAN OSTADE
Haarlem 1621–Haarlem 1649

75. *Interior of a Peasant's Cottage*

Pen and brown ink, brown wash over black chalk. 20.5 × 29.5 cm. Watermark: Foolscap (near Heawood 1930).
Signed (?) at lower left in pen and brown ink *Isack van ostade fe*. Numbered at lower right in pen and brown ink *1939* (Sparre) and *4* struck out.

PROVENANCE: Crozat (Mariette, no. 892); C. G. Tessin (List 1739–41, p. 46 v; Cat. 1749, livré 15, no. 117 or 118); Kongl. Biblioteket (Cat. 1790, no. 2140); Kongl. Museum (Lugt 1638).

BIBLIOGRAPHY: W. Bernt, *Die Niederländischen Zeichner des 17. Jahrhunderts*, Munich, 1958, II, no. 459.

EXHIBITIONS: Stockholm, 1953, no. 238; Stockholm, 1967, no. 235.

Inv. no. 2140/1863

BARTHOLOMEUS VAN DER HELST
Haarlem 1613 (?)–Amsterdam 1670

76. *Portrait of the Painter Paulus Potter*

Black and white chalk on light gray paper. 18.8 × 14.5 cm. All corners but the upper right are slightly cut.
Numbered in brown ink *2*.

The drawing is a study for the painted portrait dated 1654 now in the Mauritshuis, The Hague. While in the collection of Pierre Crozat, the drawing was copied by Watteau.

PROVENANCE: Crozat (Mariette, no. 895?); C. G. Tessin (List 1739–41, p. 36 v, as "de Vischer"; Cat. 1749, livré 17, no. 183, as "Vischer"); Kongl. Biblioteket (Cat. 1790, no. 1681, as "Corneille Vischer"); Kongl. Museum (Lugt 1638).

BIBLIOGRAPHY: J. Meder, "Eine Portraitzeichnung Paulus Potters von Bartholomeus van der Helst," *Oud Holland,* XXVI, 1908, p. 18 ff.; Schönbrunner and Meder, no. 920; W. Bernt, *Die Niederländischen Zeichner des 17. Jahrhunderts,* 1957, I, no. 289.

EXHIBITED: Stockholm, 1953, no. 205; Stockholm, 1967, no. 237.

Inv. no. 1872/1863

JAN DE BRAY
Haarlem 1627–Haarlem 1679

77. *Portrait of a Boy*

Black and red chalk. 29.2 × 19.7 cm. No watermark. Lower left corner cut.

Attributed to Jan de Bray by S. Gudlaugsson.

PROVENANCE: Crozat (Mariette, no. 808?); C. G. Tessin; Kongl. Biblioteket (Cat. 1790, no. 1679 as "Hubert Goltzius"); Kongl. Museum (Lugt 1638).

EXHIBITED: Stockholm, 1953, no. 250; Stockholm, 1967, no. 244.

Inv. no. 1868/1863

WILLEM VAN DE VELDE THE YOUNGER
Amsterdam 1633–Greenwich 1707

78. *Naval Vessel Surrounded by Small Boats*

Point of the brush and gray wash over a sketch in black chalk. 19 × 23.3 cm. Watermark: I H.S.

PROVENANCE: Count Axel Bielke (1800–1877).

EXHIBITIONS: Stockholm, 1953, no. 267.

Inv. no. 63/1876

CASPAR NETSCHER
Heidelberg ca. 1636–The Hague 1684

79. *Seated Woman with Needlework*

Black chalk, heightened with white on brownish paper. 29.2 × 19.8 cm. Watermark: P M. Hole at bottom right.

Attributed to Netscher by Lindhagen because of its stylistic kinship with the artist's early paintings.

PROVENANCE: Crozat (Mariette, no. 892?); C. G. Tessin (Cat. 1749, livré 15, no. 121 as "Begga"); Kongl. Biblioteket (Cat. 1790, no. 1947, as "Corneille Bega").

BIBLIOGRAPHY: Schönbrunner and Meder, no. 119 (as Gabriel Metsu).

EXHIBITIONS: Stockholm, 1953, no. 275; Stockholm, 1967, no. 246.

Inv. no. 2148/1863

FRENCH

CLAUDE DERUET
Nancy 1588–Nancy 1661

80. *Couple on a Horse*

Pen and brown ink, gray wash. 40.5 × 26.2 cm. No water-mark. Repair at upper left corner. Dark brown stain under the horse's belly.

Inscribed in pen and brown ink *tempeste*. Numbered *137* (Sparre) and *84* struck out.

The couple is part of a cavalcade, supposedly of Amazons. In front of their horse, the tail of the horse ahead is visible. There is a related drawing of a single Amazon on horseback in the collection of the Pierpont Morgan Library.

PROVENANCE: Crozat (Mariette, nos. 65–68?); C. G. Tessin (Cat. 1749, livré 26, no. 4); Kongl. Biblioteket (Cat. 1790, no. 137); Kongl. Museum (Lugt 1638).

BIBLIOGRAPHY: Sirén 1917, no. 115 (as Tempesta); B. Dahlbäck, "De Bellange à Deruet," *Bulletin de la société de l'histoire de l'art français*, 1953, pp. 78–81; G. Viatte, "Quatre Tableaux de Claude Deruet," *La Revue du Louvre*, XIV, 1964, p. 222.

EXHIBITIONS: Paris, Musée Carnavalet, *Théâtre et fêtes à Paris XVIe et XVIIe siècles*, 1956, no. 49; London, Arts Council; *Sixteenth and Seventeenth Century Theatre Design in Paris*, 1957, no. 29.

Inv. no. 178/1863

JACQUES BELLANGE
Working ca. 1600

81. *Couple Promenading*

Pen and brown ink, wash. Silhouetted. 33.8 × 18.5 cm. No watermark.

The fantastic character of the headdresses of both figures and of the apparel of the one on the left indicates that these costumes might have been designed for the theatre.

PROVENANCE: Prince de Carignan; C. G. Tessin; Gustaf III; The Royal Family; Charles XV.

BIBLIOGRAPHY: B. Dahlbäck, "De Bellange à Deruet," *Bulletin de la société de l'histoire de l'art français*, 1953, pp. 78–81; P. Bjurström and B. Dahlbäck, "Témoignages de l'éphémère," *L'Oeil*, XXIV, 1956, pp. 36–41.

EXHIBITIONS: Paris, Musée Carnavalet, *Théâtre et fêtes à Paris XVIe et XVIIe siècles*, 1956, no. 47; London, Arts Council, *Sixteenth and Seventeenth Century Theatre Design in Paris*, 1957, no. 27; Stockholm, 1958, no. 188.

Inv. no. 136: 81/1874

82. *Horseman*

Black chalk, pen and brown ink, brown wash. 38.8 × 20.7 cm. No watermark. Silhouetted.

PROVENANCE: Prince de Carignan; C. G. Tessin; Gustaf III; The Royal Family; Charles XV.

BIBLIOGRAPHY: B. Dahlbäck, "De Bellange à Deruet," *Bulletin de la société de l'histoire de l'art français*, 1953, pp. 78–81.

EXHIBITIONS: Paris, Musée Carnavalet, *Théâtre et fêtes à Paris XVIe et XVIIe siècles*, 1956, no. 46; London, Arts Council, *Sixteenth and Seventeenth Century Theatre Design in Paris*, 1957, no. 26; Stockholm, 1958, no. 189; Leningrad, 1963.

Inv. no. 89: 81/1874

JACQUES CALLOT
Nancy 1592–Nancy 1635

83. *A Horse Walking; Small Sketch of Rearing Horse*

Pen and brown ink. 19.8 × 25.2 cm. No watermark. Two horizontal folds.

Inscribed in pen and brown ink in lower margin *Callot due parte*. Numbered in pen and brown ink at lower right *2493* (Sparre) and *60* struck out.

Verso: Six studies of horses. Pen and brown ink. Numbered at upper left *102*.

The drawing belongs to a set of twelve or thirteen which are all copies after a series engraved by Tempesta, *Chevaux de différents pays* (Bartsch 941–68), dated 1590. The drawings are, however, larger than the engravings. The attribution to Callot is confirmed by the small studies surrounding the horses on other sheets in the set which can be connected with works engraved by Callot during his Florentine period. Ternois dates the group about 1615–17.

This drawing reproduces number 8 (*Hic maculis variis . . .*) from Tempesta's set, an engraving also used by Callot for two drawings in British Museum (Ternois nos. 25 and 26) and one in Berlin (K. Oberhuber, "Noch eine Pferdezeichnung von Jacques Callot," *Albertina-Studien*, I:3, 1963, p. 118 f.).

PROVENANCE: Crozat (Mariette, no. 998); C. G. Tessin (List 1739–41, p. 62 r; Cat. 1749, livré 20, no. 55); Kongl. Biblioteket (Cat. 1790, no. 2493); Kongl. Museum (Lugt 1638).

BIBLIOGRAPHY: G. Paulsson, "Handteckningar av Jacques Callot i Nationalmuseum," *Nationalmusei Årsbok*, II, 1920, pp. 67 ff., and no. 7 a–b; J. Laver, "Callot's 'Martyrdom of Saint Sebastian,'" *Burlington Magazine*, L, 1927, pp. 80–85; D. Ternois, *L'Art de Jacques Callot*, Paris, 1962, pp. 49, 111, 112; Id., *Jacques Callot, Catalogue complet*, Paris, 1962, no. 29.

Inv. no. 2597–98/1863

84. *Miracle of St. Mansuetus*

Red chalk, pen and brown ink, wash. 21.2 × 27.5 cm. The figure of the governor is drawn on an added piece of paper. The lines are indented for transfer. Lined.

Numbered in pen and brown ink at lower right *17* struck out.

This drawing is the fourth and last sketch known for Callot's etching of the subject. The three earlier preparatory studies are in the Musée Lorrain in Nancy, in the collection of Mr. and Mrs. Germain Seligman, New York, and the Museum of Fine Arts, Boston (Ternois nos. 570–72).

The drawing depicts St. Mansuetus, patron saint of Toul in Callot's native Lorrain, who lived in the fourth century. He revives the son of the governor, who had fallen into the Moselle River from which he had been recovered in a lifeless state. As a result the governor, all his family and subjects were converted, and recognized St. Mansuetus as their pastor.

The three earlier drawings are vertical compositions concentrating on St. Mansuetus and the governor's family. In this drawing the group has been completed with ecclesiastical and lay figures standing behind the saint while the young boy and his rescuer are isolated from the rest of the group.

The features of St. Mansuetus change radically from a portly, fleshy countenance in the Nancy and Seligman studies to an older and more sensitive face in the Boston sheet, in this drawing and in the etching. It is the features of Jean de Porcelet, Bishop of Toul in Callot's time, that are supposedly recorded in the etching; the first two drawings could have been made before Callot had met the bishop.

Freedberg is inclined to follow Meaume and Lieure in dating the etching in the Nancy period of 1621–26; on the basis of stylistic evidence Ternois is convinced that drawings and print were made in Florence at the end of the 1610's.

PROVENANCE: Crozat (Mariette, no. 998); C. G. Tessin (List 1739–41, p. 43 r; Cat. 1749, livré 13, no. 151); Kongl. Biblioteket (Cat. 1790, no. 2368); Kongl. Museum (Lugt 1638).

BIBLIOGRAPHY: G. Paulsson, "Handteckningar av Jacques Callot i Nationalmuseum," *Nationalmusei Årsbok*, II, 1920, pp. 67 ff., and no. 2; J. Vallery-Radot, *Le Dessin français au XVIIe siècle*, Lausanne, 1953, p. 185, pl. 25; A. Blake Freedberg, "A 4th Century Miracle Drawn by a 17th Century Artist," *Bulletin*, Museum of Fine Arts, Boston, 300, 1957, pp. 38 ff.; D. Ternois, *L'Art de Jacques Callot*, Paris, 1962, pp. 39, 111, 162; Id., *Jacques Callot, Catalogue complet*, Paris, 1962, no. 573.

EXHIBITIONS: Stockholm, 1958, no. 213; Leningrad, 1963.

Inv. no. 2472/1863

85. *The Temptation of St. Anthony*

Black chalk, point of brush and brown ink, wash, heightened with white. 44.8 × 67.1 cm. Vertical fold at center piece of paper 6 cm. wide added at the right.

The subject of this drawing occupied Callot on different occasions. He made an etching in Florence in 1616 (Meaume 138, Lieure 188) and returned to it in an etching, executed in Nancy and dated the year before his death, 1635 (Meaume, no. 139, Lieure, no. 1416).

In the 1741 catalogue of the Crozat collection, Mariette mentions this sheet as one of four preparatory drawings for the etching of 1635. In another connection (*Abécédario*, I, p. 286) Mariette lists two drawings in the collection of Boulle. These were sold at auction in 1732 and reappeared, the one in the Lorangère collection in 1744, the other in the collection of Jullienne. Today three versions are known, one in the Hermitage (from Lorangère), one in the British Museum, and this one in Stockholm. Crozat acquired this drawing from Antoine Triest, Bishop of Ghent, through the Dutch dealer Cornelius Vermeulen.

PROVENANCE: Antoine Triest; Crozat (Mariette, no. 1000); C. G. Tessin (Cat. 1749, livré 16, no. 88); Kongl. Biblioteket (Cat. 1790, no. 2367); Kongl. Museum.

BIBLIOGRAPHY: A. M. Hind, "Jacques Callot," *Burlington Magazine*, XXI, 1912, p. 79; G. Paulsson, "Handteckningar av Jacques Callot i Nationalmuseum," *Nationalmusei Årsbok*, II, 1920, pp. 67 ff. and no. 1; L. Ugloff, "Drawings of Jacques Callot for the Temptation of St. Anthony," *Burlington Magazine*, LXVII, 1935, p. 220; R. A. Weigert, *Jacques Callot*, Paris, 1935, p. 4; Id., "Jacques Callot," *Le Dessin*, 1935, p. 477; J. Vallery-Radot, *Le Dessin français au XVIIe siècle*, Lausanne, 1953, p. 186, pl. 31; D. Ternois, *L'Art de Jacques Callot*, Paris, 1962, ill. 57 C; Id., *Jacques Callot, Catalogue complet*, Paris, 1962, no. 953.

EXHIBITIONS: London, Royal Academy, *French Art 1200–1900*, 1932, no. 669; Stockholm, 1933, no. 59; Paris, Gazette des Beaux-Arts, *Le Dessin français dans les collections du XVIIIe siècle*, 1935, no. 53; Paris, Palais National des Arts, *Chefs d'oeuvre de l'art français*, 1937, no. 468; Brussels, Rotterdam, Paris, *Le Dessin français de Fouquet à Cézanne*, 1949–50, no. 26; Vienna, Albertina, *Meisterwerke aus Frankreichs Museen*, 1950, no. 27; Washington, Cleveland, St. Louis, Cambridge, New York, *French Drawings*, 1952–53, no. 25; Stockholm, 1958, no. 214; Leningrad, 1963.

Inv. no. 2471/1863

NICOLAS POUSSIN
Les Andelys 1593/94–Rome 1665

86. *The Triumph of Galatea*

Black chalk, brown wash. 14.2 × 20.2 cm. No watermark. Old fold at right.
Numbered *63* struck out.

There are two closely connected drawings of this subject in the Nationalmuseum. This is the more concentrated of the two and seems to be the more mature work. At first sight it appears to be con-nected with the *Triumph of Amphitrite* executed for Richelieu at the end of the 1630's and today in the Philadelphia Museum of Art. As Blunt has pointed out, the likeness can as well be accounted for on the grounds of a common ancestry in Raphael's and Annibale Carracci's versions of the theme. There is no motif which exactly links the drawing to the painting. The drawing may, however, have been executed in the same period, ca. 1635.

PROVENANCE: Crozat (Mariette, no. 971); C. G. Tessin (List 1739-41, p. 43 r; Cat. 1749, livré 13, no. 18 or 19); Kongl. Biblioteket (Cat. 1790, no. 2345); Kongl. Museum (Lugt 1638).

BIBLIOGRAPHY: G. Wengström, "Teckningar av Poussin i Nationalmuseum," *Nationalmusei Årsbok*, VI, 1924, pp. 140 f.; Id., *Nicolas Poussin. Dix-huit fac-similés en couleurs . . .* (Collection de dessins du Musée National II), Malmö, 1935, no. 13; W. Friedländer and A. Blunt, *The Drawings of Nicolas Poussin*, London, 1953, III, no. 216, pl. 166.

EXHIBITIONS: Stockholm, 1958, no. 193; Bern, *Französische Kunst des 17. Jahrhunderts*, 1959, no. 168; Paris, Musée du Louvre, *Nicolas Poussin*, 1960, no. 137.

Inv. no. 2446/1863

87. *The Triumph of Titus*

Pen and brown ink, wash. 15.1 × 27.7 cm. Lined. Small holes at left.
Inscribed at upper left *nicolò pussino 25*.

During the period 1640–45 Poussin's drawings after the antique are of two different types, most of them being simply factual notes. This drawing after one of the bas-reliefs on the Arch of Titus in Rome is, however, quite different, made as it was as a record of a sculpture that the artist admired as a work of art. It is not measured or detailed; Poussin has been more interested in the play of light on the surface.

PROVENANCE: Nathaniel Hone (Lugt 2793); J. T. Sergel (Lugt 2339 b).

BIBLIOGRAPHY: G. Wengström, "Teckningar av Poussin i Nationalmuseum," *Nationalmusei Årsbok*, VI, 1924, pp. 126 f., p. 144, no. 1; Id., *Nicolas Poussin. Dix-huit fac-similés en couleurs . . .* (Collection de dessins du Musée National II), Malmö, 1935, no. 1; U. Christoffel, *Poussin und Claude Lorrain*, Munich, 1942, p. 50; H. Ladendorf, *Antikenstudium und Antikenkopie*, Berlin, 1953, p. 180; A. Blunt, *Nicolas Poussin*, New York, 1967, p. 229.

EXHIBITIONS: Paris, Musée du Louvre, *Nicolas Poussin*, 1960, no. 184.

Inv. no. 1571/1875

88. *The Finding of Queen Zenobia*

Pen and brown ink. 11.3 × 19.3 cm. Lined. Repair at upper left corner.

Inscribed lower center *Poussin, Cabinet de Crozat*. Numbered at lower right in brown ink *2349* (Sparre).

Queen Zenobia, wife of Rhadamistus, King of Armenia, had escaped from Artaxata, the capital of Armenia, after an insurrection. Seized with the pains of childbirth during her flight, she begged her husband to kill her rather than allow her to fall into the hands of their enemies. Rhadamistus attempted to do so, and after stabbing her, threw her body into the Araxes. But she was seen by shepherds, taken out of the water and revived. It is this moment that is represented here.

The drawing is similar in composition to the *Finding of Moses* of 1647 and is dated by Friedländer to about the same period. A painting ascribed to Dufresnoy (The Hermitage, Leningrad) follows this sketch very closely.

PROVENANCE: Abbé Quesnel (Cf. E. Magne, *Nicolas Poussin...*, Paris, 1914, p. 202); Crozat (Mariette, no. 971); C. G. Tessin (List 1739–41, p. 43 r; Cat. 1749, livré 13, no. 23); Kongl. Biblioteket (Cat. 1790, no. 2349); Kongl. Museum (Lugt 1638).

BIBLIOGRAPHY: G. Wengström, "Teckningar av Poussin i Nationalmuseum," *Nationalmusei Årsbok*, VI, 1924, pp. 133 f.; Id., Nicolas Poussin *Dix-huit fac-similés en couleurs...* (Collection de dessins du Musée National II), Malmö, 1935, no. 7; W. Friedländer, *The Drawings of Nicolas Poussin*, London, 1949, II, no. 133, pl. 104.

EXHIBITIONS: Leningrad, 1963.

Inv. no. 2451/1863

89. *The Nurture of the Infant Jupiter*

Pen and brown ink on brownish paper. 17.4 × 24.1 cm. The two figures on the right are on a separate piece of paper laid over an earlier version. Lined.

Numbered at lower right in brown ink *135*. Inscribed on the old mount in brown ink *Poussin. Cabinet de Crozat* (Tessin). Numbered *2338* (Sparre).

The theme derives from Vergil, *Georgics*, IV, 149 ff. In the foreground to the left is a shepherd milking the goat Amalthea while another nymph at the right feeds Jupiter from a cup. The composition is known from two paintings, one belonging to Mr. George Tait, Malibu, California, the other to the National Gallery of Art, Washington, D.C. There are rather great differences between these and the drawing, especially in the right part of the com-

position; furthermore, landscape plays a more important role in the drawing. Before 1961 it had been generally accepted as a work by Poussin and dated in the second half of the 1630's. Then Blunt reattributed the drawing to the "Hovingham Master," an artist who imitated Poussin's earlier romantic style.

PROVENANCE: Crozat (Mariette, no. 971); C. G. Tessin (List 1739–41, p. 43 r; Cat. 1749, livré 13, no. 12); Kongl. Biblioteket (Cat. 1790, no. 2330); Kongl. Museum (Lugt 1638).

BIBLIOGRAPHY: Schönbrunner and Meder, no. 1129; W. Friedländer, *Nicolas Poussin*, Munich, 1914, p. 184; G. Wengström, "Teckningar av Poussin i Nationalmuseum," *Nationalmusei Årsbok*, 1924, VI, p. 133; Id., *Nicolas Poussin Dix-huit fac-similés en couleurs...* (Collection de dessins du Musée National II), Malmö, 1935, no. 6; A. Blunt, "Poussin Studies III: The Poussins at Dulwich," *Burlington Magazine*, XC, 1948, p. 8; W. Friedländer and A. Blunt, *The Drawings of Nicolas Poussin*, London, 1953, III, no. 165, pl. 136; A. Blunt, "Poussin Studies XII: The Hovingham Master," *Burlington Magazine*, CIII, 1961, p. 457, no. 9; A. Mongan in *Great Drawings of All Time* (Ira Moscowitz, ed.), Vol. III, Italian, New York, 1962, no. 660; A. Blunt, *The Paintings of Nicolas Poussin*, London, 1966, p. 175, no. R80 (as the "Hovingham Master").

EXHIBITIONS: Stockholm, 1958, no. 194; Bern, *Das 17. Jahrhundert in der Französischen Malerei*, 1959, no. 171; Leningrad, 1963.

Inv. no. 2438/1863

SCHOOL OF NICOLAS POUSSIN

90. *Paris and Oenone*

Red chalk, pen and brown ink, wash. 21.3 × 21.9 cm. Lined.

Numbered at lower center in brown ink *2331* (Sparre) and at lower right *45*.

The fact that a youth and a girl are shown reclining at the foot of a tree on whose trunk four illegible lines of writing are inscribed has led to their identification with Medoro and Angelica (Canto XIX of Ariosto's *Orlando Furioso*), who everywhere carved their names on the trees.

Friedländer, however, identified the scene as "Paris and Oenone." Ovid (*Heroides*, V, 21 ff.) tells how they first carved their names on trees and Paris also recorded his oath of fidelity on a tree. He swore that the River Xanthus, visible as a river god in the background of the drawing, would flow upstream with his waters, before he would desert Oenone.

Among the Nationalmuseum's drawings once

attributed to Poussin, this drawing is one of the most charming and widely exhibited. The attribution to Poussin, however, has been rejected by Friedländer and Blunt, who point instead to its closeness to the style of Blanchard.

PROVENANCE: Crozat (Mariette, no. 971); C. G. Tessin (List 1739–41, p. 43 r; Cat. 1749, livré 13, no. 5); Kongl. Biblioteket (Cat. 1790, no. 2331); Kongl. Museum (Lugt 1638).

BIBLIOGRAPHY: Schönbrunner and Meder, no. 974; W. Friedländer, *Nicolas Poussin*, Munich, 1914, p. 156; *Cézanne und seine Ahnen*, Marées-Gesellschaft, XXXIII, Munich, 1921; G. Wengström, "Teckningar av Poussin i National-museum," *Nationalmusei Årsbok*, VI, 1924, p. 130; Id., *Nicolas Poussin, Dix-huit fac-similés en couleurs . . .* (Collection de dessins du Musée National II), Malmö, 1935, no. 5; W. Friedländer and A. Blunt, *The Drawings of Nicolas Poussin*, London, 1953, III, no. B 25, pl. 183; R. Häusler and J. E. Schuler, *Meisterzeichnungen von der Welt bewundert*, Stuttgart, 1962, no. 134.

EXHIBITIONS: London, Royal Academy, *French Art 1200–1900*, 1932, no. 696; Stockholm, 1933, no. 62; Paris, Gazette des Beaux-Arts, *Le Dessin français dans les collections du XVIIIe siècle*, 1935, no. 73; Paris, Palais National des Arts, *Chefs-d'oeuvre de l'art français*, 1937, no. 492; Brussels-Rotterdam-Paris, *Le Dessin français de Fouquet à Cézanne*, 1949–50, no. 30.

Inv. no. 2431/1863

CLAUDE LORRAIN
Chamagne 1600–Rome 1682

91. *Landscape with Three Figures*

Black chalk, pen and ink, brown wash. 21.4 × 26.6 cm. No watermark. The paper is fragile in many areas where the ink has worked through.
Verso: Landscape study. Black chalk, pen and ink. Inscribed *chartrain*.

It is known that Count Tessin bought one lot containing three Claude drawings at the Crozat sale. When the main part of his collection was sold to the king, he kept the Claudes, as well as his Poussin landscapes and most of his Rembrandt landscapes, at his country estate, Åkerö. It has hitherto been impossible to trace any of these Claude drawings.

This drawing was acquired as late as 1958, but nevertheless has a special interest for a Swedish collection as it can be traced in the inventory of the estate of Prince Livio Odescalchi in 1713–14, whose collection largely originated with Queen Christina of Sweden. This and seven more drawings earlier made up part of a volume, the remainder of which

was published as the *Album Wildenstein* by M. Röthlisberger in 1962.

This drawing is connected by Röthlisberger with *Liber Veritatis 34* from 1638–39.

PROVENANCE: Queen Christina of Sweden?; Cardinal Azzolino?; Odescalchi; H. M. Calmann.

BIBLIOGRAPHY: *Statens konstsamlingars tillväxt och förvaltning*, LXXXIII, 1958, p. 13; M. Röthlisberger, *Claude Lorrain. The Paintings*, New Haven, 1961, I, p. 163; P. Bjurström, "Claude Lorrains perspektiv," *Konsthistorisk tidskrift*, XXXI, 1962, pp. 71 ff.

EXHIBITIONS: Stockholm, 1958, no. 200; Stockholm, 1966, no. 1163.

Inv. no. 147/1958

CLAUDE MELLAN
Abbeville 1598–Paris 1688

92. *Henrietta Anne of England*

Lead point. 19 × 14.2 cm. Lined.
Numbered in pen and brown ink *2527* (Sparre).

Henrietta Anne of England was born in 1644, the very year her mother, Queen Henrietta Maria, had fled with her children to France to escape the civil war in England which eventually culminated in the execution of Charles I. In 1661, Henrietta Anne was married to the brother of Louis XIV, Philip of Orleans; she died less than a decade later, in 1670.

The portrait is interesting because of its lack of royal splendor; the tiny pearl necklace is Henrietta Anne's only ornament. Mellan depicts her as a child, not as an adult in miniature.

Wengström dates the drawing ca. 1657; Vallery-Radot, ca. 1649.

PROVENANCE: Crozat (Mariette, no. 1005 or 1006); C. G. Tessin (List 1739–41, p. 38, no. 28; Cat. 1749, livré 17, no. 233); Kongl. Biblioteket (Cat. 1790, no. 2527); Kongl. Museum (Lugt 1638).

BIBLIOGRAPHY: G. Wengström, "Claude Mellan. His Drawings and Engravings," *Print Collectors Quarterly*, I, 1924, pp. 10–43, no. 51; P. Lavallée, *Le Dessin français*, Paris, 1948, p. 40; J. Vallery-Radot, *Le Dessin français au XVIIe siècle*, Lausanne, 1953, p. 192, pl. 56.

EXHIBITIONS: Paris, Gazette des Beaux-Arts, *Le Dessin français dans les collections du XVIIIe siècle*, 1935, no. 66; Paris, Musée Carnavalet, *La Suède à Paris*, 1947, no. 367; Brussels-Rotterdam-Paris, *Le Dessin français de Fouquet à Cézanne*, 1949–50, no. 24; Vienna, Albertina, *Meisterwerke aus Frankreichs Museen*, 1950, no. 32; Leningrad, 1963.

Inv. no. 2632/1863

93. *Cardinal Richelieu*

Leadpoint. 12.7 × 9.3 cm. Lined. Small stains at bottom.
Numbered at lower right in pen and brown ink *2526* (Sparre).

The portrait depicts the Cardinal, worn by illness, just before his death in 1642.

Another study formerly in the E. G. Spencer Churchill collection (repr. in Vasari Society, X, 24) which is more closely connected with Mellan's engraving of the Cardinal (Montaiglon 320), was sold at auction at Sotheby's, November 1–4, 1920. There is a third variant in the Yale University Art Gallery.

PROVENANCE: Crozat (Mariette, no. 1005 or 1006); C. G. Tessin (List 1739–41, p. 37 v; Cat. 1749, livré 17, no. 227); Kongl. Biblioteket (Cat. 1790, no. 2526); Kongl. Museum (Lugt 1638).

BIBLIOGRAPHY: G. Wengström, "Claude Mellan. His Drawings and Engravings," *Print Collectors Quarterly*, I, 1924, pp. 10–43, no. 37; P. Lavallée, *Le Dessin français*, Paris, 1948, p. 40, pl. 18 A; J. Vallery-Radot, *Le Dessin français au XVIIe siècle*, Lausanne, 1953, p. 192, pl. 57.

EXHIBITIONS: London, Royal Academy, *French Art 1200–1900*, 1932, no. 679; Stockholm, 1933, no. 64; Paris, Gazette des Beaux-Arts, *Le Dessin français dans les collections du XVIIIe siècle*, 1935, no. 64; Paris, Palais National des Arts, *Chefs-d'oeuvre de l'art français*, 1937, no. 490; Paris, Musée Carnavalet, *La Suède et Paris*, 1947, no. 366; Paris, Musée de L'Orangerie, *Le Dessin français de Fouquet à Cézanne*, 1950, s.n.; Vienna, Albertina, *Meisterwerke aus Frankreichs Museen*, 1950, no. 33; Stockholm, 1958, no. 217.

Inv. no. 2631/1863

RAYMOND LA FAGE
Lisle d'Albigeois 1658–Lyon 1684

94. *The Triumph of Amphitrite*

Pen and brown ink, wash. 20 × 34.2 cm. Watermark: Dovecote.
Inscribed in pen and brown ink at bottom right *Cabinet de Crozat*. Numbered *2579* (Sparre) and *180* struck out (Crozat?).

The goddess is seen surrounded by Tritons and Nereids. In the sky are Saturn and Time.

PROVENANCE: Crozat (Mariette, no. 1046 or 1048); C. G. Tessin (List 1739–41, p. 43 v; Cat. 1749, livré 13, no. 180); Kongl. Biblioteket (Cat. 1790, no. 2579); Kongl. Museum (Lugt 1638).

BIBLIOGRAPHY: J. Arvengas, *Raymond la Fage, dessinateur*, Paris, 1965, pl. 24.

EXHIBITIONS: Toulouse, *Les Dessins de Raymond La Fage*, 1962, no. 79.

Inv. no. 2685/1863

ANTOINE COYPEL
Paris 1661–Paris 1722

95. *Satyr's Head*

Black, red and white chalk on brown paper. 25.8 × 22 cm. Lined.
Inscribed at lower right in pen and black ink *A. Coipel*. Numbered *2752* (Sparre).

The drawing was used for the painting *Ariadne and Bacchus* (engraved by G. Audran) and for *Cupid and Pan Playing the Flute* (engraved by J. Audran).

PROVENANCE: C. G. Tessin (acquired in 1728?; Cat. 1749, livré 17, no. 274); Kongl. Biblioteket (Cat. 1790, no. 2752); Kongl. Museum (Lugt 1638).

BIBLIOGRAPHY: Schönbrunner and Meder, no. 952; Cf. L. Dimier, *Les Peintres français du XVIIIe siècle*, Paris and Brussels, 1928, I, p. 133, no. 75.

EXHIBITIONS: Stockholm, 1922, no. 8; London, Royal Academy, *French Art 1200–1900*, 1932, no. 722; Paris, Gazette des Beaux-Arts, *Le Dessin français dans les collections du XVIIIe siècle*, 1935, no. 59; Paris, Palais National des Arts, *Chefs-d'oeuvre de l'art français*, 1937, no. 525.

Inv. no. 2857/1863

96. *Portrait of a Young Lady*

Black, white and red chalk on brown paper. 34.6 × 24.5 cm. Watermark: Grapes.
Inscribed in pen and black ink *A. Coipel*. (Tessin).

PROVENANCE: C. G. Tessin (acquired in 1728?; Cat. 1749, livré 17, no. 277); Kongl. Biblioteket (Cat. 1790, no. 2749); Kongl. Museum (Lugt 1638).

BIBLIOGRAPHY: Schönbrunner and Meder, no. 1032.

EXHIBITIONS: Stockholm, 1922, no. 7.

Inv. no. 2854/1863

FRANÇOIS DESPORTES
Champigneulles 1661–Paris 1743

97. *Still Life*

Black chalk, heightened with white on gray-brown paper. 25.2 × 23.6 cm. Lined.
Inscribed in pen and black ink *Desportes* (Tessin). Numbered at lower right in pen and brown ink *2675* (Sparre).

PROVENANCE: C. G. Tessin (acquired in 1728?; Cat. 1749, livré 20, no. 59); Kongl. Biblioteket (Cat. 1790, no. 2675); Kongl. Museum (Lugt 1638).

Inv. no. 2788/1863

JEAN-ANTOINE WATTEAU
Valenciennes 1684–Nogent sur Marne 1721

98. *Four Studies of a Young Woman's Head*

Black, white and red chalk on brownish gray paper. 34 × 24.5 cm. No watermark.

It has been thought that Watteau made this drawing about 1718–19, during the artist's last stay with Sirois and that it portrays Mlle Anne Elizabeth Sirois, Gersaint's sister-in-law, in different poses.

Parker and Mathey, however, do not accept this identification and compare the sheet with a drawing in the British Museum (Parker and Mathey 788), where the same woman is also depicted in four poses.

PROVENANCE: Crozat (Mariette, no. 1063 "Ce sont les Desseins que ce Peintre légua en mourant à M. Crozat, en reconnoissance de tous les bons offices qu'il en avoit reçûs); C. G. Tessin (List 1739–41, p. 38 v; Cat. 1749, livré 17, no. 264); Kongl. Biblioteket (Cat. 1790, no. 2722); Kongl. Museum (Lugt 1638).

BIBLIOGRAPHY: Schönbrunner and Meder, no. 1110; E. Dacier and A. Vuaflart, *Jean de Jullienne et les graveurs de Watteau au XVIIIe siècle*, Paris, 1922–29, I (*Notices et documents biographiques* by J. Herold and A. Vuaflart), p. 9; K. T. Parker, *The Drawings of Antoine Watteau*, 1931, p. 22; G. Engwall, "Les Dessins d'Antoine Watteau au Musée National de Stockholm," *Gazette des Beaux-Arts*, 6:XIII, 1935, pp. 336 ff., no. 29; K. T. Parker and J. Mathey, *Antoine Watteau, Catalogue complet de son oeuvre dessiné*, Paris, 1957, II, no. 787.

EXHIBITIONS: Stockholm, 1922, no. 17; Stockholm, 1933, no. 66; Paris, Gazette des Beaux-Arts, *Le Dessin français dans les collections du XVIIIe siècle*, 1935, no. 82; Copenhagen, Charlottenborg, *L'Art français du XVIIIe siècle*, 1935, no. 543; Paris, Musée Carnavalet, *La Suède et Paris*, 1947, no. 380; London, Arts Council, *French Drawings from Fouquet to Gauguin*, 1952, no. 173.

Inv. no. 2836/1863

99. *Philippe Poisson, the Actor, in the Role of Blaise in Dancourt's Comedy, "Les Trois Cousines"*

Red chalk. 12 × 7.5 cm. Lined.

Working drawing for an engraving by Desplaces in *Figures Françoises et Comiques* entitled *Poisson en habit de Paisan*. The first study, in larger scale and in the opposite direction, without the pedestal and the vase is in the British Museum (Parker and Mathey no. 910). *Les Trois Cousines* was performed in a revival in 1709.

PROVENANCE: C. G. Tessin (List 1739–41, no. 43; Cat. 1749, livré 14, no. 34), Kongl. Biblioteket (Cat. 1790, no. 2707 b); Kongl. Museum (Lugt 1638).

BIBLIOGRAPHY: E. Dacier and A. Vuaflart, *Jean de Jullienne et les graveurs de Watteau au XVIIIe siècle*, Paris, 1922–29, I, (*Notices et documents biographiques* by J. Herold and A. Vuaflart) p. 198, II, p. 72; G. Engwall, "Les dessins d'Antoine Watteau au Musée National de Stockholm," *Gazette des Beaux-Arts*, 6:XIII, 1935, pp. 336 ff., no. 11; K. T. Parker and J. Mathey, *Antoine Watteau, catalogue complet de son oeuvre dessiné*, Paris 1957, I, no. 172.

EXHIBITIONS: Stockholm, 1922, no. 18; Paris, Gazette des Beaux-Arts, *Le Dessin français dans les collections du XVIIIe siècle*, Paris 1935, no. 81; Copenhagen, Charlottenborg, *L'Art français au XVIIIe siècle*, 1935, no. 543; Leningrad, 1963.

Inv. no. 2821 b/1863

100. *The Crucifixion of St. Peter*

Black, white and red chalk on blue paper. 51 × 39.5 cm. Numbered in pen and brown ink *1772* (Sparre).

Since the time of Crozat and Tessin this drawing has been attributed alternatively to Rubens and Van Dyck. The attribution to Watteau was made in 1949 by Ludwig Burchard, who pointed out that the drawing is a copy after the Rubens drawing once owned by Crozat and now at Basel.

PROVENANCE: Crozat (Mariette, no. 821 "une premiere idée pleine d'esprit du Martyre de S. Pierre, dont on a rapporté ci-devant un Dessein terminé" /no. 818/); C. G. Tessin (Cat. 1749, livré 16, no. 82, as Van Dyck); Kongl. Biblioteket (Cat. 1790, no. 1772, as Van Dyck); Kongl. Museum (Lugt 1638).

BIBLIOGRAPHY: M. Rooses, *L'Œuvre de P. P. Rubens*, Antwerp, 1888, II, no. 344; K. T. Parker and J. Mathey, *Antoine Watteau*, Paris, 1957, I, no. 311; P. Bjurström, "Carl Gustaf Tessin as a Collector of Drawings," *Contributions to the History and Theory of Art, Acta Universitatis Upsaliensis, Figura*, N.S. VI, 1967, p. 115.

Inv. no. 1965/1863

JEAN-BAPTISTE OUDRY
Paris 1686–Beauvais 1755

101. *Fox*

Black and white chalk on blue-green paper. 29.6 × 36.9 cm. Lined.

The subject of this drawing supposedly appeared for the first time in another drawing, *Fox Guarding a Partridge*, now in the Staatliches Museum of Schwerin. A signed painting dated 1727 and cor-

responding closely to this latter drawing was sold at the Hôtel Drouot in 1936. When reproducing the fox in the Stockholm drawing, the artist omits its left foreleg—hidden by the partridge in the original drawing—and the partridge itself. There is an exact replica of the Schwerin drawing, signed and dated 1746, in the Fodor collection, Gemeente Museum, Amsterdam.

This sheet was not housed with the other drawings in Count Tessin's boxes but was kept framed along with eleven other drawings and painted studies by Oudry. Nine of the drawings, not including this one, were engraved by J. E. Rehn in Paris, 1739–41. Tessin later gave the Oudry group to the Swedish Crown Princess Lovisa Ulrica, who at her death in 1782 had on her walls ninety-seven framed drawings. In 1748, she had received twenty-one of them as a Christmas gift from Tessin, and all but one were from the Crozat collection. They were eventually acquired by Count Nils Barck who sold the whole collection to A.-N. Thibaudeau in the early 1850's. Only five Oudry sketches from the collection have found their way back to Sweden.

PROVENANCE: C. G. Tessin (List 1739–41); Lovisa Ulrica of Sweden; Fredric Adolph and Sophia Albertina; Count Gustaf Harald Stenbock; Count Magnus Stenbock; Count Nils Barck; Count A.-N. Thibaudeau (Sale April 20–25, 1857, Cat. by C. Le Blanc); G. A. Schuknecht.

BIBLIOGRAPHY: O. Antonsson, "Fem återfunna skisser av Oudry," *Nationalmusei Årsbok*, XI, 1929, pp. 81 ff.; H. N. Opperman, "Some Animal Drawings by Jean-Baptiste Oudry," *Master Drawings*, IV, 1966, pp. 392 ff., p. 405, note 37, no. 5.

Inv. no. 5/1866

NICOLAS LANCRET
Paris 1690–Paris 1743

102. *Studies of a Young Woman*

Black, white and red chalk on brownish paper. 28.7 × 33.3 cm. Vertical fold at center. Lined.
 Inscribed in pen and brown ink at lower right *lancret fecit*. Numbered *2505*, changed to *2724* (Sparre) and *27*, cut by the margin.

The different studies on this sheet have obviously been used by Lancret in different paintings. The two heads at right and left were probably used in *La Danse des bergers* in Berlin (Wildenstein, *Lancret*, no. 140). A certain resemblance to the seated lady

can be observed in *Danse devant la tente* (Wildenstein, *Lancret*, no. 151) and in *La Danse dans un parc* in the Wallace Collection, London (Wildenstein, *Lancret*, no. 138). The last mentioned painting is dated 1738.

PROVENANCE: C. G. Tessin (Acquired in 1728?; Cat. 1749, livré 27, no. 161); Kongl. Biblioteket (Cat. 1790, no. 2725); Kongl. Museum (Lugt 1638).

BIBLIOGRAPHY: Schönbrunner and Meder, no. 1116; G. Wildenstein, *Lancret*, Paris, 1924, p. 29 (as belonging to the Royal Library, Stockholm).

EXHIBITIONS: Stockholm, 1922, no. 34; London, Royal Academy, *French Art 1200–1900*, 1932, no. 765; Stockholm, 1933, no. 70; Paris, Palais National des Arts, *Chefs d'oeuvre de l'art français*, 1937, no. 554; Paris, Musée Carnavalet, *La Suède et Paris*, 1947, no. 381; London, Arts Council, *French Drawings from Fouquet to Gauguin*, 1952, no. 98; Stockholm, 1958, no. 218; Leningrad, 1963.

Inv. no. 2839/1863

JEAN-BAPTISTE SIMÉON CHARDIN
Paris 1699–Paris 1779

103. *The Sedan Chair*

Black chalk, heightened with white on brownish gray paper. 38.3 × 26.3 cm. No watermark. Gray stains at upper left.
 Inscribed in pen and brown ink at lower right *Chardin* (Tessin). Numbered *2854* (Sparre), *108* (Tessin), and in lead *2960* (Nationalmuseum).
 Verso: Fragment of nude male figure (not by Chardin) Black and white chalk.

Chardin's drawings are extremely rare and in addition to this one, only two other drawings, also in Stockholm, are generally accepted as his. They are all rather large, of the same size as his paintings, and this raises a question as to whether or not Chardin did not normally prepare his compositions directly on the canvas. The present drawing can be connected with Chardin's first known work, a sign for a surgeon, which is known only from an engraved illustration in the study of Chardin by the Goncourt brothers. Supposedly executed in the 1720's and traceable to the collection of the engraver Le Bas, the sign was acquired by a nephew of Chardin after the death of Le Bas in 1783; it then disappeared. Jules de Goncourt etched the illustration for *L'Art au dix-huitième siècle*, Paris, 1880–82, after a sketch of the sign once in the Hôtel de Ville but destroyed by fire in 1871.

Broad, resolute strokes are characteristic of Chardin's drawing style.

The genuineness of one of the Stockholm draw-ings by Chardin has recently been questioned (P. Hulton, in *Master Drawings*, VI, 1968, p. 163) on fairly loose grounds, however.

PROVENANCE: C. G. Tessin (List 1739–41, p. 69 v; Cat. 1749, livré 14, no. 106); Kongl. Biblioteket (Cat. 1790, no. 2854); Kongl. Museum (Lugt 1638).

BIBLIOGRAPHY: "Chardin et ses oeuvres à Potsdam et à Stockholm," *Gazette des Beaux-Arts*, 3:XXII, 1899, p. 390; Schönbrunner and Meder, no. 914; J. Guiffrey, *Catalogue de l'Oeuvre de Chardin*, Paris, 1908, no. 247; J. Mathey, "Jeurat, Cochin, Durameau et les dessins de Chardin," *Bulletin de la société de l'histoire de l'art français*, 1933, pp. 82 ff.; J. Robiquet, "Notice sur les 'brouettes,' 'roulettes,' ou 'vinaigrettes,'" *Nationalmusei Årsbok*, n.s. VIII, 1938, pp. 130 ff.; E. Gold-schmidt, *J. B. S. Chardin*, Stockholm, 1945, pp. 62 ff.; P. Lavallée, *Le Dessin français*, Paris, 1948, p. 73; D. Sutton, *French Drawings of the XVIIIth Century*, London, 1949, pl. XLIX; F. Boucher and P. Jaccottet, *Le Dessin français au XVIIIe siècle*, Lausanne, 1952, no. 44; J. Mathey, "Les des-sins de Chardin," *Albertina-Studien*, 1 and 2, 1964, pp. 17 ff.; A. Ananoff, "Chardin," *Connaissance des arts*, CLXXX, February, 1967, p. 61. Cf. also P. Hulton in *Master Drawings*, VI, 1968, p. 163 and P. Bjurström in *Master Drawings*, VII, 1969, no. 1.

EXHIBITIONS: Stockholm, 1922, no. 42; London, Royal Academy, *French Art 1200–1900*, 1932, no. 764; Stockholm, 1933, no. 73; Paris, Gazette des Beaux-Arts, *Le Dessin fran-çais dans les collections du XVIIIe siècle*, 1935, no. 56; Copen-hagen, *L'Art français du XVIIIe siècle*, 1935, no. 333; Paris, Palais National des Arts, *Chefs-d'oeuvre de l'art français*, 1937, no. 520; Paris, Musée de l'Orangerie, *Le Dessin français de Fouquet à Cézanne*, 1950, no. 77 bis; Vienna, Albertina, *Mei-sterwerke aus Frankreichs Museen*, 1950, no. 97; London, Arts Council, *French Drawings from Fouquet to Gauguin*, 1952, no. 18; Munich, Residenz, *Europäisches Rokoko*, 1958, no. 263; Leningrad, 1963.

Inv. no. 2960/1863

FRANÇOIS BOUCHER
Paris 1703–Paris 1770

104. *Cupid and Psyche*

Black chalk, heightened with white on bluish gray paper. 19.7 × 35.7 cm.
 Inscribed in pen and black ink at lower left *pour l'Hôtel Mazarin*, at lower right *Boucher* (both inscriptions by Tessin). Numbered *2842* (Sparre).

This drawing, as well as three other similar ones also in the Nationalmuseum, is a study for a *dessus de porte* supposedly for the Hôtel Mazarin, also called Hôtel de Brienne, which formerly existed on the Quai Malaquais at the site of the present École des Beaux-Arts. At least two of the four compo-sitions have been recorded in engravings by F. Basan.

PROVENANCE: C. G. Tessin (List 1739–41, p. 44 v; Cat. 1749, livré 14, no. 101); Kongl. Biblioteket (Cat. 1790, no. 2842); Kongl. Museum (Lugt 1638).

BIBLIOGRAPHY: A. Gauffin and R. Hoppe, *François Boucher*, Malmö, 1930, p. 10, no. 4; A. Ananoff, *L'Oeuvre dessiné de François Boucher*, Paris, 1966, I, no. 866.

EXHIBITIONS: Stockholm, 1922, no. 74; Paris, Gazette des Beaux-Arts, *Le Dessin français dans les collections du XVIIIe siècle*, 1935, no. 41; Leningrad, 1963.

Inv. no. 2848/1863

105. *Landscape with Women Bathing*

Red chalk, pen and black ink, gray wash, heightened with white. 29.1 × 36.8 cm. Lined.
 Signed at lower left in pen and black ink F BOUCHER *1734*.

PROVENANCE: C. G. Tessin (List 1739–41, p. 44 v; Cat. 1749, livré 14, no. 104); Kongl. Biblioteket (Cat. 1790, no. 2823); Kongl. Museum (Lugt 1638).

BIBLIOGRAPHY: Schönbrunner and Meder, no. 1241; A. Gauffin and R. Hoppe, *François Boucher*, Malmö, 1930, p. 11, no. 9; F. Boucher and P. Jaccottet, *Le Dessin français au XVIIIe siècle*, Lausanne, 1952, p. 51; A. Ananoff, *L'Oeuvre dessiné de François Boucher*, Paris, 1966, I, no. 521.

EXHIBITIONS: Stockholm, 1922, no. 69; Paris, Gazette des Beaux-Arts, *Le Dessin français dans les collections du XVIIIe siècle*, 1935, no. 43; London, *European Masters of the XVIIIth Century*, 1954–55, no. 423.

Inv. no. 2930/1863

106. *Young Lady Regarding her Ring*

Black, white and red chalk on brownish gray paper. 34.5 × 29.5 cm. Lined.
 Inscribed at lower right in black chalk *f. boucher*. Num-bered in pen and brown ink *2819* (Sparre) and *90* struck out.

PROVENANCE: C. G. Tessin (Cat. 1749, livré 14, no. 90); Kongl. Biblioteket (Cat. 1790, no. 2819); Kongl. Museum (Lugt 1638).

BIBLIOGRAPHY: A. Gauffin and R. Hoppe, *François Boucher*, Malmö, 1930, p. 14, no. 21; A. Schönberger and H. Soehner, *Die Welt des Rokoko*, Munich, 1959, pl. 248; A. Ananoff, *L'Oeuvre dessiné de François Boucher*, Paris, 1966, I, no. 209, fig. 36.

EXHIBITIONS: Stockholm, 1922, no. 61; Stockholm, 1933, no. 79; Paris, Gazette des Beaux-Arts, *Le Dessin français dans les collections du XVIIIe siècle*, 1935, no. 45; Copenhagen, Charlottenborg, *L'Art français au XVIIIe siècle*, 1935, no. 309; Munich, Residenz, *Europäisches Rokoko*, 1958, no. 253; Rome, Palazzo Venezia, *Il Disegno francese da Fouquet a Tou-louse-Lautrec*, 1959–60, no. 74.

Inv. no. 2926/1863

107. *Study of a Rooster*

Black, white and red chalk on brownish-gray paper. 17.2 × 20.2 cm. Lined.

The study was used for the painting *Le Repos des fermiers*, in the James de Rothschild collection. Agnes Mongan further points out that the rooster plays an even more dramatic role in the pastoral *La Fontaine*, which is known through an engraving by Pelletier. She further remarks on the obvious influence of drawings of similar subjects by d'Hondecoeter.

PROVENANCE: C. G. Tessin (List 1739–41, p. 69 v; Cat. 1749, livré 20, no. 76); Kongl. Biblioteket (Cat. 1790, no. 2846); Kongl. Museum (Lugt 1638).

BIBLIOGRAPHY: A. Gauffin, *Konstverk och människor*, Stockholm, 1915, p. 143; A. Gauffin and R. Hoppe, *François Boucher*, Malmö, 1930, p. 16, no. 33; F. Boucher and P. Jaccottet, *Le Dessin français au XVIIIe siècle*, Lausanne, 1952, no. 54; A. Schönberger and H. Soehner, *Die Welt des Rokoko*, Munich, 1959, pl. 258; A. Mongan in *Great Drawings of All Time*, (Ira Moscowitz ed.), New York, 1962, III, French, no. 645; J. Vallery-Radot, *Drawings of the Masters: French Drawings from the 15th Century through Géricault*, New York, 1964, pl. 49; A. Ananoff, *L'Oeuvre dessiné de François Boucher*, Paris, 1966, I, no. 618, fig. 108.

EXHIBITIONS: Stockholm, 1922, no. 77; Paris, Charpentier, *François Boucher*, 1932, no. 58; Stockholm, 1933, no. 78; Paris, Musée Carnavalet, *La Suède et Paris*, 1947, no. 384; London, *European Masters of the XVIIIth Century*, 1954–55, no. 426; Munich, Residenz, *Europäisches Rokoko*, 1958, no. 254.

Inv. no. 2952/1863

JÉRÔME-FRANÇOIS CHANTEREAU
ca. 1710–Paris 1757

108. *Soldiers and Boys Playing Dice*

Black, white and red chalk on brown paper. 23.2 × 37.7 cm. Lined.
Inscribed in pen and brown ink at lower right *Chantreau* (Tessin). Numbered *2692* (Sparre) and *111*.

The drawings left by Chantereau seem to be concentrated in two places: there are four in the Louvre and nine in the Nationalmuseum. Little is known about him but his manner of drawing seems to be influenced by Chardin and Watteau. His subjects are taken mostly from the life of peasants and soldiers.

PROVENANCE: C. G. Tessin (List 1739–41, p. 68 r; Cat. 1749, livré 14, no. 111); Kongl. Biblioteket (Cat. 1790, no. 2692); Kongl. Museum (Lugt 1638).

BIBLIOGRAPHY: Schönbrunner and Meder, no. 1145; A. Ananoff, "Les cent 'petits maîtres' qu'il faut connaître," *Connaissance des arts*, June, 1964, p. 65.

EXHIBITIONS: Stockholm, 1922, no. 45; London, Royal Academy, *French Art 1200–1900*, 1932, no. 786; Paris, Gazette des Beaux-Arts, *Le Dessin français dans les collections du XVIIIe siècle*, no. 54.

Inv. no. 2806/1863

GABRIEL DE SAINT-AUBIN
Paris 1724–Paris 1780

109. *The Kitchen of the Hôtel des Invalides*

Black chalk, black ink and touches of bodycolor. 18.3 × 12.2 cm.
Inscribed in black ink *Pain, 300; viande 100; canons enclués pour Colonnes, afuts pour tables, mortiers pour marmites. Cuisines de Mars.* Signed in lead and black ink *G. de Saint-Aubin f 1779. Pour M. le baron d'Espagnac, père des soldats.*

In the Hôtel des Invalides there were many kitchens, and there are similarities between this drawing and the kitchen of the soldiers as well as the kitchen of the officers, but the imagination of the artist has obviously been very active.

Baron d'Espagnac was governor of the Hôtel from 1766 until his death in 1783 and became so popular that he used to be characterized as "father of the soldiers" as in the dedication on this drawing.

PROVENANCE: W. Wohlfart; F. W. Wohlfart.

BIBLIOGRAPHY: A. Gauffin, "Gabriel de Saint-Aubin i Nationalmuseum," *Konsthistoriska sällskapets publikation*, 1915, pp. 23–33; Id., *Konstverk och människor*, Stockholm, 1915, pp. 148 ff.; Id., "Gabriel de Saint-Aubin au Musée National de Stockholm," *Gazette des Beaux-Arts*, 6:III, 1930, pp. 47 ff.; E. Dacier, *Gabriel de Saint-Aubin*, Paris, 1931, II, no. 434.

EXHIBITIONS: Stockholm, 1922, no. 94; London, Royal Academy, *French Art 1200–1900*, 1932, no. 830; Stockholm, 1933, no. 82; Paris, Palais National des Arts, *Chefs-d'oeuvre de l'art français*, 1937, no. 578; Paris, Musée Carnavalet, *La Suède et Paris*, 1947, no. 573; Stockholm, 1958, no. 234; Leningrad, 1963.

Inv. no. 398/1891

SWEDISH

CARL GUSTAF PILO
Nyköping 1711–Stockholm 1793

Pilo received his first education in the arts at the Royal Academy of Art in Stockholm. In 1740, he moved to Denmark where he became court painter, and remained until 1772. After returning to Sweden he executed his masterpiece, the *Coronation of Gustavus III*. He worked on the painting between 1782 and 1793, but never finished it. He ranks as Sweden's greatest painter of the eighteenth century. His use of color reminds one of that of Rembrandt and contemporary Venetian artists.

110. *H. V. Peil at the Funeral of Mrs. A. J. Grill*

Point of the brush and black ink. 34.6 × 27.8 cm. No watermark.

Inv. no. 605/1927

111. *Landscape with Nine Men Making Merry*

Point of the brush and black ink. 25.5 × 33.7 cm. No watermark.

PROVENANCE: Lewenhaupt.

Inv. no. 9/1869

ELIAS MARTIN
Stockholm 1739–Stockholm 1818

Elias Martin was first apprenticed to his father, a master carpenter, but later transferred his vocational allegiance to an obscure "guild painter," Friedrich Karl Schultz, under whom he learnt the rudiments of his future profession. In 1763, Martin found his first independent employment at Sveaborg, outside Helsinki, where he taught drawing to young naval officers. The years 1766–68 he spent in France, studying at the École des Beaux-Arts. In 1768, Martin left France and established himself in London where he remained until 1780. From this time on, various English influences can be traced in Martin's style. After he returned to Sweden he traveled through the country, drawing and painting manors, ironworks and landscapes. In 1788, he returned to England, this time for three years, joining the fashionable world in Bath. Back in Sweden he once again directed his keen sense of observation to the study of the landscape, also manifesting an intense interest in atmospheric phenomena. In his last period he also turned to religious painting.

BIBLIOGRAPHY: R. Hoppe, *Elias Martin*, Stockholm, 1933 (cited Hoppe); R. Hoppe and G. Jungmarker, *Akvareller och teckningar av Elias Martin i Nationalmuseum* (Ur Nationalmusei handteckningssamling III), Malmö, 1943 (cited Hoppe and Jungmarker); N. Lindhagen, "Elias Martin," *Svenska Mästartecknare, Sergel/Martin/Ehrensvärd* (G. Jungmarker, ed.), Stockholm, 1955 (cited Lindhagen).

112. *Portrait of a Young Lady in a Black Hat*

Point of the brush, wash and black ink, watercolors. 29 × 21.7 cm. Watermark: I Whatman (?) fragmentary.

The drawing supposedly was executed in England and shows a striking resemblance to engravings executed during Martin's first English stay, 1768–80.

PROVENANCE: E. Cederström.

BIBLIOGRAPHY: Hoppe, p. 197; Hoppe and Jungmarker, I.

EXHIBITIONS: Stockholm, *Elias Martin*, 1950, no. 181.

Inv. no. 317/1884

113. *Three Carpenters at their Bench*

Pen and brown ink, wash, watercolors. 10.3 × 15 cm. No watermark.

As a delineator of craftsmen and workers, Martin occupies a unique position in his time for he works with a social consciousness. He depicted his models without ridicule or caricature, and his drawings are more likely to be characterized as precursors of the *reportage* drawings of modern times.

PROVENANCE: E. Cederström.

BIBLIOGRAPHY: Hoppe, p. 233; Hoppe and Jungmarker, VII; Lindhagen, pl. 26.

EXHIBITIONS: Stockholm, *Elias Martin*, 1950, no. 571.

Inv. no. 217/1884

114. *Johan Fredrik Martin and his Wife out for a Walk in Windy Weather*

Pen and gray ink, gray wash. 20.2 × 16.5 cm. Watermark: Coat of arms with fleur-de-lis and C R.

Johan Fredrik (1755–1816) was Elias Martin's brother, sixteen years his junior and a hunchback. Elias took him to England in 1770, where he trained as an engraver under Bartolozzi and Woollett. He engraved many of his brother's compositions. On his return to Sweden he established himself as a teacher, became a member of the Academy of Art in 1796 and a professor in 1815.

BIBLIOGRAPHY: Hoppe, p. 79; Lindhagen, pl. 19.

EXHIBITIONS: Stockholm, *Elias Martin*, 1950, no. 434; London, *Elias Martin*, 1963, no. 96.

Inv. no. 207/1918

115. *View of Tyresö Church and Manor from the West*

Leadpencil, wash and watercolors. 33.3 × 47.8 cm. No watermark.

This drawing of Tyresö outside Stockholm conveys an impression of the rather rough landscape that surrounded the manors of the Swedish countryside at the end of the eighteenth century.

PROVENANCE: E. Cederström.

BIBLIOGRAPHY: Hoppe, p. 72; Lindhagen, pl. 25.

EXHIBITIONS: Stockholm, *Elias Martin*, 1950, no. 639.

Inv. no. 407/1884

116. *Autumn at Haga*

Leadpencil, watercolor. 24.9 × 40 cm. Watermark: Coat-of-arms with fleur-de-lis and C & I Honig.

Haga, on the northern outskirts of Stockholm, is the English park laid out by Gustavus III in the 1780's with a pavilion in neo-classic style designed for him by Olof Tempelman. This pavilion, which has been preserved in its original form, is shown on the right in the present drawing.

PROVENANCE: E. Cederström.

BIBLIOGRAPHY: Hoppe and Jungmarker, IX.

EXHIBITIONS: Stockholm, *Elias Martin*, 1950, no. 636; London, *Elias Martin*, 1963, no. 117.

Inv. no. 397/1884

117. *Salmon Fishing at Älvkarleby*

Leadpencil, watercolor. 23.3 × 39.2 cm. Watermark: Coat-of-arms with fleur-de-lis and C & I Honig.
 Inscribed to the left in leadpencil and gray ink *Elfkarby Laxfiske*; to the right in gray ink *E Martin*.

On his journeys around the mining district north of Stockholm, Martin divided his time between the life of the manor houses and the ironworks on the one hand, and the countryside itself on the other. His inclusion of a self-portrait on the right of the group of figures in this drawing is characteristic.

EXHIBITIONS: Stockholm, *Elias Martin*, 1950, no. 672; London, *Elias Martin*, 1963, no. 125.

Inv. no. 9/1922

JOHAN TOBIAS SERGEL
Stockholm 1740–Stockholm 1814

In so far as Johan Tobias Sergel is known outside Sweden at all, he is known as a sculptor. His talent first showed itself in Rome, where he went in 1767 at the age of twenty-seven, and his work reflects the tendency of the time to turn to the classics for inspiration. Another side to Sergel's art is his occasional drawings, mostly caricatures or scenes illustrating indiscreet incidents from daily life. Caricaturing was a favourite amusement among Sergel's circle of friends in Rome, and we find affinities to his style in the works of Johann Heinrich Füssli, Nicolai Abildgaard and François-André Vincent.

 On his return to Sweden in 1779, Sergel was completely absorbed by his new *milieu*. He had op-

portunities of contact with the court and the middle classes, artistic and theatrical circles, and noted his impressions of these various *milieux* with equal disillusioned realism.

BIBLIOGRAPHY: G. Göthe, *Johan Tobias Sergel*, Stockholm, 1898 (henceforth cited as Göthe); J. Kruse, *Sergel. Teckningar i Nationalmuseum utgifna af Föreningen för grafisk konst*, Stockholm, 1910–12 (cited Kruse); L. Looström, *Johan Tobias Sergel*, Stockholm, 1914 (cited Looström); H. Brising, *Sergels konst*, Stockholm, 1914 (cited Brising); O. Antonsson, *Sergels ungdom och romtid*, Stockholm, 1942 (cited Antonsson); O. Antonsson and G. Jungmarker, *Teckningar av Johan Tobias Sergel i Nationalmuseum* (Ur Nationalmusei handteckningssamling IV), Malmö, 1945 (cited Antonsson and Jungmarker); P. Bjurström, "Johan Tobias Sergel," *Svenska Mästartecknare, Sergel/Martin/Ehrensvärd*, G. Jungmarker, ed., Stockholm, 1955 (cited Bjurström); R. Josephson, *Sergels fantasi*, I–II, Stockholm, 1956 (cited Josephson).

118. *A Fountain Project*

Red chalk, pen and brown ink, gray and brown wash. 56.5 × 42.5 cm. Watermark: Fleur-de-lis in circle. Horizontal fold.

This drawing represents Sergel's manner of drawing before his Italian journey when he was still dependent on the style of his teacher, the French sculptor Pierre-Hubert Larchevesque (1721–78), active in Stockholm from 1756. The drawing was executed either in Stockholm or in Paris where Sergel accompanied his teacher in 1758.

BIBLIOGRAPHY: Bjurström, p. 25; cf. Josephson, pp. 23 ff.

Inv. no. 22/1891

119. *Hero (Achilles?) and Woman Lamenting*

Black chalk, pen and brown ink. 24.5 × 26.4 cm. Watermark: Coat of arms with heart and cross.
Verso: The head of the man repeated.

Sergel treated this and similar subjects in a large number of drawings made in Rome during the years 1775–76. He never executed any related sculpture.

PROVENANCE: J. T. Sergel and his heirs.

BIBLIOGRAPHY: Kruse, VI, 5; Brising, pp. 75–76; Antonsson, p. 193; Antonsson and Jungmarker, XXVI; Bjurström, pl. 2; Josephson, I, p. 231.

Inv. no. 903/1875

120. *Portrait of François-André Vincent*

Pen and brown ink. 18 × 16.3 cm. No watermark.
Inscribed in pen and brown ink *Vincen*. Numbered *41*.

The French painter Vincent (1746–1816) belonged to Sergel's circle in Rome where he resided from 1771 to 1776 as a pensioner at the French Academy. Sergel brought home some drawings by Vincent now in the Nationalmuseum. Sergel portrays his friend in a caricature-like style which is rather close to Vincent's corresponding caricatures of his associates at the French Academy. This drawing was executed ca. 1773.

BIBLIOGRAPHY: Antonsson, p. 219; Antonsson and Jungmarker, XVI; Bjurström, pl. 15.

Inv. no. s.n.

121. *A Pair of Lovers*

Pen and brown ink, wash. 21 × 17.7 cm. Watermark: Letters. Supposedly executed in Rome ca. 1775.

BIBLIOGRAPHY: Antonsson and Jungmarker, IV; Bjurström, pl. 4.

Inv. no. s.n.

122. *Portrait of Johann Heinrich Füssli*

Black chalk, pen and brown ink, brown and gray wash. 23.4 × 19.4 cm. No watermark.
Inscribed in pen and brown ink *fuseli*.

The Swiss painter Füssli (1741–1825) was one of Sergel's closest friends in Rome. Here he is depicted in front of St. Peter's, chased by witches partly hidden in the clouds and spitting fire at him. Sergel not only portrayed his friend in caricature drawings, but ca. 1776 he also made a bust of him (Nationalmuseum). This drawing was executed perhaps a year or two earlier than the bust when Sergel was still critical of the *Sturm und Drang* of his friend.

BIBLIOGRAPHY: Antonsson and Jungmarker, XIV; Bjurström, pl. 10; Josephson, I, p. 235.

Inv. no. s.n.

123. *Sergel on Crutches in Rome*

Black chalk, pen and brown ink, wash. 37.2 × 25 cm. Watermark: Grapes.
Inscribed in pen and brown ink at upper right *Sergell i Rom går med k*.
Verso: Standing man seen from behind.

The drawing supposedly dates from the time of Sergel's depression in 1777. Sergel fell ill in January that year and his mental state paved the way to attacks of gout.

PROVENANCE: J. T. Sergel and heirs.

BIBLIOGRAPHY: Looström, p. 17; Antonsson, p. 227; Antonsson and Jungmarker, I; Bjurström, pl. 13; Josephson, I, p. 221.

Inv. no. 584/1875

124. *The Meditator*

Black chalk, pen and brown and black ink. 22.4 × 21.8 cm. Watermark: Fleur-de-lis in a circle.

Towards the middle of the 1770's, Sergel seems to have studied Michelangelo's Sistine ceiling closely, and the present drawing is one of his most personal interpretations of this experience. It is also possible that the drawing gives expression to his emotional state during a depression in January, 1777.

PROVENANCE: J. T. Sergel and his heirs.

BIBLIOGRAPHY: Antonsson, p. 229; Antonsson and Jungmarker, V; Josephson, I, p. 248.

EXHIBITIONS: London, *The Romantic Movement*, 1959, no. 852.

Inv. no. 871/1875

125. *Sergel Visiting Elias Martin in London, 1779*

Pen and brown ink, brown and gray wash. 20.1 × 25 cm. Watermark: Pro patria.
Inscribed in pen and brown ink *Elias Martin London 1779.*

When Sergel was summoned home in 1778, he prolonged his stay on the Continent as long as possible. During the winter of 1778–79 he stayed in Paris, and then in the spring paid a visit to his old friend the painter Elias Martin in London before returning to Sweden in the summer of 1779. In this drawing Sergel depicted himself being received by Martin in his combined shop and studio where Martin's wife turns over the drawings on the stand and a little child plays on the floor.

PROVENANCE: J. T. Sergel and heirs.

BIBLIOGRAPHY: Göthe, p. 128; Kruse, IV, 3; Looström, p. 45; Antonsson and Jungmarker, VIII; Bjurström, pl. 13.

Inv. no. 625/1875

126. *Portrait of the Admiral Count Carl August Ehrensvärd*

Pen and brown ink. Gray and brown wash. 19.4 × 15.7 cm. No watermark.
Inscribed on the old mount *amiral Gref A. Ehrensvärd.*

Ehrensvärd was one of Sergel's closest friends between the years 1780 and 1800 when Ehrensvärd died. The two seem to have had the same opinions about most problems except one: Sergel was one of the greatest admirers of the king; Ehrensvärd tested de him. Sergel here represents his friend in front of a northern landscape with spruces to the left, an Italian landscape with classical and Renaissance remains on the right.

BIBLIOGRAPHY: Looström, p. 24; Antonsson and Jungmarker, IX; Bjurström, pl. 21.

Inv. no. s.n.

127. *A Boisterous Dinner*

Pen and brown ink, brown and gray wash. 21 × 33.7 cm. No watermark.
Inscribed in pen and brown ink at lower right *en stående middag* and in lead pencil *Madame de . . . Schön . . . Fru Möller Sergell.*

Sergel depicts himself, to the right, with a number of empty bottles behind him, as the liberal host to a party of Swedish friends. The drawing is supposedly from the 1780's.

PROVENANCE: J. T. Sergel and heirs.

BIBLIOGRAPHY: Bjurström, pl. 16.

Inv. no. 610/1875

128. *King Gustavus III Walking in Procession*

Black chalk. Pen and brown ink. 23.2 × 16 cm. No watermark.
Inscribed in pen and brown ink at bottom left *Gustaf III.*

Sergel was a great admirer of the king and portrayed him on various occasions. His most penetrating and personal portraits are the group of profiles he drew in Florence in 1783 when he was acting as a guide during the king's Italian journey. This drawing is reminiscent of these profiles although it must have been executed on a solemn occasion in Sweden when the king was wearing his full regalia.

PROVENANCE: J. T. Sergel and heirs.

BIBLIOGRAPHY: Kruse, II, 3; Looström, p. 34.

Inv. no. 749/1875

129. *King Gustavus III and his Suite Ascending Mount Vesuvius, 1784*

Pen and brown ink, brown wash. 24.7 × 39.2 cm. Watermark: J. Kool and coat-of-arms with fleur-de-lis.
Inscribed in pen and brown ink *Sergell f. Naples ce 21 fevrier 1784.*

In 1783–84, Gustavus III traveled *incognito* in Italy as the "Count of Haga." Here he is shown halting

for a rest during the ascent of Vesuvius; at the right, people from his suite prepare food.

PROVENANCE: J. T. Sergel and his heirs.

BIBLIOGRAPHY: Kruse, VIII, 1; Bjurström, pl. 19.

Inv. no. 749/1875

130. *Painful Dream*

Pen and brown ink, gray and brown wash. 20.4 × 33.2 cm. No watermark.
Inscribed at lower right in pen and brown ink *3. Plågsam dröm 1795. Sergell*. Numbered at upper right *5377* (Hammer).

In 1792, King Gustavus III was murdered, and thereafter the spiritual climate of the country became oppressive. Sergel did not receive any more important commissions, and his physical suffering from the gout and his inactivity combined to produce a depression during the winter of 1794–95. He depicted the experiences of his depressed state in one series of eight drawings (five of which have been preserved) and another series of thirtheen, made after his recovery and in part repeating the previous drawings. This is the third drawing in the second set wherein Sergel depicts himself as an idealized youth surrounded by horrible visions of snakes and skulls.

PROVENANCE: Christian Hammer.

BIBLIOGRAPHY: Antonsson and Jungmarker, XVIII; Josephson, II, p. 473.

Inv. no. 106/1906

131. *Drinking Water*

Pen and brown ink, gray and brown wash. 19.8 × 33.3 cm. Watermark: Bolltorps bruk and three crowns.
Inscribed at lower left in pen and brown ink *10 Dricker Watn. 1795*. Numbered at upper right *5326* (Hammer).

One of the last drawings from the same set as No. 130, this drawing symbolizes the artist's recovery.

PROVENANCE: Christian Hammer.

BIBLIOGRAPHY: Antonsson and Jungmarker, XIX; Bjurström, pl. 27; Josephson, II, p. 477.

Inv. no. 113/1906

132 *The Old Sergel Meeting the Crown Prince Karl Johan*

Black chalk, pen and brown ink, brown wash. 21.3 × 31.2 cm. Watermark: Coat of arms with hive and I H (Honig).
Inscribed at upper right in pen and brown ink *26 9bre 1810*.

The French Field Marshal Jean-Baptiste Bernadotte was elected Swedish crown prince in August,

1810. He arrived in Stockholm on November 2 and changed his name to Karl Johan. Less than a month later he paid a visit to the great sculptor. Sergel has represented the meeting as an historical event using a compositional scheme of contemporary classicistic painters.

BIBLIOGRAPHY: Josephson, II, pl. 619.

Inv. no. s.n.

CARL AUGUST EHRENSVÄRD
Stockholm 1745–Örebro 1800

Carl August Ehrensvärd received his first art training from Elias Martin during the years 1763–65. Martin was employed by his father, the Admiral Augustin Ehrensvärd, to teach drawing to the officers at the Sveaborg fortress outside Helsinki. In 1766, Ehrensvärd traveled through Holland and France to study military establishments and he used the time as well to improve his skill in drawing. Works produced during this journey show a special interest in atmospheric effects. After returning home Ehrensvärd won promotion in his military career, and in 1784 he became an admiral.

Another period of importance for his artistic development was his journey to Italy in 1780–82. From then on, he became one of the most important classicists in Sweden. He spent his time in museums studying archaeological finds, he penetrated the theories of the importance of climate and after his return wrote an account of his travels and a philosophy of the liberal arts. Ehrensvärd's imagination was, however, quite independent of these theories and managed to give form to his ideas, which are frequently difficult to interpret without a thorough knowledge of the contemporary thought. Ehrensvärd was a very close friend of Sergel and the admiral and the sculptor influenced each other in artistic matters.

BIBLIOGRAPHY: G. Jungmarker, "Carl August Ehrensvärd," *Svenska Mästartecknare, Sergel/Martin/Ehrensvärd*, G. Jungmarker, ed., Stockholm, 1955 (cited Jungmarker); R. Josephson, *Carl August Ehrensvärd*, Stockholm, 1963 (cited Josephson).

133. *The Concordia Temple, Agrigentum*

Pen and gray ink, watercolors. 18.4 × 31 cm. Watermark: Pro patria.
Inscribed in pen and gray ink at lower left *Concordia Templet* and to the right *agrigenta*.

During his Italian journey of 1780–82, Ehrensvärd traveled all the way to Sicily, which he visited in March and April of 1781. Like Goethe six years later, Ehrensvärd regarded the Doric temples at Agrigentum as the perfect exemplar of the "truly beautiful."

PROVENANCE: Kongl. Biblioteket.

BIBLIOGRAPHY: Jungmarker, pl. 10; Josephson, p. 57.

Inv. no. 169/1866

134. *Scania Landscape with Ploughmen*

Pen and gray ink, watercolors. 20 × 32.4 cm. Watermark: I.B.Davies.

In the summer of 1795, Ehrensvärd traveled through Scania, Sweden's most southerly province for the purpose of study. He found a certain kinship between this rich part of the country and his beloved classical ideal, Italy, and he idealized the landscape in his drawings.

PROVENANCE: Kongl. Biblioteket.

BIBLIOGRAPHY: Jungmarker, pl. 20; Josephson, p. 296 ff.

EXHIBITIONS: London, *The Romantic Movement*, 1959, no. 676.

Inv. no. 164/1866

135. *From the "Story of the Poet": The Real Birth of the Poet*

Pen and brown ink. 33.2 × 21 cm.
Inscribed in pen and brown ink at upper left *17 Graden Poetens rätta Födelse* and at lower right *Ehrensvärd 1795.* Numbered at upper right *4334* (Hammer).

The *Story of the Poet* was originally a set of sixty-six drawings of which sixty-three have been preserved in the Nationalmuseum. The series was created in homage to Ehrensvärd's friend, the poet Johan Gabriel Oxenstierna, who is symbolized as a bird; the drawing reflects the dialogue on poetry and philosophy that was carried on between the two friends. The set was divided into "grades" according to the system of the secret orders of Masonry and dealt with the different characteristics and qualities of the poet. In this drawing the poet is represented leaving the body of nature which, together with classical antiquity, was the source of his inspiration.

PROVENANCE: Christian Hammer.

BIBLIOGRAPHY: Jungmarker, pl. 31; H. Frykenstedt, *Carl August Ehrensvärd och Johan Gabriel Oxenstierna—Konstellation i Vänskapens och Poesiens tecken* (to appear).

Inv. no. 263/1906

136. *From the "Story of the Poet": The Poet Learns the Constellations*

Pen and brown ink. Brown wash. 31.3 × 19.7 cm.
Inscribed in pen and brown ink at upper left *23de Graden in Duplo*, at lower left *Lär sig Constellationerna*, and at lower right *Ehrensvärd 1795.* Numbered at upper right *4308* (Hammer).

Cf. No. 135.

PROVENANCE: Christian Hammer.

BIBLIOGRAPHY: Jungmarker, pl. 28; H. Frykenstedt, *Carl August Ehrensvärd och Johan Gabriel Oxenstierna—Konstellation i Vänskapens och Poesiens tecken* (to appear).

Inv. no. 273/1906

137. *A Stormy Sea*

Pen and brown and gray ink, watercolors. 21.6 × 34.3 cm. Watermark: Letters. Stains all over the sky.
Inscribed in pen and brown ink at lower left *Ehrensvärd Dömmestorp d. 20 Nov. 1796.*

PROVENANCE: Kongl. Biblioteket.

BIBLIOGRAPHY: Jungmarker, pl. 24.

EXHIBITIONS: London, *The Romantic Movement*, 1959, no. 677.

Inv. no. 283/1882

138. *"My Friend Shall Drink and Be Voluptuously Drowned"*

Pen and black ink, watercolors. 15.3 × 21.2 cm. No watermark.
Inscribed at bottom in pen and black ink *Min Vän Skall Dricka och Dränkas i Wällust* and in gray ink at the right *Ehrensvärd 1797.*

Ehrensvärd's imagination was frequently extremely eccentric and the parallels to surrealism are obvious. From 1783 onward, Ehrensvärd was a Freemason, and although he was critical of the mysticism of his fellow members in the order, he showed a vivid interest in the interpretation of dreams in the early 1790's.

PROVENANCE: Eichorn.

BIBLIOGRAPHY: Jungmarker, p. 129.

Inv. no. 163/1891

PLATES

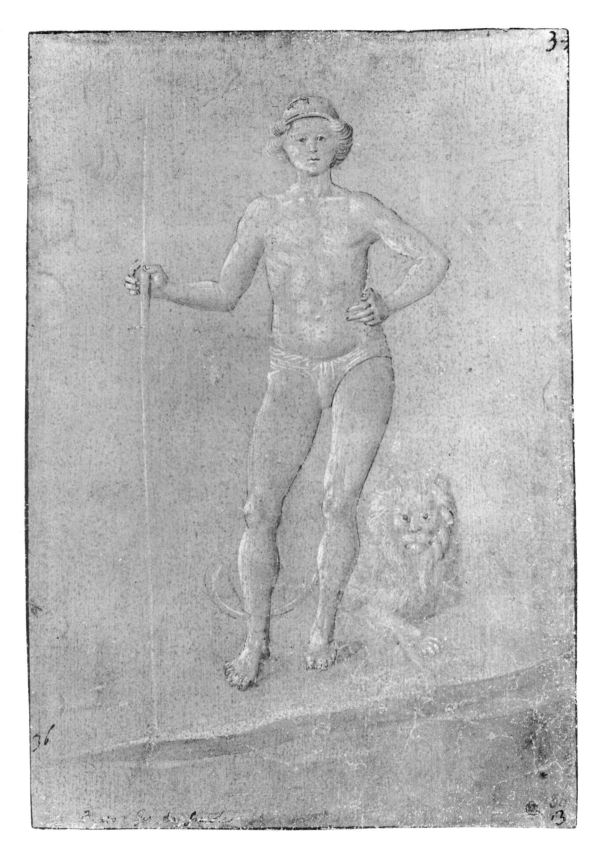

1. BENOZZO GOZZOLI *Nude Young Man Holding a Staff, a Lion at his Feet*

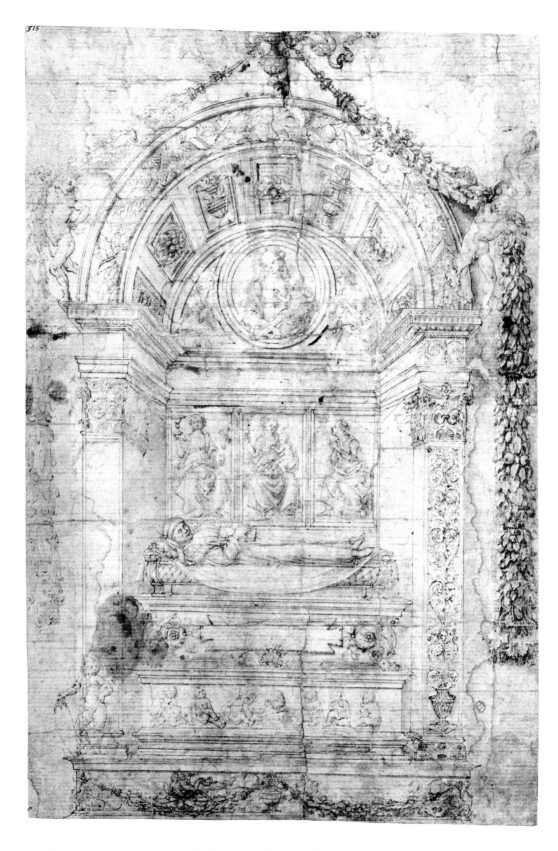

2. FRANCESCO DI SIMONE *The Tomb of Alessandro Tartagni*

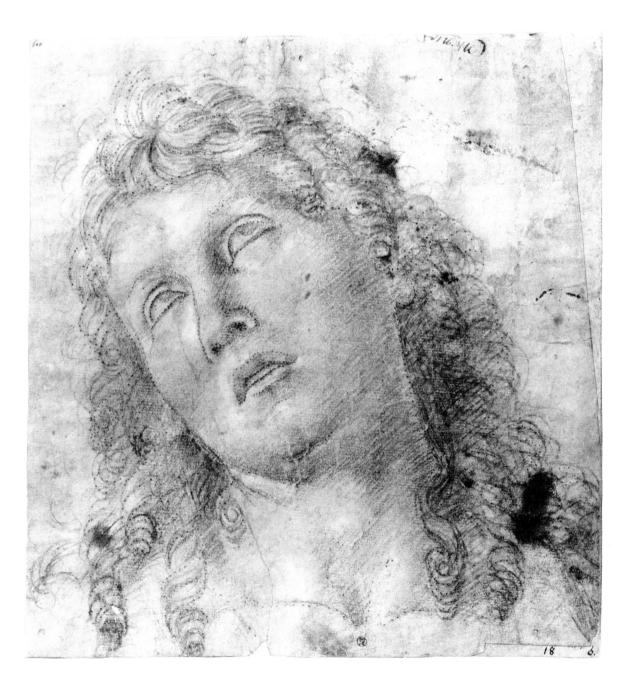

3. LUCA SIGNORELLI *Head of a Youth*

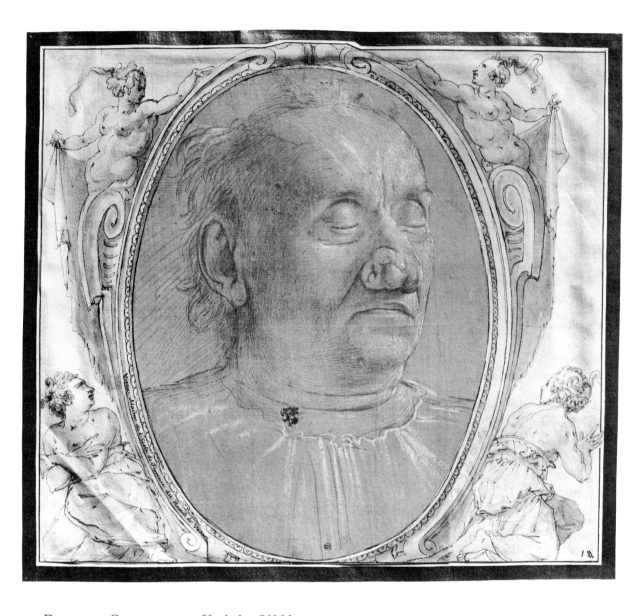

4. Domenico Ghirlandaio *Head of an Old Man*

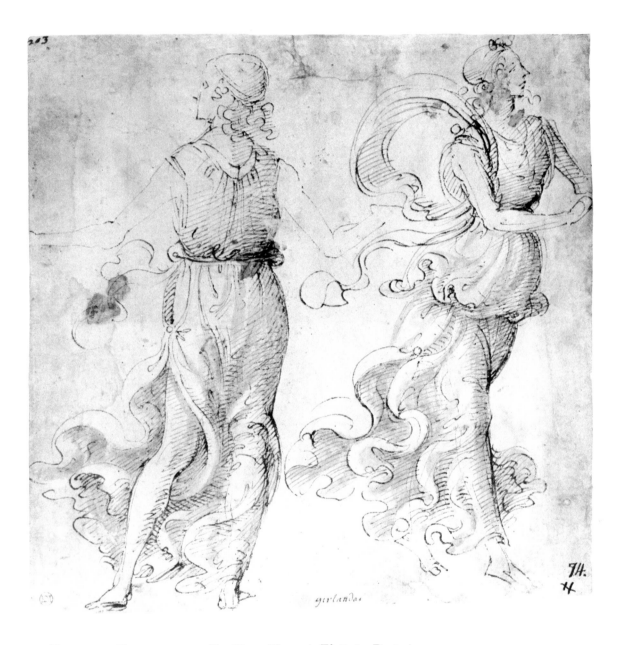

5. DOMENICO GHIRLANDAIO *Two Young Women in Fluttering Draperies*

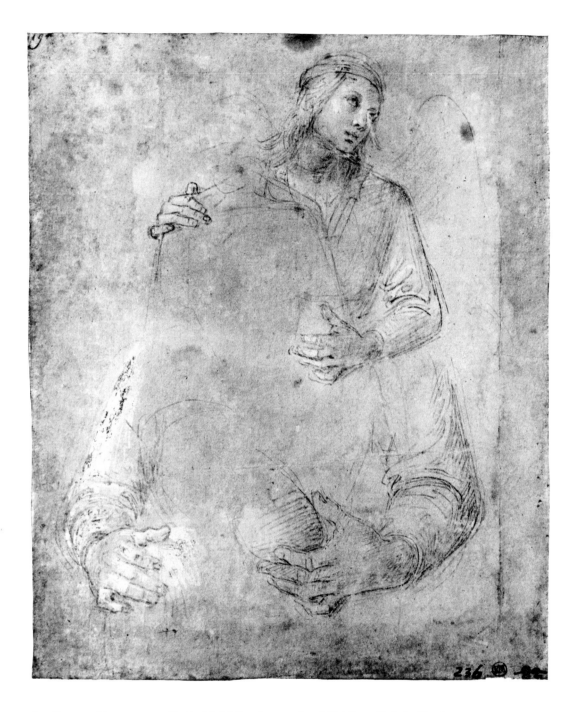

6. PIETRO PERUGINO *Studio Model Posed as an Angel Holding a Body in his Arms*

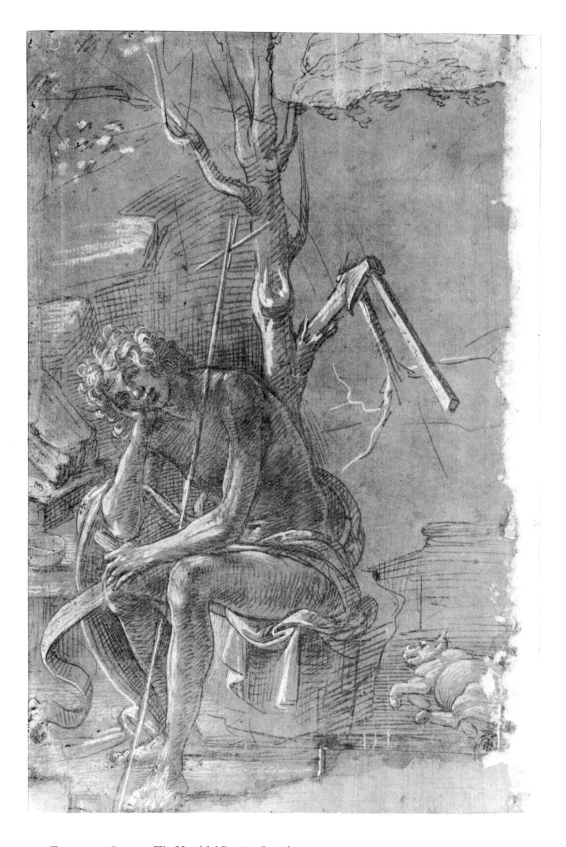

7. FILIPPINO LIPPI *The Youthful Baptist Seated*

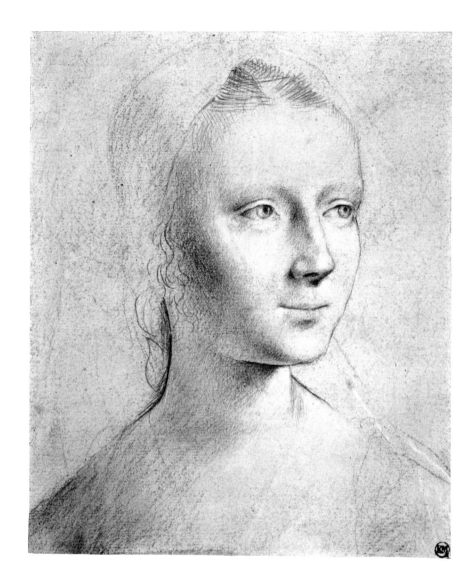

8. UNKNOWN LOMBARD ARTIST *Portrait of a Young Girl*

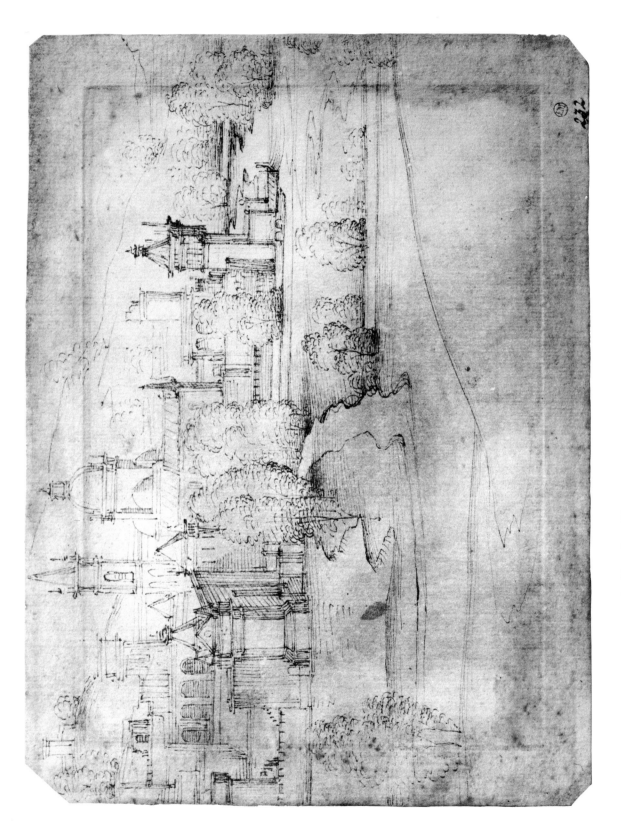

9. FRA BARTOLOMMEO *View of a Town by a River*

10. RAPHAEL *The Adoration of the Magi*

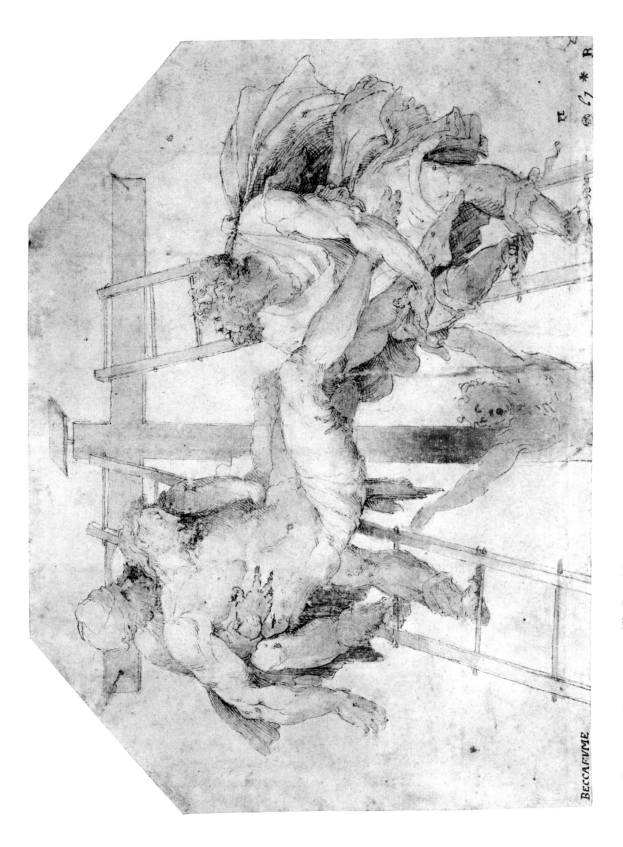

11. Domenico Beccafumi *The Deposition*

12. GIROLAMO ROMANINO *Battle in Front of a Castle*

13. GIOVANNI DA UDINE *Finch*

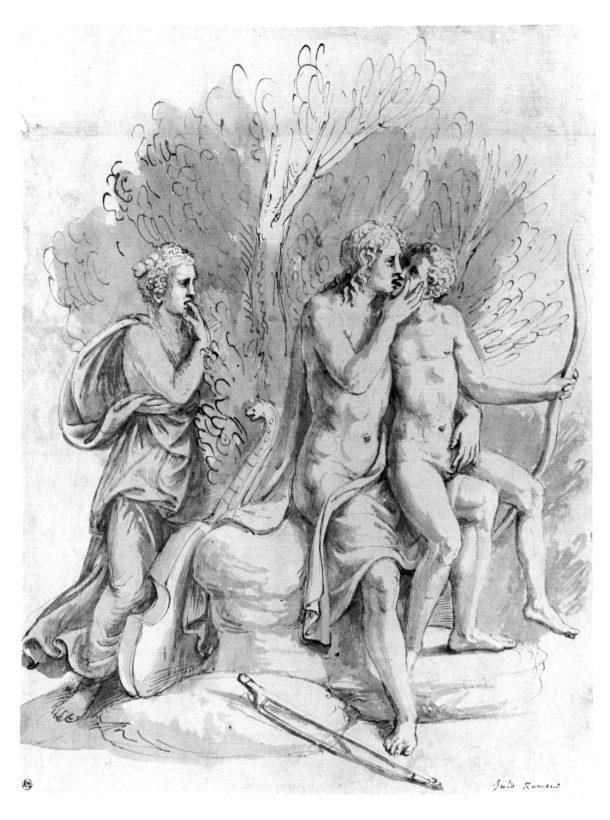

14. GIULIO ROMANO *Apollo and Cyparissus*

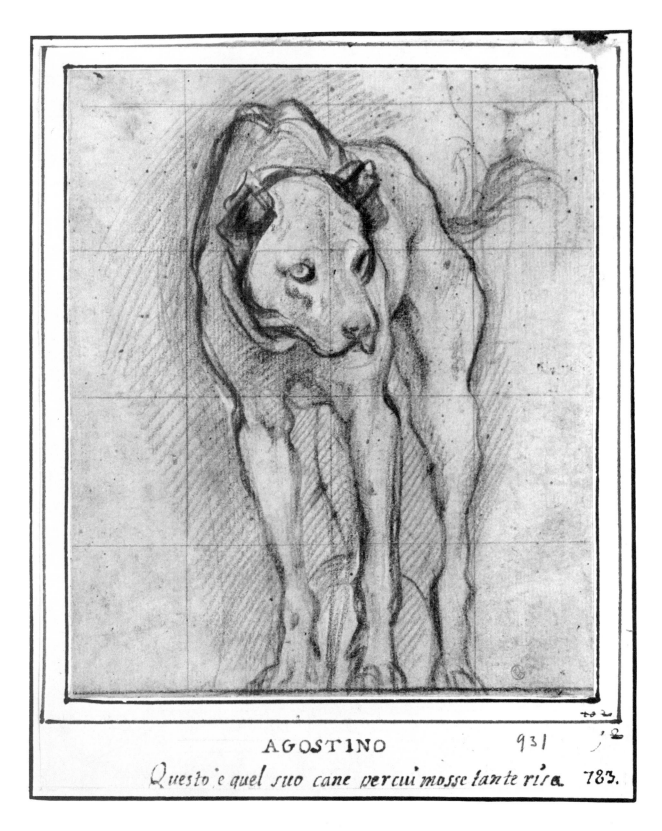

AGOSTINO 931 '2

Questo è quel suo cane percui mosse tante risa. 783.

15. JACOPO PONTORMO *Dog*

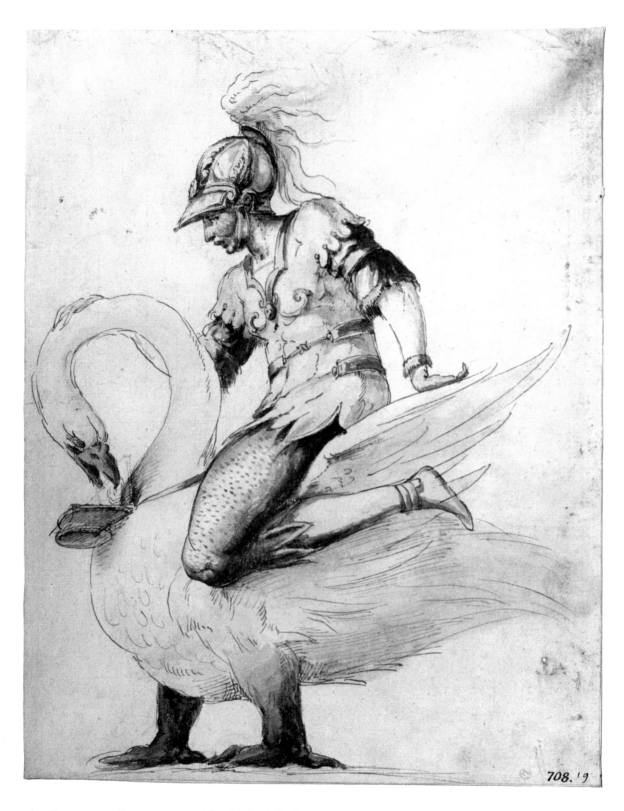

708. 19

16. FRANCESCO PRIMATICCIO *The Knight of the Swan*

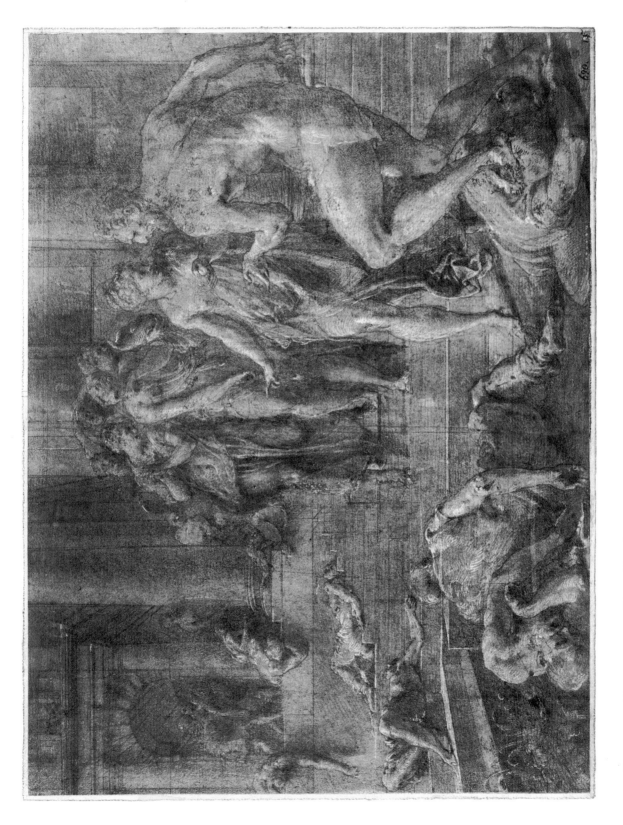

17. Francesco Primaticcio *Ulysses Has the Servants of Penelope Executed*

18. JACOPO TINTORETTO *Three Studies of a Sculpture of Atlas*

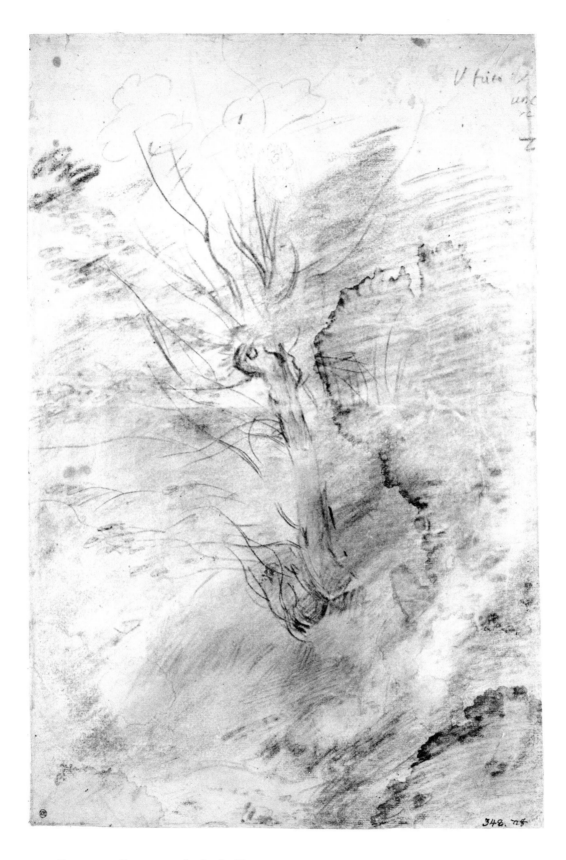

19. FEDERIGO BAROCCI *Study of a Tree*

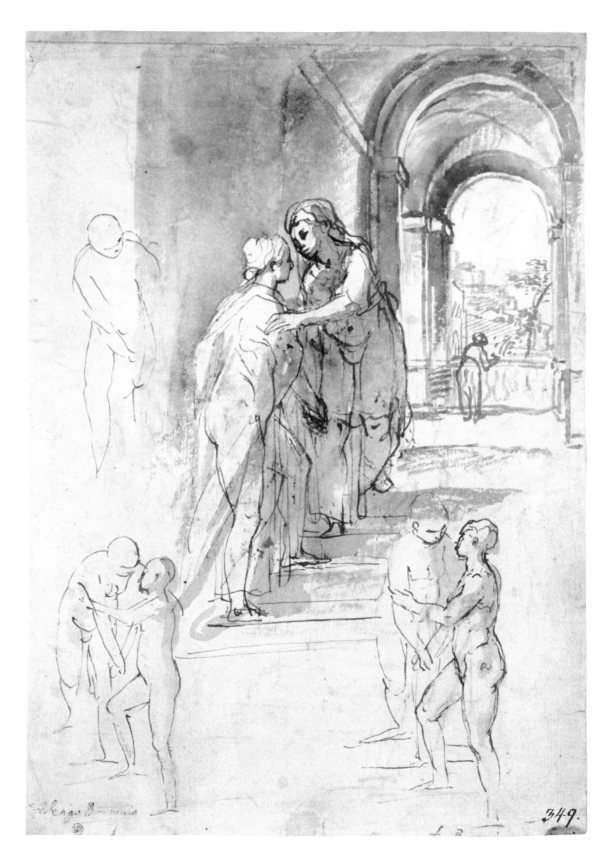

20. FEDERIGO BAROCCI *The Visitation*

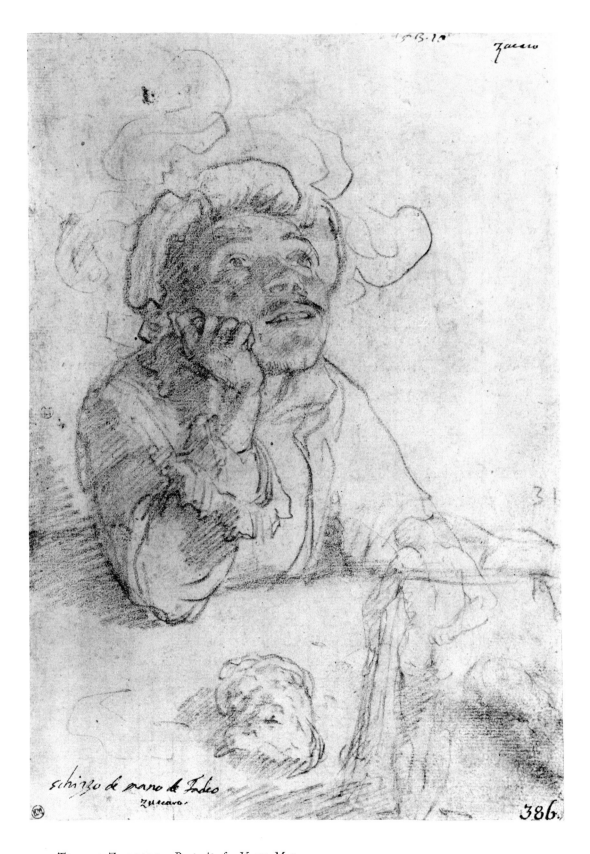

21. TADDEO ZUCCARO *Portrait of a Young Man*

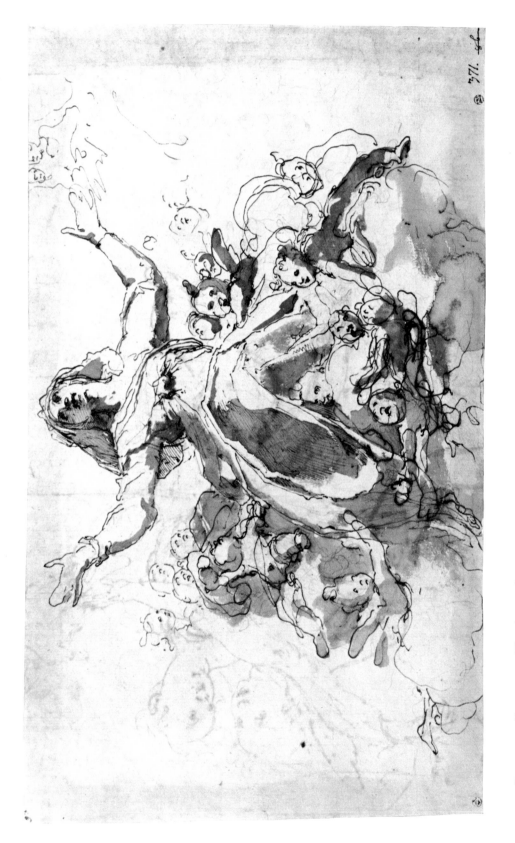

22. FEDERIGO ZUCCARO *The Assumption*

23. Francesco Curia *Baptism in a Church*

24. PALMA GIOVANE *St. John the Evangelist, St. Mark, and St. Paul in the Clouds*

25. LUDOVICO CARRACCI *The Martyrdom of St. Catherine*

26. AGOSTINO CARRACCI *Christ and the Adulteress*

27. ANNIBALE CARRACCI *Madonna and Child with St. John*

28. GUIDO RENI *The Penitent Magdalene*

29. GIOVANNI LANFRANCO *Seated Woman Seen "di sotto in sù"*

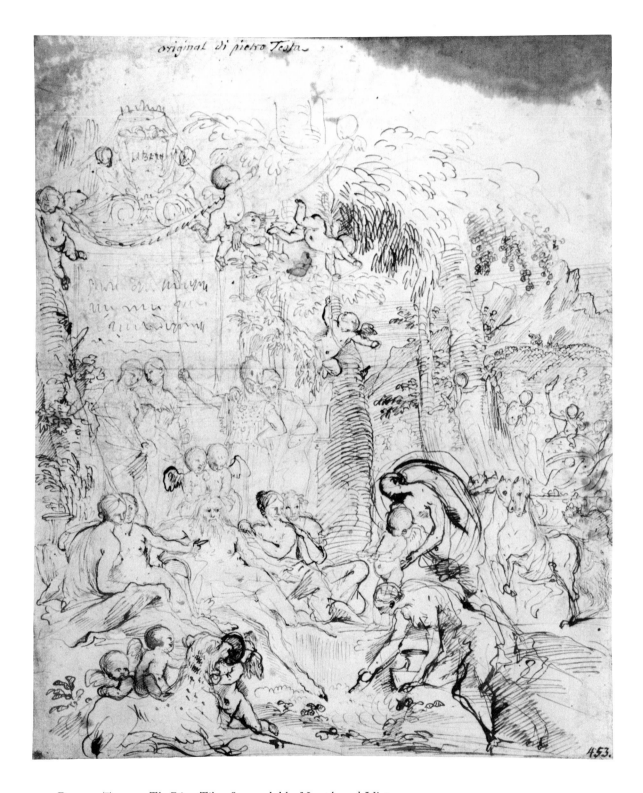

30. PIETRO TESTA *The River Tiber Surrounded by Nymphs and Virtues*

31. Stefano della Bella *Piazza della Rotonda*

32. STEFANO DELLA BELLA *Standard Bearer*

33. Stefano della Bella *Tournament in Modena, 1660*

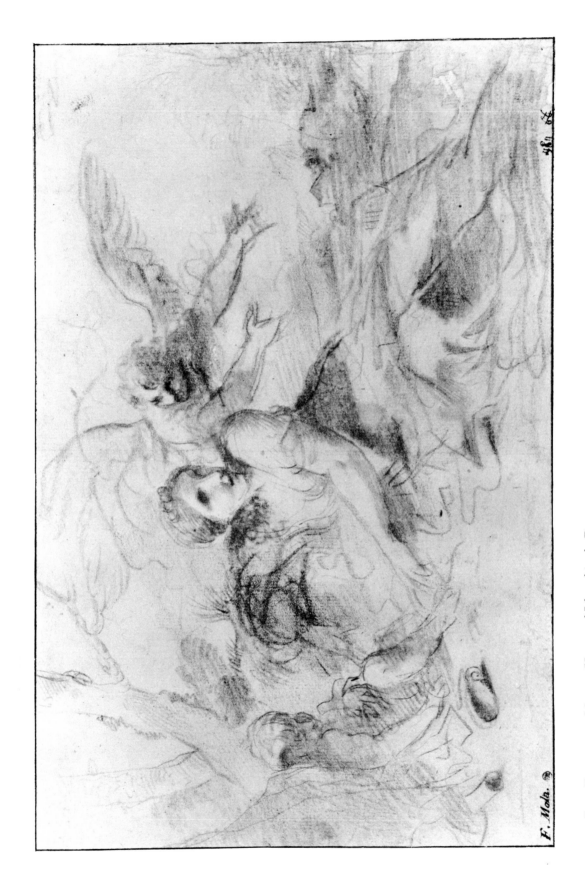

34. PIER FRANCESCO MOLA *Hagar and Ishmael in the Desert*

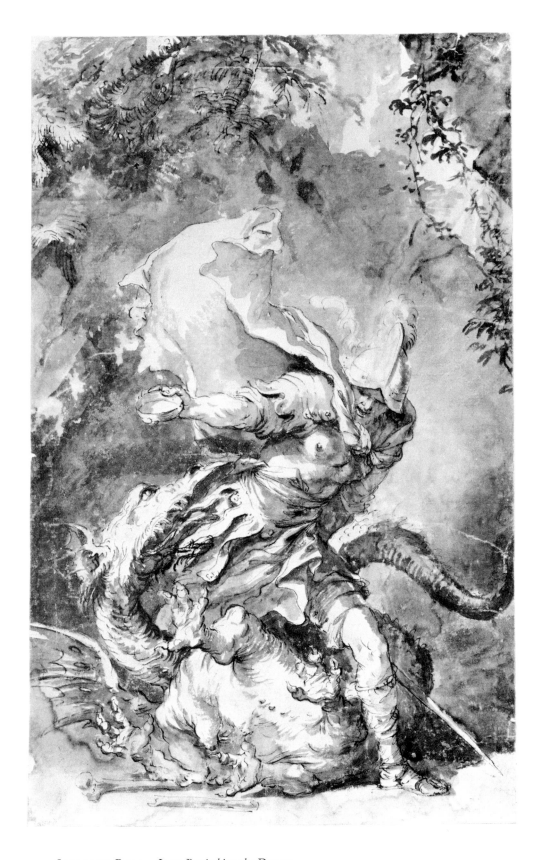

35. Salvator Rosa *Jason Bewitching the Dragon*

36. CIRO FERRI *Academy with Pupils Drawing*

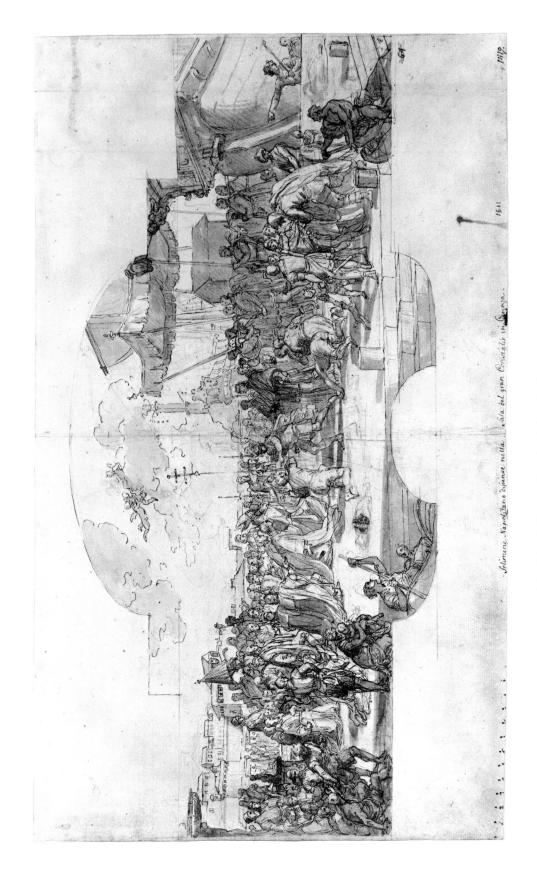

37. Francesco Solimena *The Remains of St. John the Baptist Brought Ashore in Genoa*

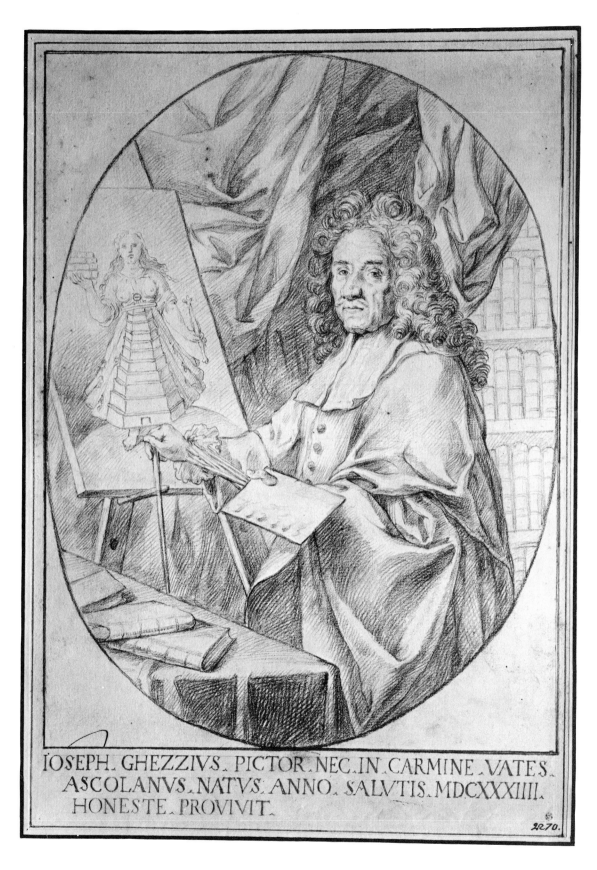

IOSEPH. GHEZZIVS. PICTOR. NEC. IN. CARMINE. VATES.
ASCOLANVS. NATVS. ANNO. SALVTIS. MDCXXXIIII.
HONESTE. PROVIVIT.

2270.

38. GIUSEPPE GHEZZI *Self-Portrait*

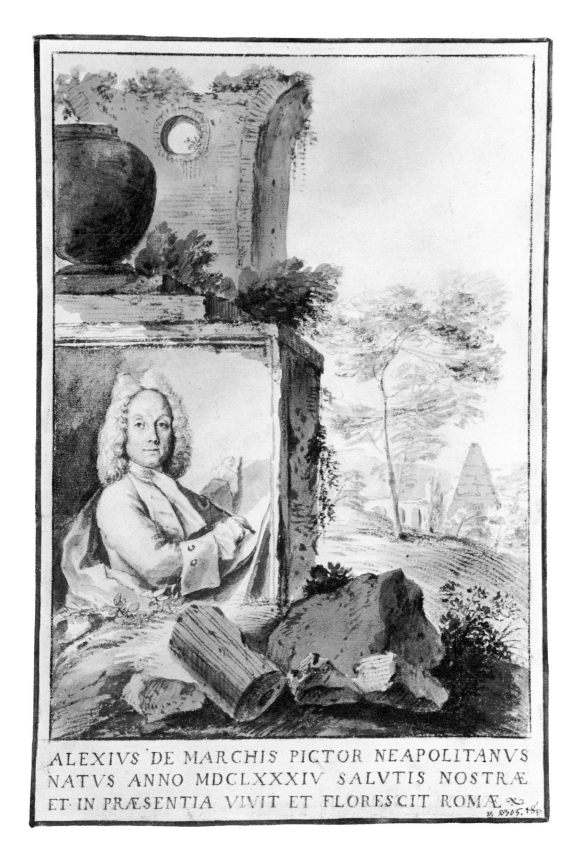

ALEXIVS DE MARCHIS PICTOR NEAPOLITANVS
NATVS ANNO MDCLXXXIV SALVTIS NOSTRÆ
ET·IN PRÆSENTIA VIVIT ET FLORESCIT ROMÆ

39. AGOSTINO MASUCCI AND ALESSIO DE' MARCHIS *Portrait of Alessio de' Marchis*

40. GIOVANNI ANTONIO PELLEGRINI *Triumph of a Conqueror*

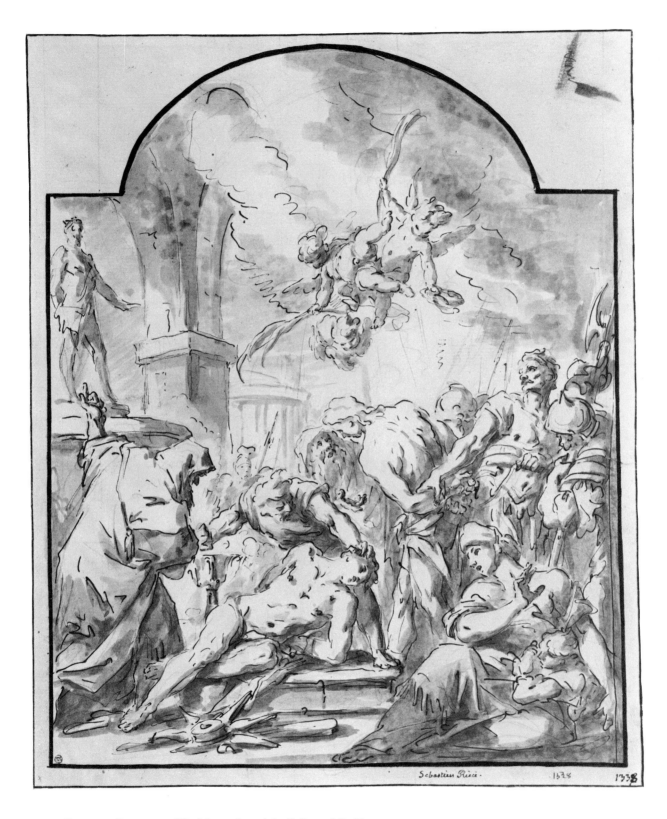

Sebastien Ricci· 1838 1338

41. GASPARE DIZIANI *The Martyrdom of St. Felix and St. Fortunatus*

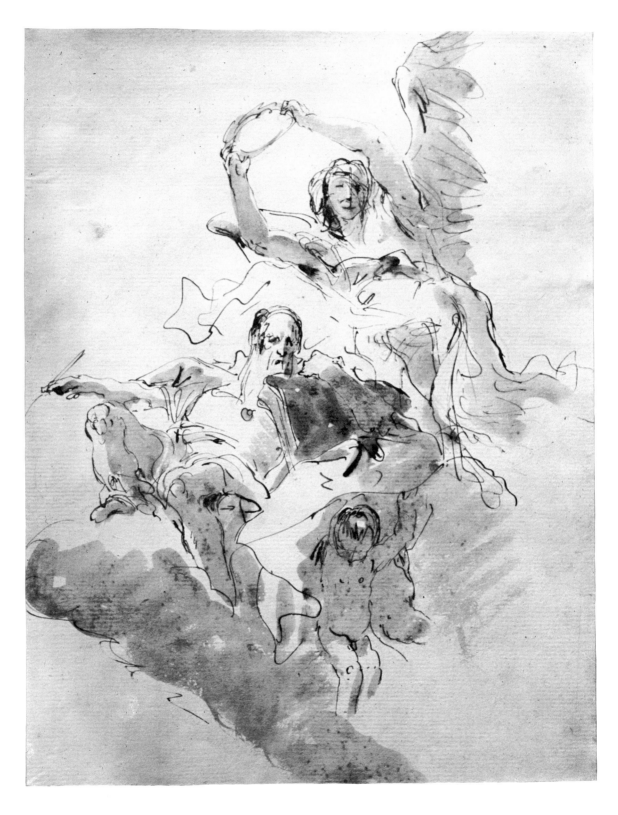

42. GIOVANNI BATTISTA TIEPOLO *Apotheosis of the Poet Geresio Soderini*

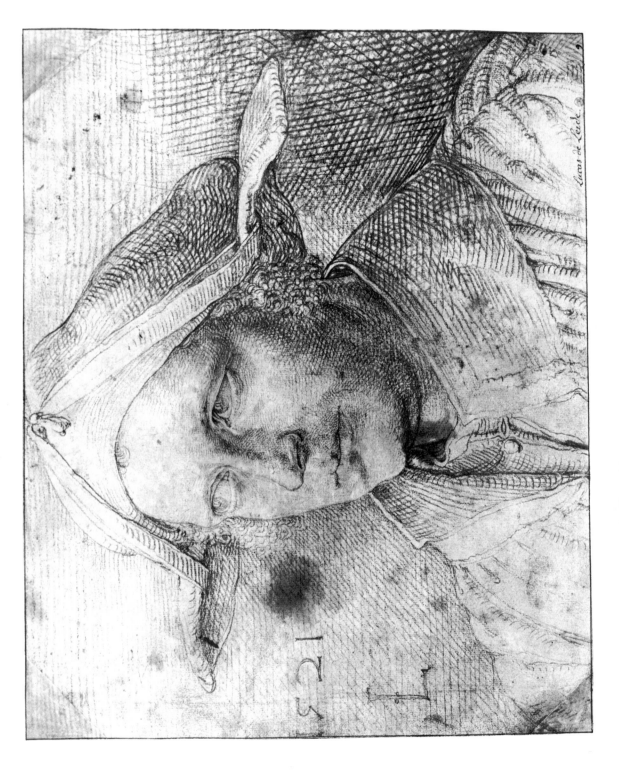

43. LUCAS VAN LEYDEN *Portrait of a Young Man*

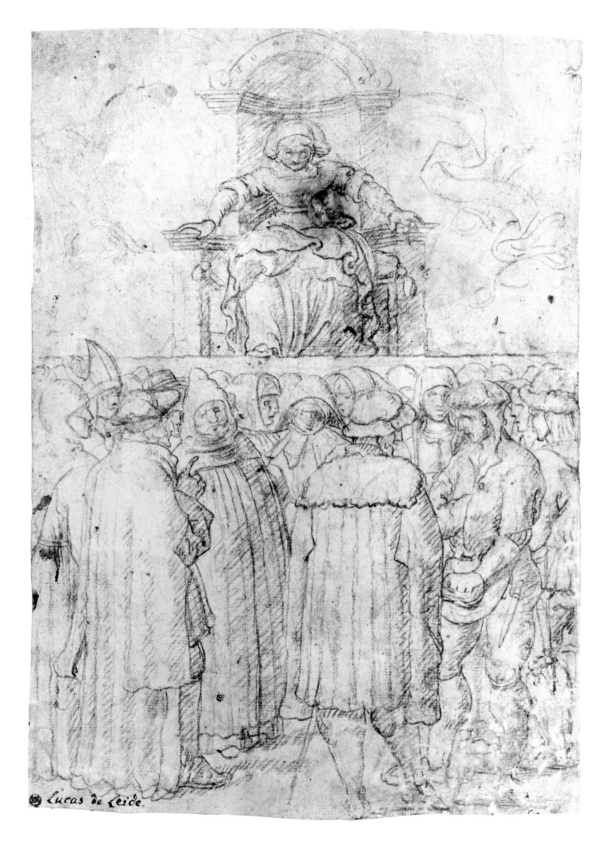

Lucas de Leide.

44. THE MASTER OF THE MIRACLES OF THE APOSTLES *Illustration to Erasmus' "Encomium Moriae"*

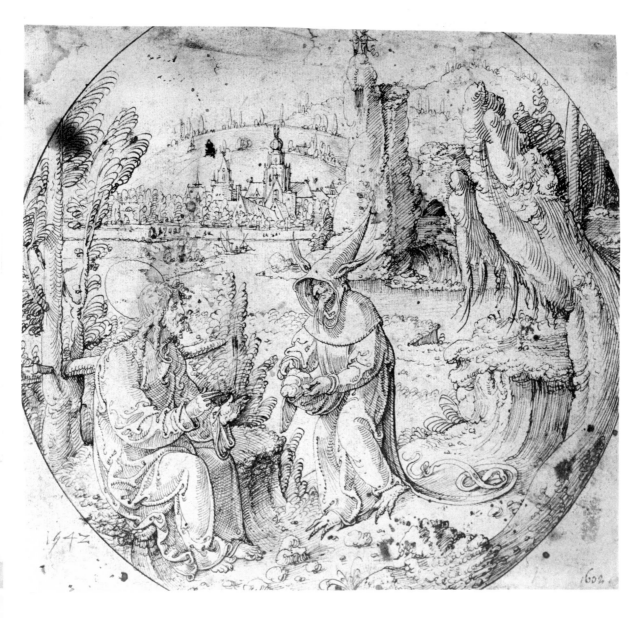

45. PIETER CORNELISZ *The Temptation of Christ*

46. MAERTEN VAN HEEMSKERK (?) *Transept in St. Peter's, Rome, under Construction*

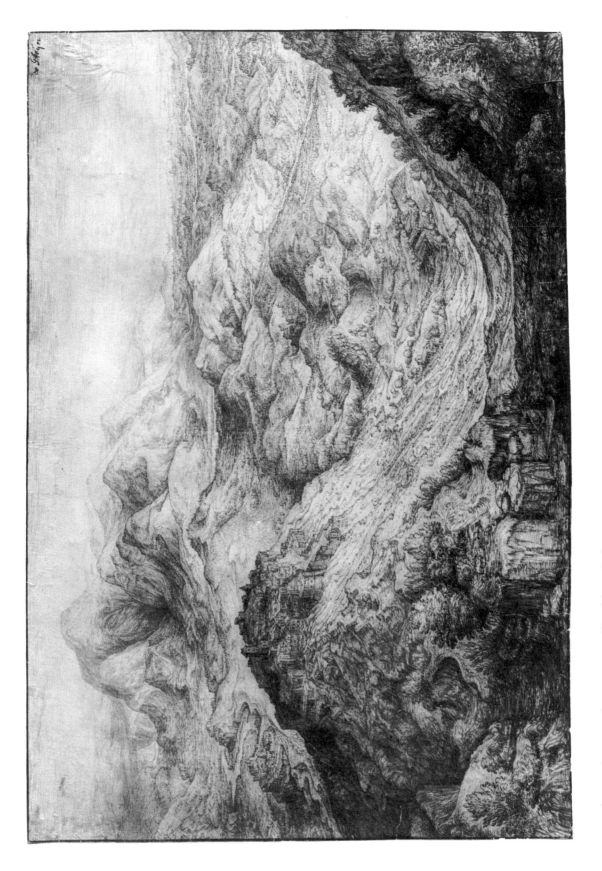

47. After Jan van Stinemolen (?) *Mountain Scenery*

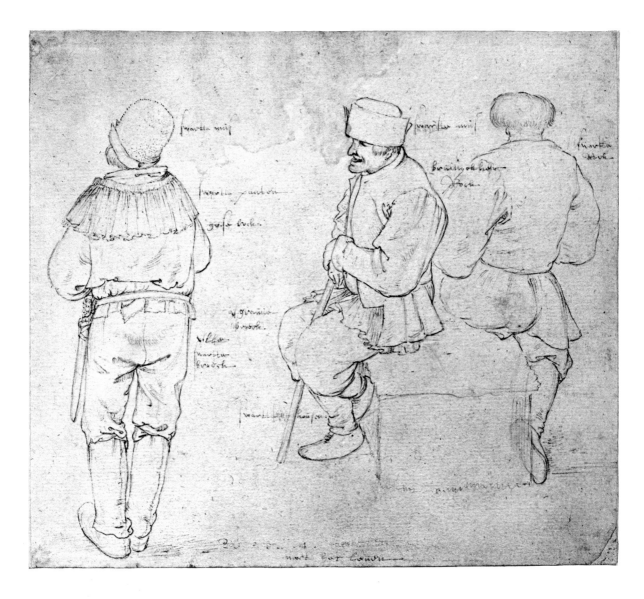

48. PIETER BRUEGEL THE ELDER *Three Peasants*

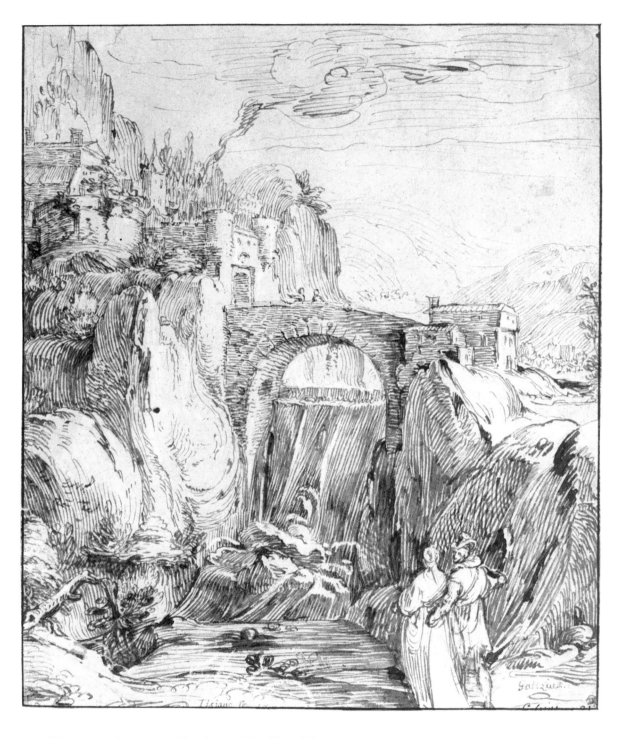

49. HENDRICK GOLTZIUS *Landscape with a Waterfall*

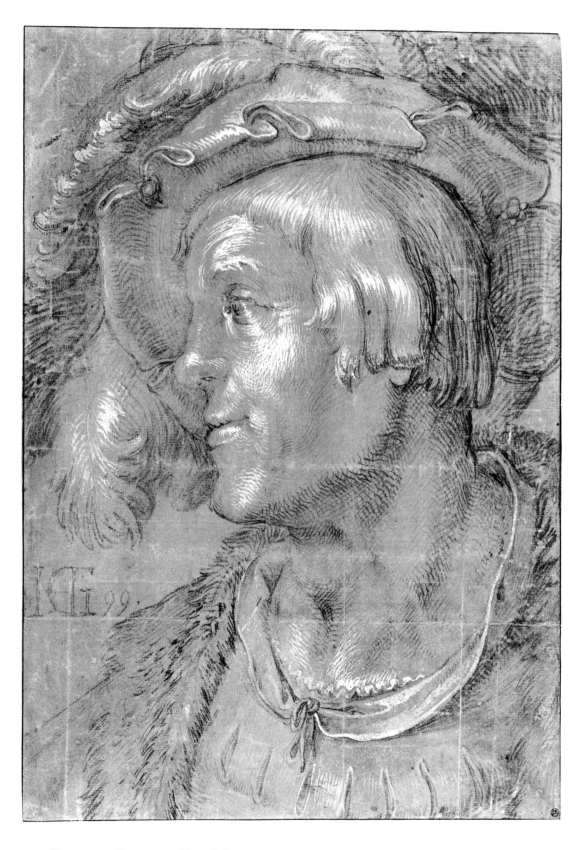

50. HENDRICK GOLTZIUS *Young Man Wearing a Large Plumed Hat*

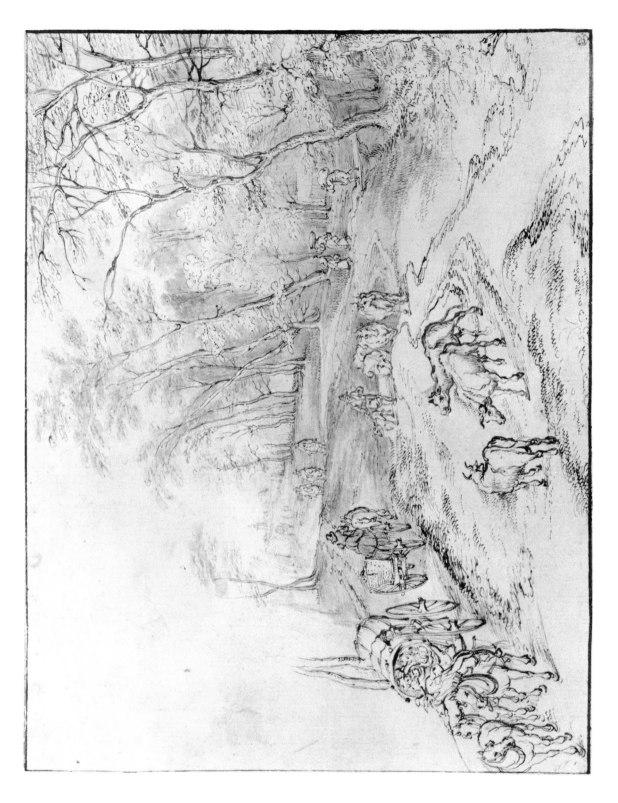

51. JAN BRUEGEL THE ELDER *Landscape with Wagon and Wayfarers*

52. GILLIS VAN VALCKENBORCH *River Landscape*

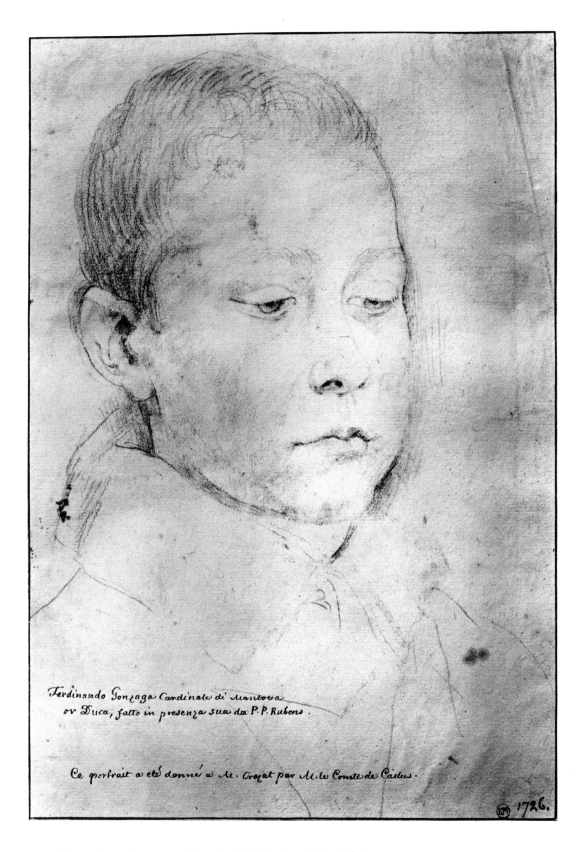

Ferdinando Gonzaga Cardinale di Mantova
ov Duca, fatto in presenza sua da P. P. Rubens.

Ce portrait a été donné à M. Crozat par M. le Comte de Caylus.

1726.

53. PETER PAUL RUBENS *Portrait of the Mantuan Prince Silvio*

54. PETER PAUL RUBENS *Robin, the Dwarf of the Earl of Arundel*

55. PETER PAUL RUBENS *The Virgin Adored by Saints*

56. Claes Jansz Visscher the Younger (?) *Scene of Traders in a Dutch Colony*

57. JAN PORCELLIS (?) *Seascape with Fishing Boats*

58. ESAIAS VAN DE VELDE *River Landscape*

59. LUCAS VAN UDEN *Landscape with a Country Estate*

60. ANTHONY VAN DYCK *Profile and Left Arm of a Young Woman*

61. ANTHONY VAN DYCK *Portrait of Cornelius van der Geest*

62. ADRIAEN BROUWER (?) *Self-Portrait* (?)

63. REMBRANDT VAN RIJN *Nude Woman in a Landscape*

64. REMBRANDT VAN RIJN *Farmstead beneath Trees*

65. REMBRANDT VAN RIJN *Girl Asleep in a Window*

66. REMBRANDT VAN RIJN *Christ and the Woman Taken in Adultery*

L'ange quitte Manüé et sa femme, et s'éleve au milieu de la flame qu'il avoit excité. 1807.

67. REMBRANDT VAN RIJN *Manoah's Offering*

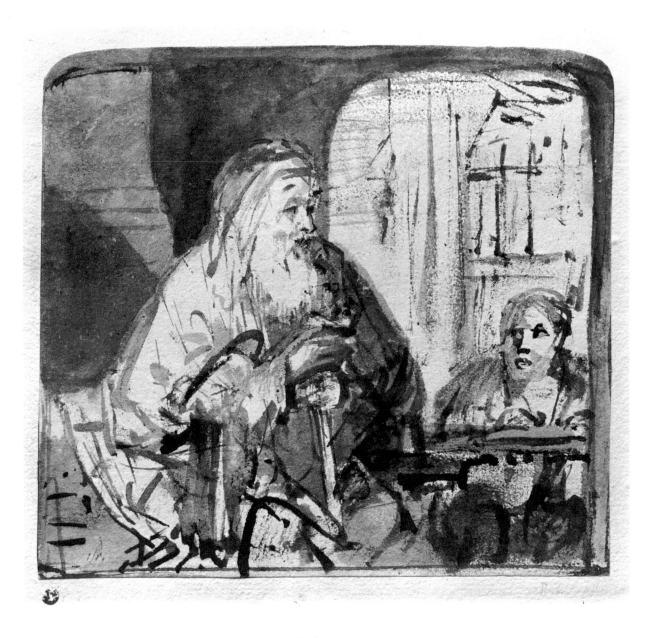

68. REMBRANDT VAN RIJN *Homer Dictating to a Scribe*

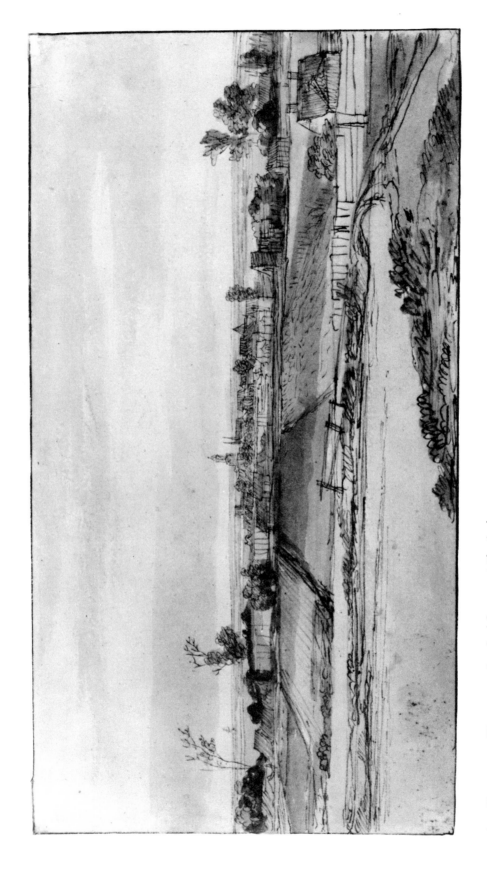

69. PHILIPS DE KONINCK *Lowland Scenery outside Arnhem*

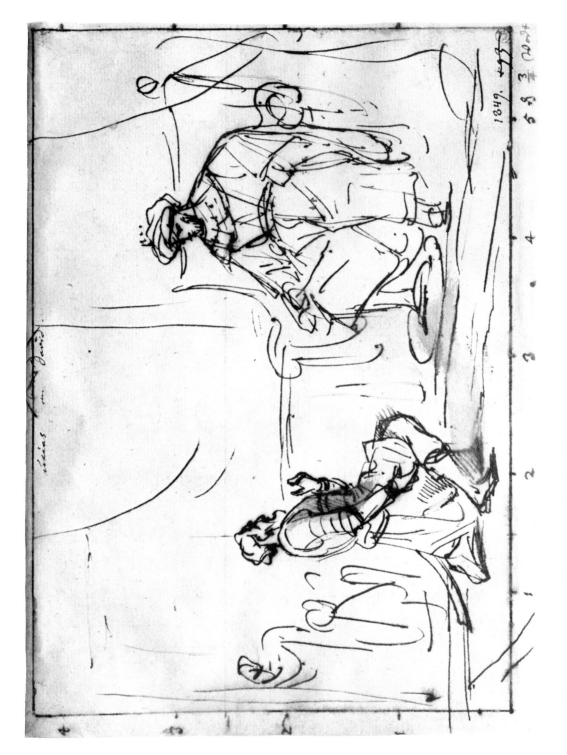

70. GERBRAND VAN DEN EECKHOUT *David and Uriah*

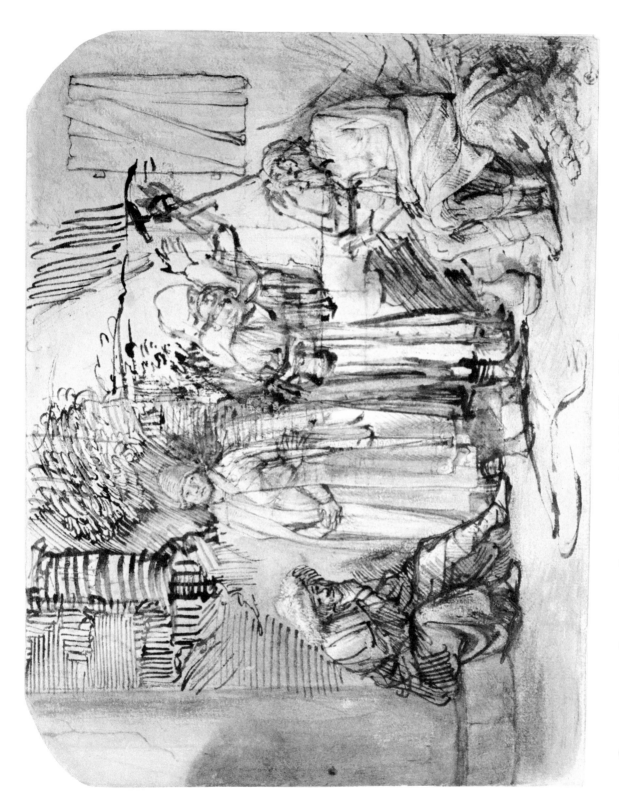

71. Constantijn van Renesse and Rembrandt *Job with his Wife and Friends*

72. ANTHONIE VAN BORSSOM *Jetty with Buildings*

73. Aert de Gelder *Vertumnus and Pomona*

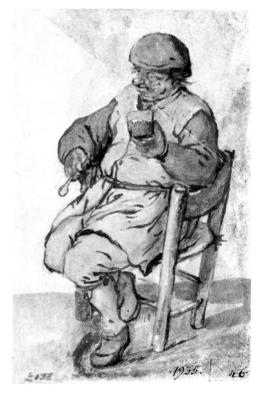

74. ADRIAEN VAN OSTADE *Studies of Peasants*

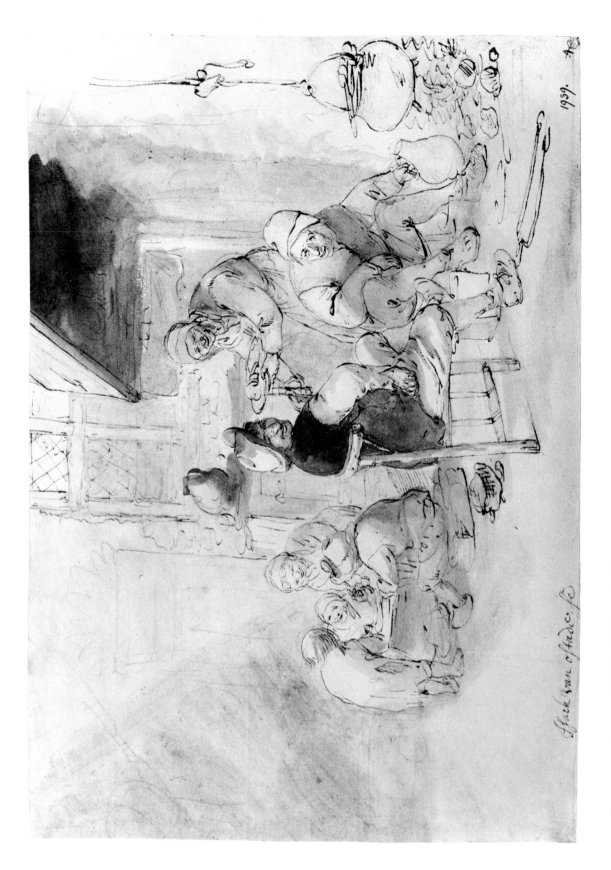

75. Isaac van Ostade *Interior of a Peasant's Cottage*

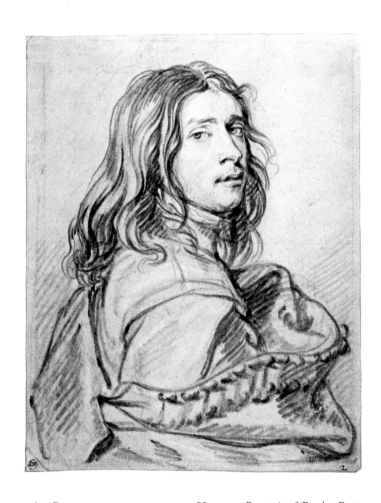

76. BARTHOLOMEUS VAN DER HELST *Portrait of Paulus Potter*

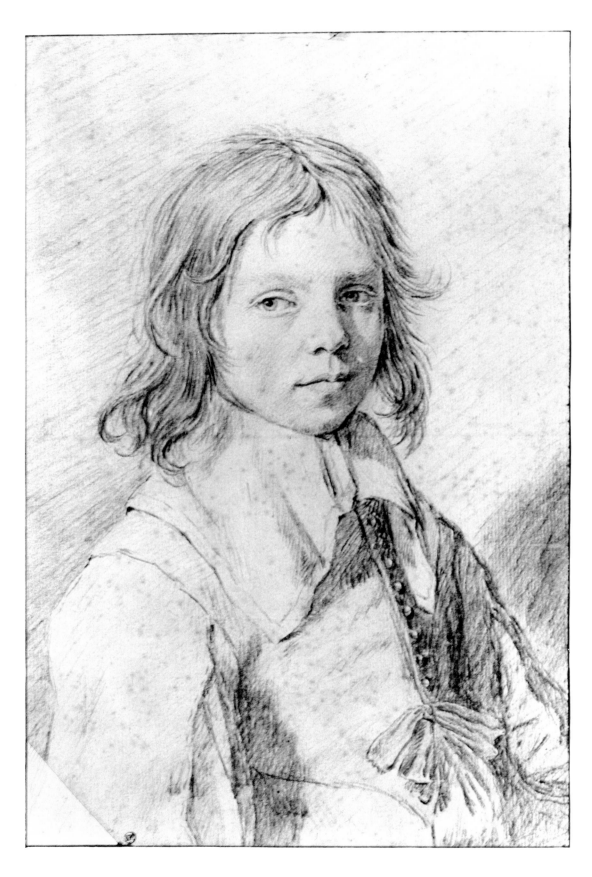

77. JAN DE BRAY *Portrait of a Boy*

78. WILLEM VAN DE VELDE THE YOUNGER *Naval Vessel Surrounded by Small Boats*

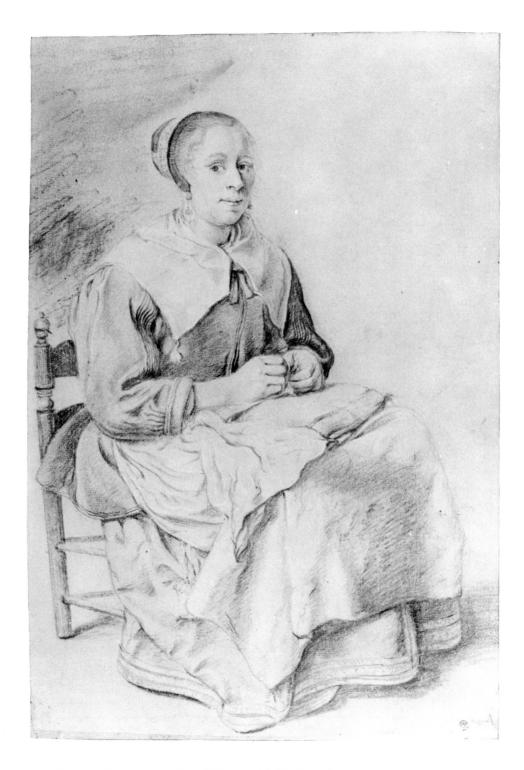

79. CASPAR NETSCHER *Seated Woman with Needlework*

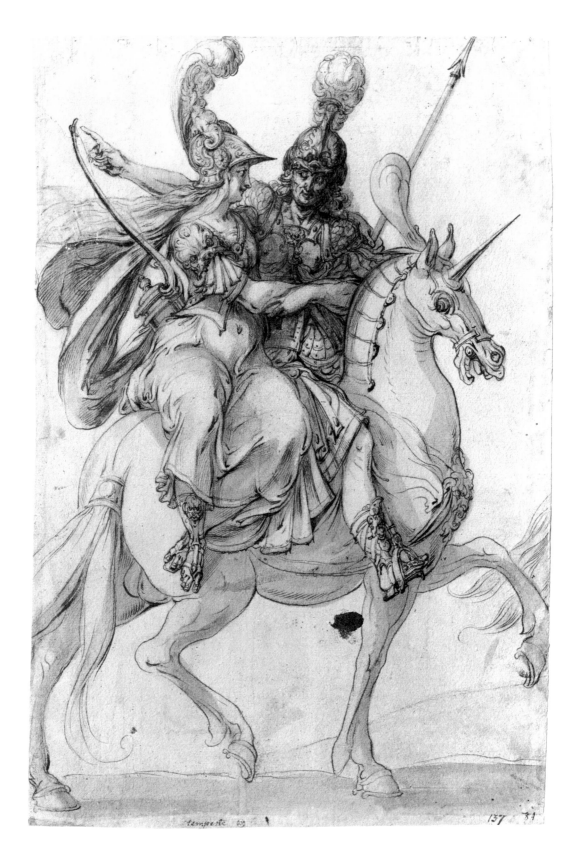

80. CLAUDE DERUET *Couple on a Horse*

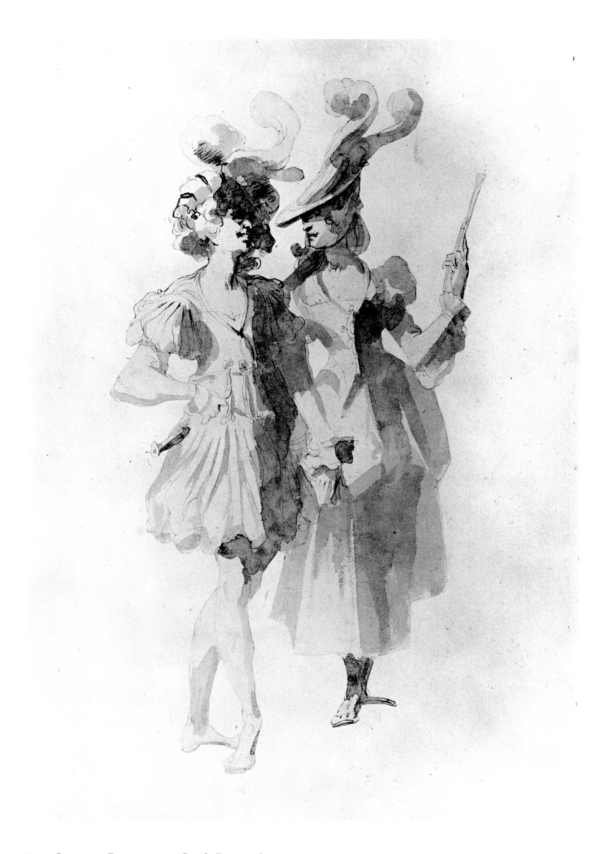

81. Jacques Bellange *Couple Promenading*

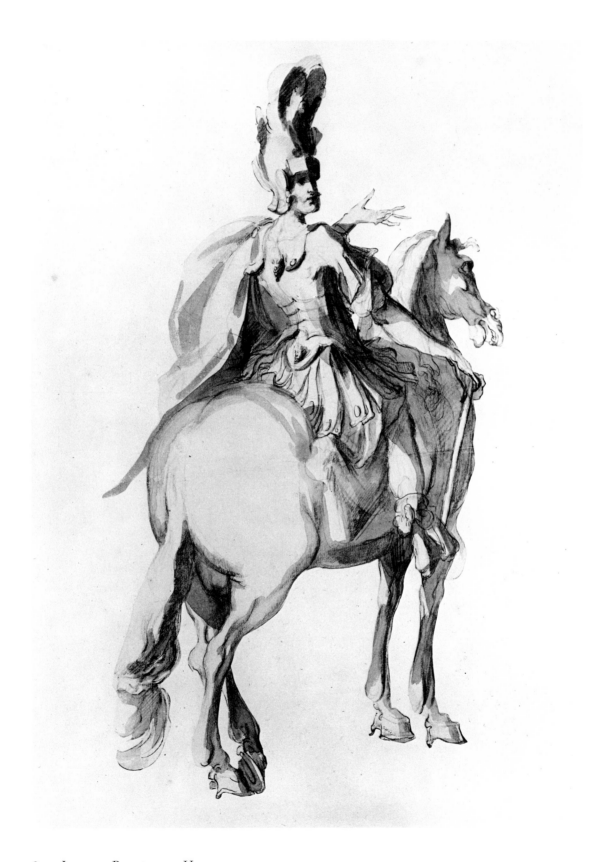

82. JACQUES BELLANGE *Horseman*

83. JACQUES CALLOT *Horse Walking; Small Sketch of Rearing Horse*

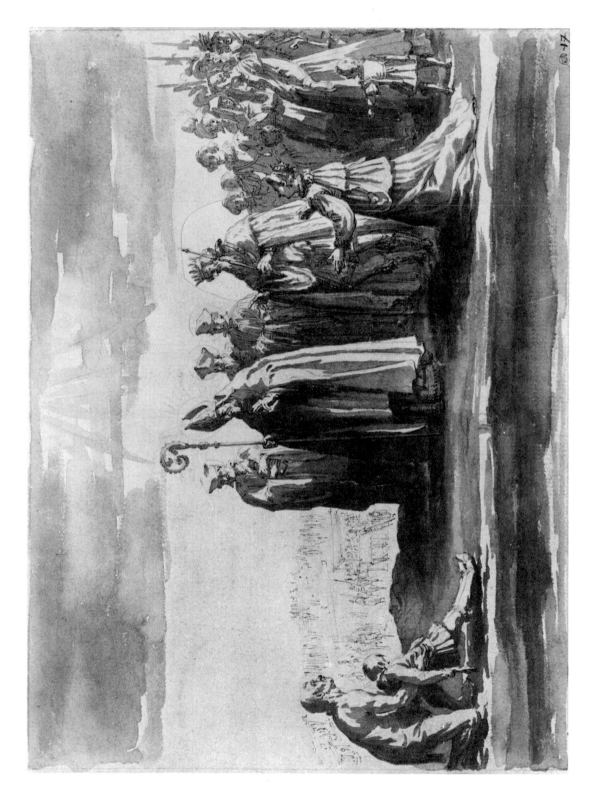

84. JACQUES CALLOT *Miracle of St. Mansuetus*

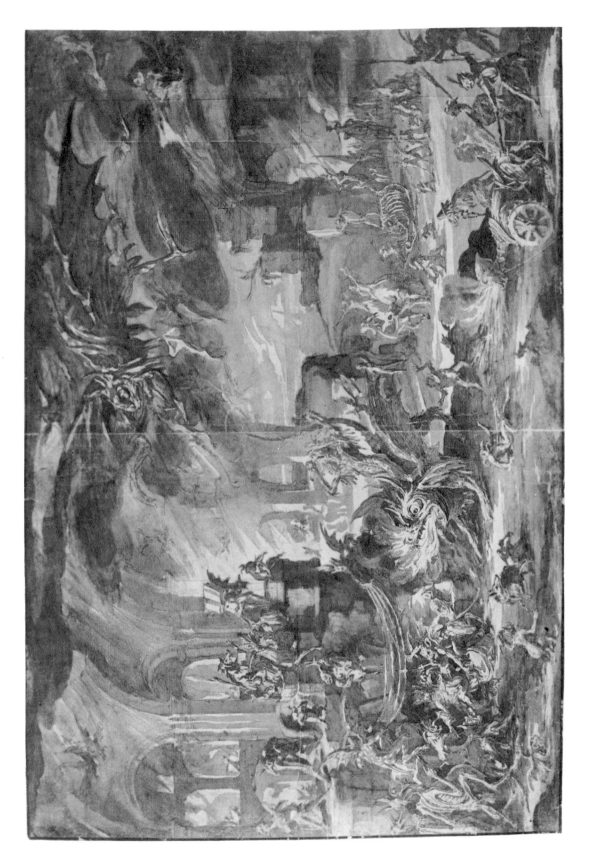

85. JACQUES CALLOT *The Temptation of St. Anthony*

86. NICOLAS POUSSIN *The Triumph of Galatea*

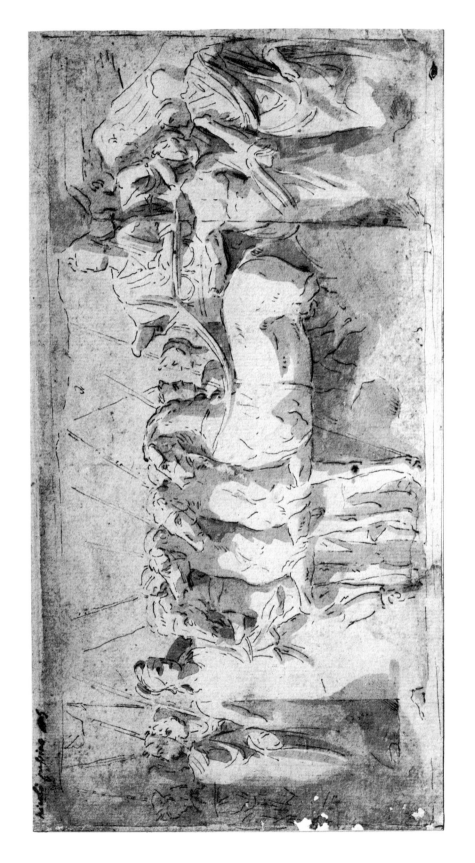

87. Nicolas Poussin *The Triumph of Titus*

Poussin. Cabinet de Crozat.

2349.

88. NICOLAS POUSSIN *The Finding of Queen Zenobia*

89. NICOLAS POUSSIN *The Nurture of the Infant Jupiter*

90. SCHOOL OF POUSSIN *Paris and Oenone*

91. CLAUDE LORRAIN *Landscape with Three Figures*

92. CLAUDE MELLAN *Henrietta Anne of England*

93. CLAUDE MELLAN *Cardinal Richelieu*

94. RAYMOND LA FAGE *The Triumph of Amphitrite*

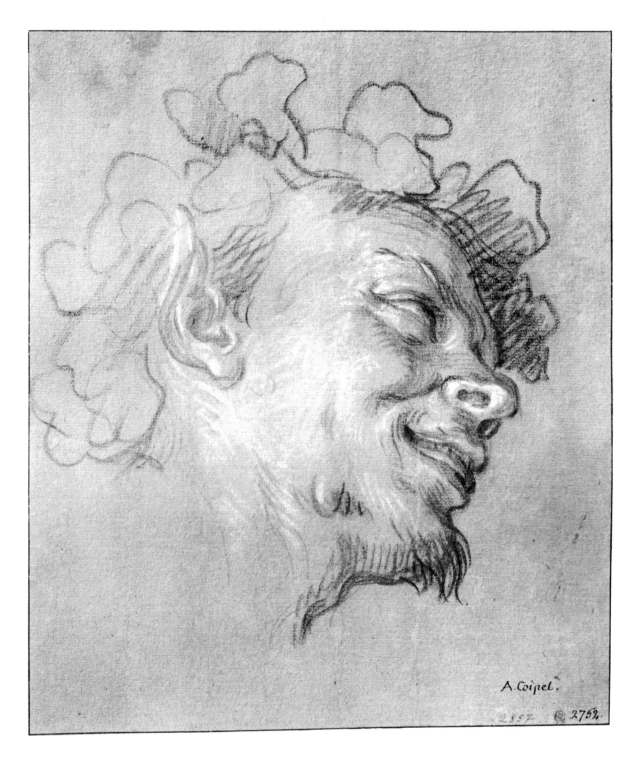

95. ANTOINE COYPEL *Satyr's Head*

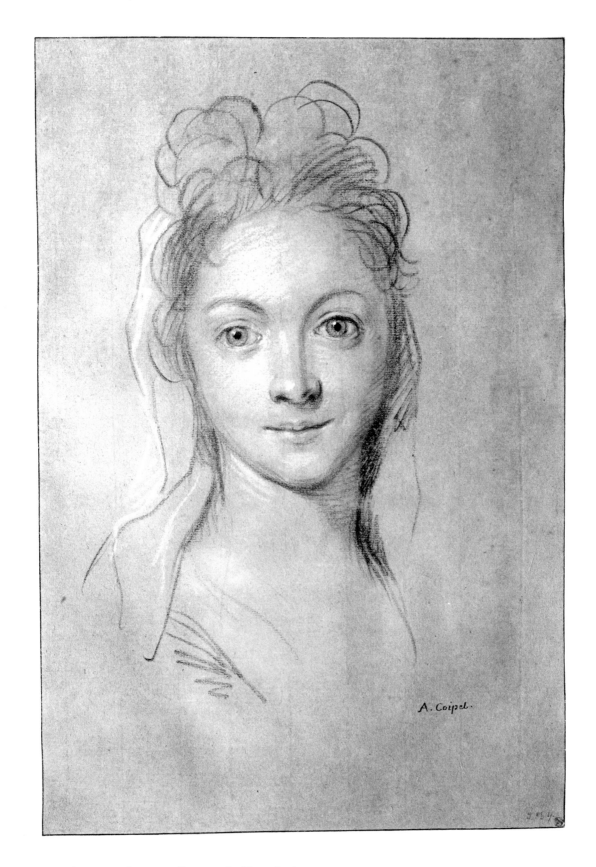

96. ANTOINE COYPEL *Portrait of a Young Lady*

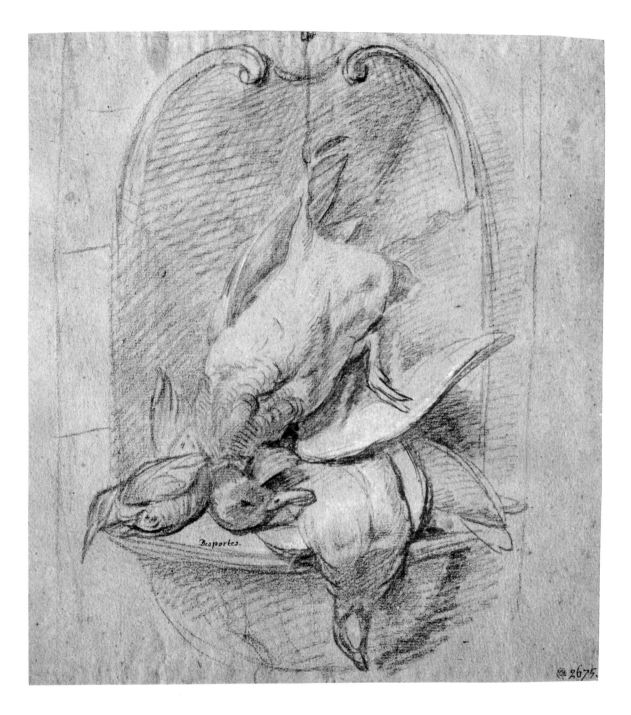

97. FRANÇOIS DESPORTES *Still Life*

98. JEAN-ANTOINE WATTEAU *Four Studies of a Young Woman's Head*

99. JEAN-ANTOINE WATTEAU *Philippe Poisson, the Actor*

100. JEAN-ANTOINE WATTEAU AFTER RUBENS *The Crucifixion of St. Peter*

101. JEAN-BAPTISTE OUDRY *Fox*

102. NICOLAS LANCRET *Studies of a Young Woman*

103. JEAN-BAPTISTE SIMÉON CHARDIN *The Sedan Chair*

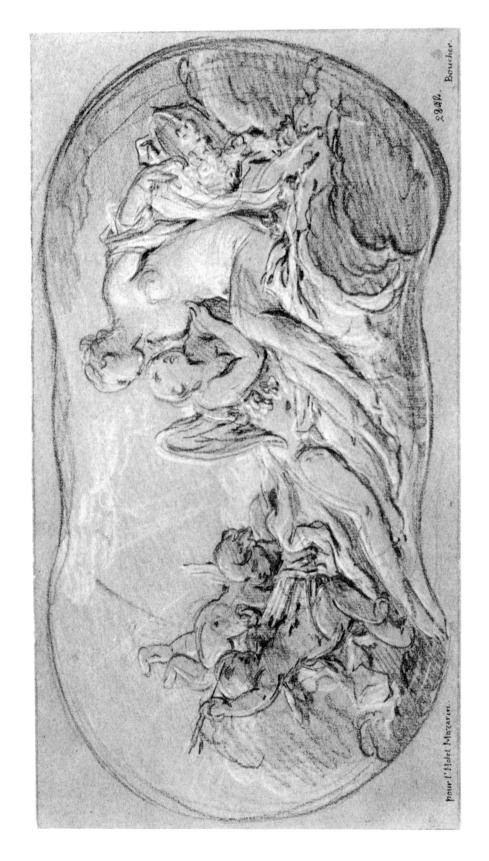

104. FRANÇOIS BOUCHER *Cupid and Psyche*

105. FRANÇOIS BOUCHER *Landscape with Women Bathing*

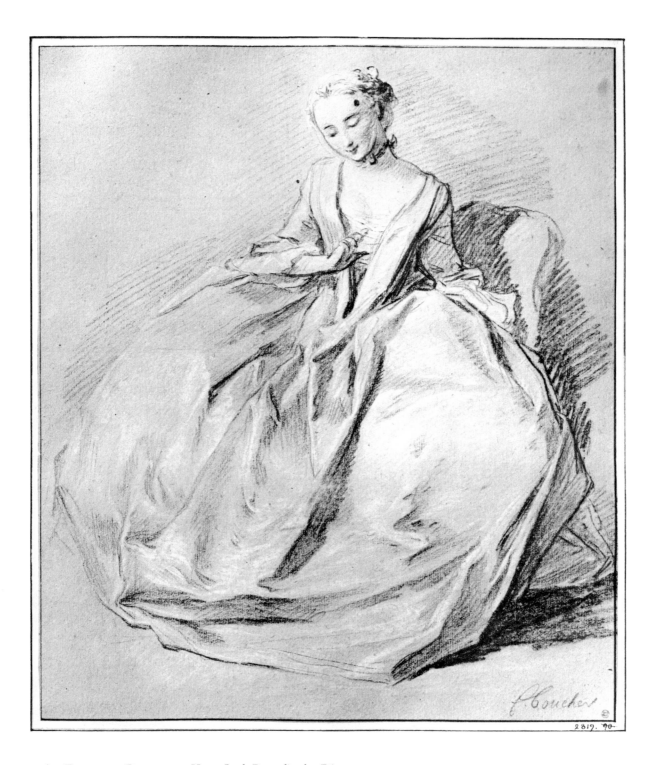

106. FRANÇOIS BOUCHER *Young Lady Regarding her Ring*

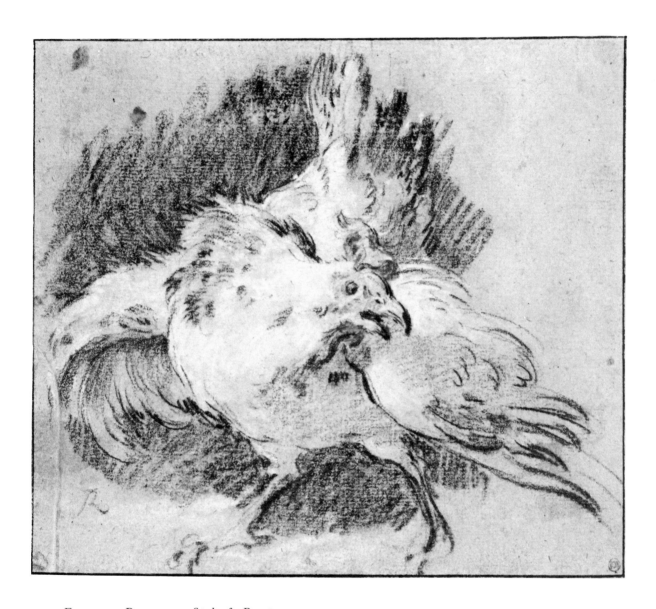

107. FRANÇOIS BOUCHER *Study of a Rooster*

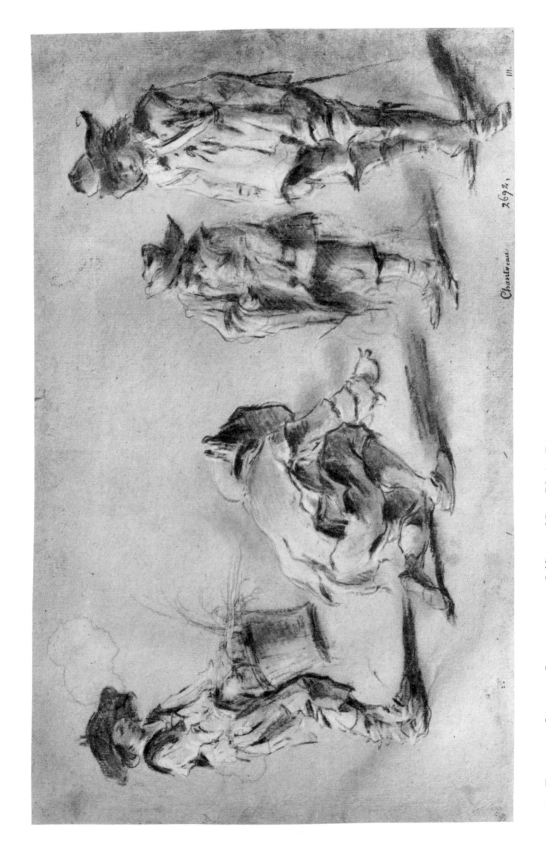

108. FRANÇOIS-JÉROME CHANTEREAU *Soldiers and Boys Playing Dice*

109. GABRIEL DE SAINT-AUBIN · *The Kitchen of the Hôtel des Invalides*

110. CARL GUSTAF PILO *H. V. Peil at the Funeral of Mrs. A. J. Grill*

111. CARL GUSTAF PILO *Landscape with Nine Men Making Merry*

112. ELIAS MARTIN *Portrait of a Young Lady in a Black Hat*

113. ELIAS MARTIN *Three Carpenters at their Bench*

114. ELIAS MARTIN *Johan Fredrik Martin and his Wife*

115. Elias Martin *View of Tyresö Church and Manor*

116. ELIAS MARTIN *Autumn at Haga*

117. ELIAS MARTIN *Salmon Fishing at Älvkarleby*

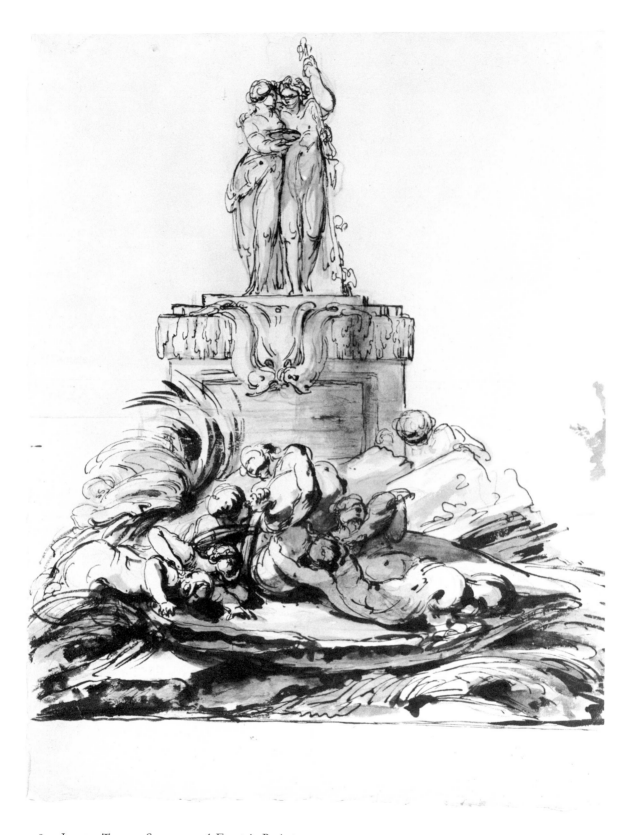

118. JOHAN TOBIAS SERGEL *A Fountain Project*

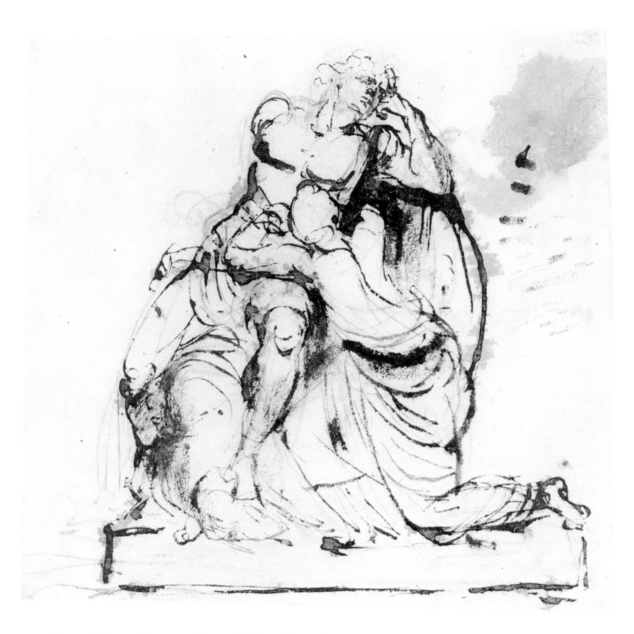

119. JOHAN TOBIAS SERGEL *Hero and Woman Lamenting*

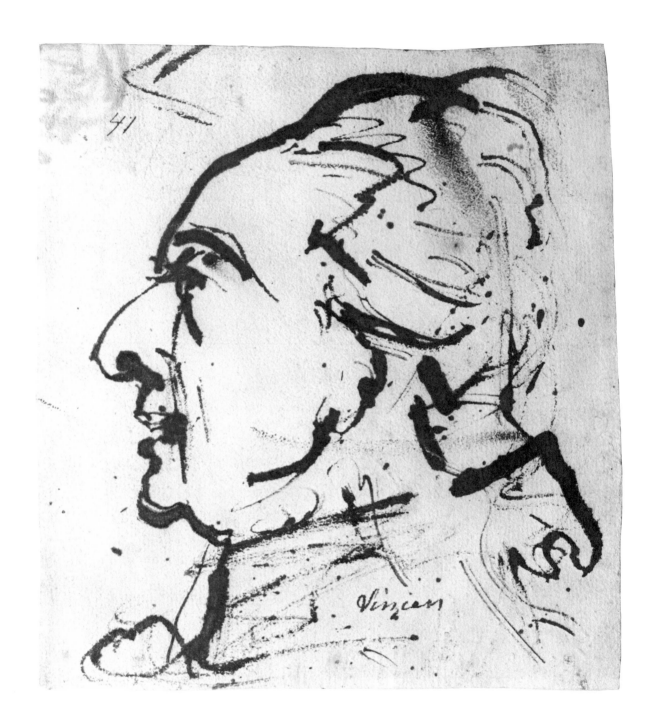

120. JOHAN TOBIAS SERGEL *Portrait of François-André Vincent*

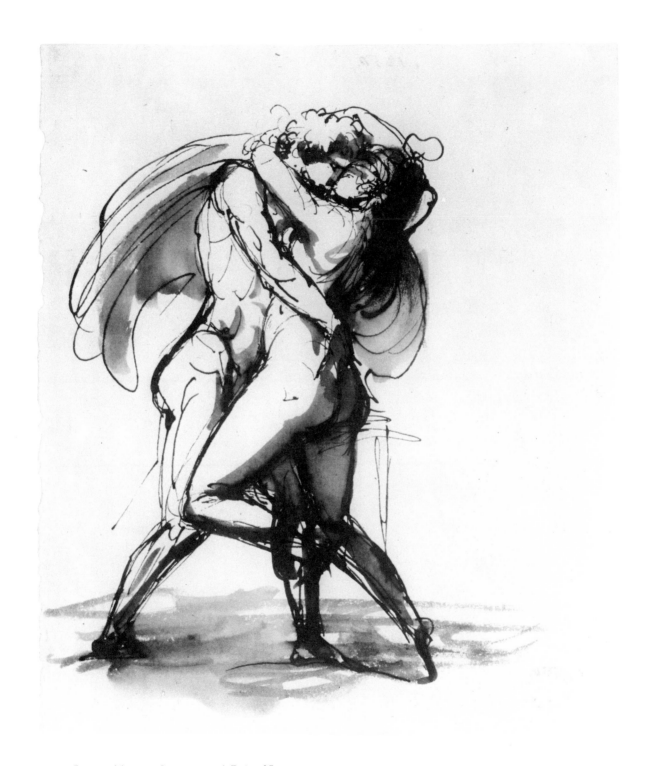

121. JOHAN TOBIAS SERGEL *A Pair of Lovers*

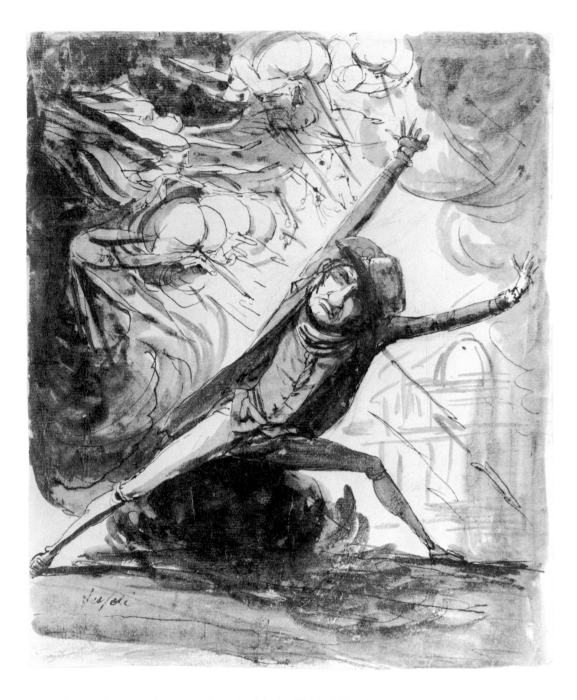

122. JOHAN TOBIAS SERGEL *Portrait of Johann Heinrich Füssli*

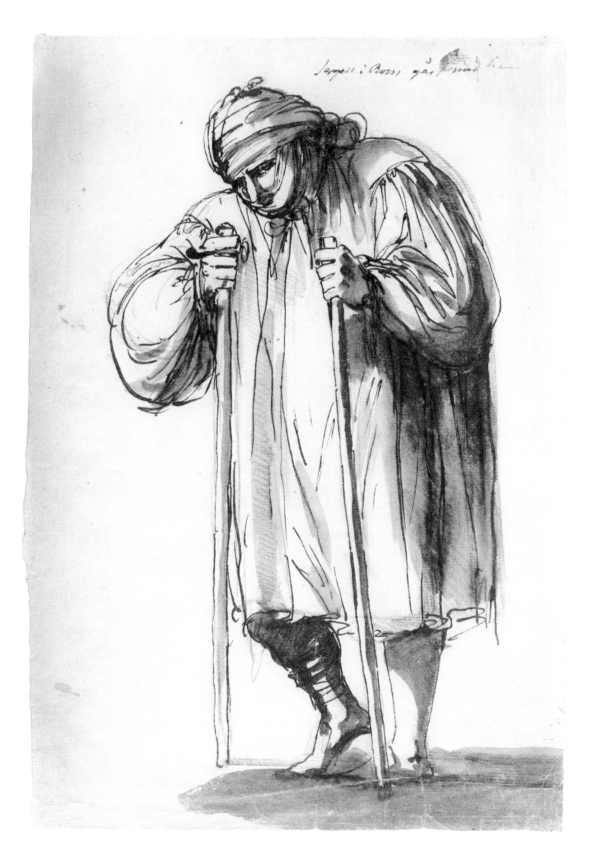

123. Johan Tobias Sergel *Sergel on Crutches in Rome*

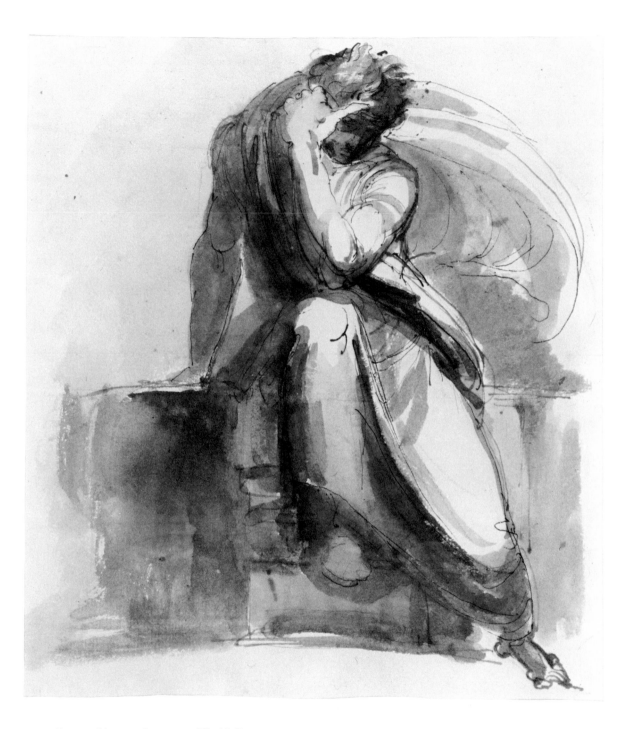

124. JOHAN TOBIAS SERGEL *The Meditator*

Elias Martin
London . 1799 .

125. JOHAN TOBIAS SERGEL *Sergel Visiting Elias Martin in London*

126. JOHAN TOBIAS SERGEL *Portrait of Admiral Count Carl August Ehrensvärd*

127. Johan Tobias Sergel *A Boisterous Dinner*

128. JOHAN TOBIAS SERGEL *King Gustavus III Walking in Procession*

129. JOHAN TOBIAS SERGEL *King Gustavus III and his Suite Ascending Mount Vesuvius*

130. JOHAN TOBIAS SERGEL *Painful Dream*

131. Johan Tobias Sergel *Drinking Water*

132. JOHAN TOBIAS SERGEL *The Old Sergel Meeting the Crown Prince Karl Johan*

133. CARL AUGUST EHRENSVÄRD *The Concordia Temple, Agrigentum*

134. CARL AUGUST EHRENSVÄRD *Scania Landscape with Ploughmen*

135. CARL AUGUST EHRENSVÄRD *The Real Birth of the Poet*

136. CARL AUGUST EHRENSVÄRD *The Poet Learns the Constellations*

137. Carl August Ehrensvärd *A Stormy Sea*

138. CARL AUGUST EHRENSVÄRD *"My Friend Shall Drink and Be Voluptuously Drowned"*

INDEX OF ARTISTS

The numbers refer to catalogue entries.